GREEK ART
OF THE
AEGEAN ISLANDS

GREEK ART OF THE AEGEAN ISLANDS

An exhibition sponsored by the Government of the Republic of Greece
complemented by a loan from the Musée du Louvre
at The Metropolitan Museum of Art

November 1, 1979 – February 10, 1980

The Metropolitan Museum of Art, New York

Library of Congress Cataloging in Publication Data

New York (City). Metropolitan Museum of Art.
 Greek art of the Aegean Islands.

 "Based on 'Mer Égée: Grèce des îles,' the
French catalogue of the exhibition that was held
at the Louvre from April 26 to September 3, 1979."
 Includes bibliographical references.
 1. Art, Greek — Islands of the Aegean —
Exhibitions. 2. Islands of the Aegean — Antiqui-
ties — Exhibitions. I. Title.
N5640.N48 1979 730'.09391'07401471 79-3070
ISBN 0-87099-216-3

Hardcover edition distributed by George Braziller, New York
ISBN 0-8076-0947-1

Published by The Metropolitan Museum of Art, New York
Bradford D. Kelleher, Publisher
John P. O'Neill, Editor in Chief
Ellen Shultz, Editor
Gerald Pryor, Designer

Cover: Incense burner, supported by a statuette of a woman **184**

CONTENTS

GREEK COUNCIL

Honorary Committee
Mr. George Rallis, Minister of Foreign Affairs
Mr. Ioannis Varvitsiotis, Minister of National Education and Religion
Mr. Dimitrios Nianias, Minister of Culture and Science
His Excellency Ioannis Tzounis, Greek Ambassador to the United States

Organizing Committee
Mr. Perikles Theocharis, Right Rector, Technical University of Athens;
Member, Academy of Athens
Mr. Nikolaos Yalouris, Inspector General of Antiquities
Mr. Tryphon Karachalios, Air Force General (retired)
Mr. George Maraghidis, Director of International Cultural Relations of
the Ministry of Culture and Science
Mr. Christos Doumas, Director of Antiquities
Mr. Tassos Margaritof, painter-restorer
Mr. Tonis Spiteris, art historian-art critic

Art Commissioners
Mr. Christos Doumas, Director of Antiquities
Mr. George Steinhauer, Epimelete of Antiquities (Deputy)

PREFACE

"Greek Art of the Aegean Islands" holds the singular distinction of being the first loan exhibition sent by the Republic of Greece to the United States. The theme of the exhibition, chosen by Professor Nikolaos Yalouris, Inspector General of Antiquities in the Ministry of Culture and Science, Athens, was initially proposed to the French government in 1978; the exhibition that opened at the Louvre in April 1979, "Mer Égée: Grèce des Îles," was selected by a committee of Greek archaeologists and M. François Villard, Conservateur-en-Chef of the Département des Antiquités Grecques et Romaines of the Louvre.

It was in February 1950 that representatives of the Greek Embassy in Washington and of The Metropolitan Museum of Art first discussed the possibility of a loan exhibition from Greece. The Museum's interest continued throughout the years, and became especially strong at the time of its Centennial celebrations. Nothing could be done, however, until 1976, when the Greek government legalized the temporary exportation of antiquities for exhibition purposes. Finally, in the early summer of 1978, negotiations were successfully concluded and The Metropolitan Museum of Art, in partnership with the Louvre, is now privileged to mount the exhibition of Greek art of the Aegean in New York, following the exhibition's stay in Paris.

Under the terms of an agreement between the Ministry of Culture and Science and The Metropolitan Museum of Art, and after many meetings in Athens and in New York, the Museum prepared, in exchange, an exhibition chosen from its collections illustrating classical influences on later Western art. "Under the Classical Spell" opened at the National Pinakothek in Athens in the fall of 1979. We hope that this exchange will be the first of many future collaborative efforts between the Museum and Greece.

For the realization of this landmark exhibition I should like to extend my special thanks to Constantine Karamanlis, Prime Minister of the Republic of Greece, whose constant support and unwavering assistance have made the exchange program possible.

Douglas Dillon
Chairman, Board of Trustees

FOREWORD

The exhibition now at The Metropolitan Museum of Art presents us with a rich sampling of the splendid cultural heritage of Greece. Not only does it emphasize the diverse geographic centers of artistic production but it also covers a broad chronological span, extending from the Early Bronze Age to the Classic Period of the fifth century B.C. Many of the objects are of particular interest in that they are recent finds, which, outside of archaeological circles, are known only to those who have actually visited the National Museum in Athens and the many different local museums throughout the Greek islands. The loan demonstrates the significant cultural interconnections among the islands as well as the wealth and variety of materials used and the lively forms that characterize so much of Greek art.

The Metropolitan Museum of Art is indebted to a large number of colleagues both here and abroad for making possible the realization of this exhibition. I should like to express the Museum's sincere gratitude to the President of the Republic of Greece, Constantine Tsatsos; to the Minister of Culture and Science, Dimitrios Nianias, and to his predecessor, George Plytas; and to Professor Nikolaos Yalouris, Inspector General of Antiquities in the Ministry of Culture and Science, Athens. For their unstinting and constant support and for their cooperative efforts, I extend my thanks to M. Hubert Landais, Directeur des Musées de France, and to Mlle. Irène Bizot, Chef des Services des Expositions.

The curators of the Département des Antiquités Grecques et Romaines at the Musée du Louvre have collaborated consistently and efficiently on every phase of the negotiations and preparations. I would particularly like to thank M. François Villard and M. Alain Pasquier for their help. I am indeed delighted by the liberal loan of forty-four exceptional objects from the Louvre that greatly enriches the exhibition.

For his curatorial guidance and scholarly contribution in the writing of the English catalogue (adapted from the French publication) Dietrich von Bothmer, Chairman of the Department of Greek and Roman Art and coordinator of the exhibition, deserves special recognition. In this work he was assisted by Joan R. Mertens, Associate Curator of Greek and Roman Art. I should like to thank Herb Schmidt for the skillful design of the exhibition, and Ellen Shultz and Gerald Pryor, respectively, for their outstanding work in editing and in designing the catalogue.

Mrs. Alexandra Antoniou in Athens and Karl Katz, Chairman of Special Projects at the Metropolitan Museum, were ardent spokesmen in the organization and planning of the show. I also offer the Museum's appreciation to Mr. Christos Bastis, a strong and enthusiastic supporter who has championed the exhibition since its inception.

No undertaking of such a scope can become a reality without considerable financial assistance. The Metropolitan is deeply grateful to Mobil for its generous grant, which helped to make possible "Greek Art of the Aegean Islands."

Philippe de Montebello
Director

NOTE ON THE CATALOGUE

The catalogue *Greek Art of the Aegean Islands* is based on *Mer Égée: Grèce des Îles*, the French catalogue of the exhibition that was held at the Louvre from April 26 to September 3, 1979. The French publication was prepared by M. François Villard and M. Alain Pasquier with the collaboration of Mme. Kate de Kersauson, Mme. A. Kauffmann-Samaras, Mme. Nassi Malagardis, Mme. M.-F. Billot, Mme. M. Hamiaux-Fuentes, and M. B. Holtzmann, and we are grateful to our colleagues in France for having helped in so many ways to make our task much easier. Although the catalogue is primarily intended as an aid to visitors to the exhibition, its selected bibliography and commentaries are also addressed to scholars and students. Hence, the scope at times goes somewhat beyond mere general information.

The undersigned has had the constant help and collaboration of Joan R. Mertens, Associate Curator of Greek and Roman Art. She wrote the first fifty-six entries and read the entire manuscript. Together with Ellen Shultz, Associate Editor in the Museum's Editorial Department, who edited the manuscript, she also shared in the proofreading. Mrs. C. Struse-Springer typed the manuscript and prepared the list of abbreviations. The catalogue was designed by Gerald Pryor.

Dietrich von Bothmer
Chairman,
Department of Greek and Roman Art

Lenders to the Exhibition

Athens, Acropolis Museum: **156, 159**
 Benaki Museum: **57, 100**
 École Française d'Athènes: **61**
 National Museum: **3, 5, 8–11, 16–18, 23–25,
 27–38, 41, 64, 68, 71, 72, 75, 77, 101–104,
 119, 124, 142, 147, 157, 161, 162, 166,
 170, 174, 186–190**
Chania Museum, Crete: **51, 52, 80**
Delos, Museum: **73, 74**
Delphi, Museum: **158, 184**
Kos, Museum: **58, 59, 171**
Melos, Archaeological Museum: **40**
Olympia, Museum: **128–133, 148, 149**
Paros, Museum: **169**
Rhodes, Museum: **56, 191**
Samos (Vathy), Museum: **134–141, 143–146, 150,
 151, 153**
Thasos, Museum: **70, 165, 167, 168**
Thera, Museum: **65–67, 69, 87**

Musée du Louvre: **2, 6, 7, 12, 22, 26, 39, 53, 54, 60, 62,
 76, 79, 81, 82, 88, 95, 96, 99, 106–113, 117, 121,
 122, 127, 152, 154, 155, 160, 164, 172, 173, 175,
 177–179, 181, 183**
The Brooklyn Museum: **47**
The Metropolitan Museum of Art: **1, 4, 13–15, 19–21,
 42–46, 48–50, 55, 63, 78, 83–86, 89–94, 97, 98,
 105, 114–116, 118, 120, 123, 125, 126, 163, 176,
 180, 182, 185**

Provenances

Aegina	124
Amorgos	3, 11, 12, 57, 187
Anatolia	61, 97, 125
Athens	156, 159, 189
Crete	42–45, 48, 49, 51, 52, 72, 77, 80, 83–86, 88–94
Cyprus	63, 123
Delos	73, 74, 157, 162
Delphi	158, 184
Egypt	47
Etruria	152
Euboea	20, 21, 75, 190
Heraia	22
Herakleia	13
Kos	58, 59, 100, 171
Kythera	170, 186
Kythnos	188
Melos	23–25, 40, 71, 101–104, 174, 181
Naxos	10, 16
Olympia	128–133, 148, 149
Paros	5, 160, 163, 169, 185
Rhodes	53–56, 60, 96, 99, 105–113, 121, 122, 127, 191
Samos	134–147, 150, 151, 153
Samothrace	155
Sicily	120
Siphnos	161
Syros	7–9, 17, 18
Thasos	70, 164–168, 172, 173
Thebes	119
Thera	26–39, 41, 65–69, 87

GREECE OF THE AEGEAN

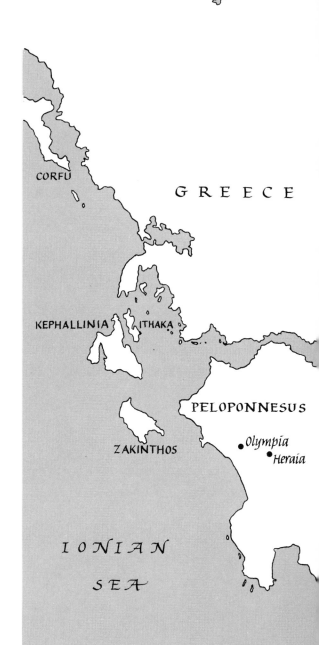

GREECE

CORFU

KEPHALLINIA ITHAKA

PELOPONNESUS

• Olympia
• Heraia

ZAKINTHOS

I O N I A N

S E A

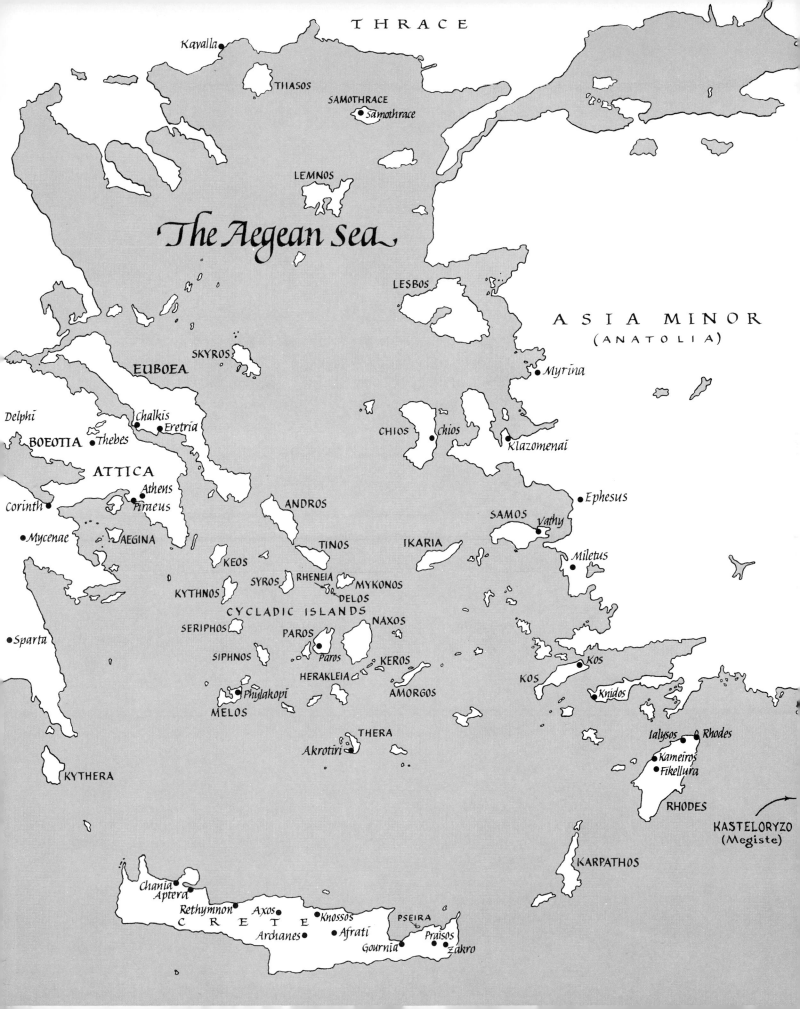

INTRODUCTION

In his search for the truth about the origin of the universe, the ancient philosopher Thales of Miletus reached the conclusion that "water is the principle of all things" and that "water is the origin of all elements."

The particular experiences that enabled him to establish this principle could only have happened to a philosopher born and bred in the region of the Aegean archipelago and only in a country such as Greece, the greater part of which is cooled by a revitalizing sea studded with small sun-drenched and luminous islands.

It is in Greek lands—to which the Hellenistic epigram about Lindos, "delighting in the sea," so aptly applies—that those two fundamental elements, earth and water, are knit together in serene harmony. It was in such surroundings that the Greek spirit flourished and bore fruit wherever it penetrated, in philosophy and poetry, the arts and the sciences.

Setting out from their native cities, the Greeks took to their ships and furrowed the waters of the Mediterranean from East to West, reaching as far as the Black Sea. In Plato's *Phaedo*, Socrates says that the Greeks had spread from the Phasis River in the Caucasus to the Pillars of Hercules where the Mediterranean meets the Atlantic. On all these shores were founded Greek cities that prospered throughout antiquity and continued in existence during the years of Roman dominion, most of them surviving to this day.

Constant communication, arising from Greeks traveling "for commerce as well as to see the world," not only laid the foundation for the development of economic life, but also became the taproot of knowledge about cities without which, in Homer's view, man could not enrich his mind. Thus, each time they sailed back to their own country with rare and valuable merchandise, Greeks also took back with them countless memories of whatever was superb and wonderful in foreign places. In the course of thousands of years, civilizations rose and fell in the Aegean archipelago and on the Mainland shores by which it is surrounded.

Like stepping-stones leading from one riverbank to another, the islands of the Aegean Sea form a link between East and West, Asia and Europe. Their mild climate and strategic position contributed to the growth of some of the most ancient civilizations of the world, the Cycladic and the Minoan. The first flourished in the Cyclades and is noted for marvelous

metalwork, marble sculpture, and pottery. Cycladic products found in the farthest parts of the ancient world, from the Sea of Azov to the Balearic Islands, justify the reputation of Cycladic islanders as eminent seafarers.

The second civilization, the Minoan, which originated and matured in Crete, marked the high point in the cultural achievements of the Aegean Bronze Age. It was succeeded by the Mycenaean, the first civilization to impose a kind of cultural unity throughout the archipelago. But neither the Minoan nor the Mycenaean world would have attained such a degree of perfection had it not been for the sea routes of the Aegean. This is evidenced mostly by the rich assortment of pottery discovered at Akrotiri on Thera, a blend of delicate Minoan motifs and forms drawn from nature and of severe and sometimes coarse Mycenaean features.

The late geometric and archaic period, in which new cities were founded by communities from both mainland and Aegean Greece, are marked by similar deep disturbances and changes in the outlook and inspiration of the Greeks. For the first time ever on the Aegean islands and the Ionian shores that bordered them, the Greek spirit went beyond the theocratic concept "concerning the origin of all things." An unprecedented yearning for knowledge and for certitude about man's intellectual capacities imbued philosophical thinking. Without ceasing to be awed by the wonders of creation, and without dismissing mythology and divinity from their minds, these Greeks made Greece, and subsequently all of Europe, the land of reason and logic, of science and technical skills. It is on the Aegean islands and in the cities opposite, in Ionia and Aeolia, that we now encounter for the first time, in all its early freshness, a love of knowledge and a joy of inquiry; foremost were such men as Pythagoras and Epicurus of Samos; Pittakos of Lesbos; Thales, Anaximenes, and Anaximander of Miletus; Herakleitos of Ephesus; Anaxagoras of Klazomenai, and others.

In poetry, too, it was Aegean islanders who expressed the sentiments of the Greeks. The first of all poets, not only of Greece but also of the entire Western world, Homer, came from the Aegean; together with several Ionian cities, Chios claims to have been his birthplace. Homer, and other poets, sang of the recollected feats of their ancestors, of the Greeks, and of the deeds of their gods. The Aegean was a storehouse of such memories: the audacious flight of Daedalus and his son Icarus; the voyages of Theseus to Crete and Naxos; the Trojan War; the miraculous birth of Apollo on Delos; the arrival of Tleptolemos in Rhodes; the voyage of the Argonauts; the delightful dalliance of Dionysos as he roved in Aegean waters; the abduction by Zeus of Europa and her brief sojourn in Crete before she eventually settled on our continent, giving to it her own name, a symbolic, but in no way final offering from Greece to "the old continent."

From the seventh century on, poetry—and letters generally—reached great heights in the world of the Aegean and in the Ionia of Asia Minor. Archilochos of Paros (714–676 B.C.), Homer's peer according to the

ancients, was the originator of iambic and perhaps, too, of elegiac poetry; he was also the father of satire and, it might be said, of Western realism. Semonides (c. 650), the iambic poet from Samos, settled on Amorgos. Terpander (c. 630), Alkaios (620), and Sappho (c. 620), all born on Lesbos, were leading representatives of lyric poetry. Anacreon of Teos (563–478) was another, honored, as few others were, especially in Athens. Thaletas from Crete (mid-seventh century) excelled in choral poetry, as did Simonides (556–467) and Bacchylides (early fifth century), both from Keos.

Natives of the Aegean were also among the foremost scientists. Science made remarkable advances in the medical schools of Rhodes, Knidos, and particularly of Kos. Indeed, it was on Kos that medicine was given a truly scientific direction by Hippocrates and emancipated from religious medicine. Without ceasing to dispense medical care from the Asklepieia, Hippocrates established new methods of treatment based on observation and pure research. He also defined in his renowned Oath the basic principles of scientific ethics, principles that are fully valid today.

Other areas of science were later to engage the attention of learned Islanders: Aristarchos of Samos was concerned with mathematics and astronomy, and Theophrastos of Lesbos, a pupil and successor of Aristotle, with botany.

The Aegean was also a center of architecture and technology. Apsidal, ellipsoidal, and rectangular constructions on Lesbos, Crete, Andros, and Tinos number among the first outstanding buildings dating from the dawn of Greek history. It was there that the forerunner of the temple in antis and the temple with colonnades first took shape. Examples of them are on Lemnos, Chios, Delos, Naxos, and Crete.

The first temple of Hera, built on Samos around 800 B.C., is of special importance in the history of the Greek temple. The second temple of Hera on Samos is linked with the sudden emergence of monumental architecture in the opening years of the seventh century B.C. It is the earliest example of the Greek temple in its pure and almost final form. The third Heraion of Samos (570–560) was the work of two Samian brothers, Rhoikos and Theodoros. Men of diverse activities and talents, who were not only architects but also sculptors, bronze casters, and engineers (the distant forebears of Renaissance artists in the West), the two brothers devised marvelous solutions to technical and engineering problems; notably, they provided stable foundations for buildings like the Heraion of Samos, erected on swampy ground. They were the first to develop the technique of casting hollow bronze statues. The monumental character of the third Heraion of Samos rivals Egyptian buildings in size and brilliance.

When the Ephesians of Asia Minor set out to build their great temple of Artemis after the design of the Cretan architects Chersiphron and Metagenes, they entrusted the supervision of the work to the Samian

architect Theodoros. The colossal temples of Samos, and others like them on Lesbos, Chios, and elsewhere are comparable to imposing and grandiose structures in the Ionian cities of Asia Minor. It was in this eastern region of the Aegean that the Ionian order of architecture was conceived and developed alongside the more floral and vivacious Aeolic order. There was yet another superb architect from Samos, Mandrokles. In his *History*, Herodotus relates that in 514 B.C. Mandrokles constructed a pontoon bridge across the Bosporus so that Darius, campaigning against the Scythians, could pass over with his army of 700,000 men. Paid for out of the fee he earned for this work, Mandrokles dedicated to the Heraion of Samos a painting in which the army was depicted crossing the bridge under the gaze of the great Persian ruler seated on his throne. This work is considered to have been one of the oldest and most famous monumental Greek paintings.

Again, it was artists of the archipelago who led the way in the plastic arts. Ancient tradition makes admiring reference to the Cretan craftsman Daedalus. However doubtful we may be of his real existence, we can be certain of the evidence for the existence of Dipoinos and Skyllis, reputedly his pupils, fellow-Cretans who worked throughout Greece in the middle of the seventh century. Even if we cannot grant Crete the honor of being the first home of monumental sculpture, we must nevertheless recognize its outstanding achievements.

There were five other important centers of sculpture in the Aegean: Naxos, Melos, Samos, Chios, and Paros. It was in Naxian workshops, the earliest ones of all, that some striking works were produced. These were sometimes of colossal size, like the figure still lying in the island quarry, eleven meters in length, but only half finished. Neighboring Delos, a religious center of the Ionian world, was already, in the middle of the seventh century, crowded with Naxian works of sculpture or architecture, just as were other Greek cities such as Athens and Delphi. Generalized in conception and idealized in expression, Naxian sculptures are distinct from those of Melos that are fluid in outline and willowy in form.

Samos was particularly attracted by the delicacy of the female body and the play of drapery over it. This attraction is manifest in the predilection for finely spun chitons combined with heavily draped himatia, a fashion that originated on the shores of Ionia and later spread throughout Greece. At the frontiers of the eastern and western worlds, Samos became the point at which various influences met and fused. The stout, heavy figures of Anatolia were remolded by the Greek spirit. The new figures that emerged were full of vitality, capable now of action and lively movement. Samos's outstanding advances in metal-working techniques, such as bronze casting, were due to the inventiveness of her craftsmen, a fact we are just beginning to recognize. It may well have been Samos that introduced those oriental bronzes that flooded Greek sanctuaries from the opening of the seventh

century on and that gave rise to a new style in most forms of art, namely, the Orientalizing.

Chios's contribution to sculpture was equally significant. Her artists and their work found their way to mainland Greece, especially to Attica. A single family of Chiot marble sculptors, headed by Mikkiades, who was succeeded by his son Archermos and his grandsons Boupalos and Athenis, furnished Delos and Lesbos, as well as other Aegean islands and cities of Asia Minor, with their works. They exercised a powerful influence on Attic sculptors who, in the sixth century, accepted Ionian sculpture without resistance, assimilating it into their own conventions.

Using an exceptional local marble, Parian workshops were famous from the early part of the sixth century on; their influence was widely felt, mostly on Thasos and Miletus but also in Athens where Parian sculptors had taken up residence. It is likely that they had a hand in the sculptural decoration of the Siphnian Treasury at Delphi.

Statues from Paros of kouroi and korai (youths and maidens) stand out in the context of Cycladic and Ionian sculpture on account of their taut lines, the plasticity of their outlines, and the throbbing vitality that pervades every figure.

Most prominent among notable centers of pottery production that flourished in the Aegean region are those that created the "Melian" vases, from the second half of the seventh century (probably of Parian provenance), and the Chiot and the Rhodian workshops dating to the sixth century.

In classical times the most beloved pupils and collaborators of Pheidias were the Aegean sculptors Alkamenes of Lesbos, Agorakritos of Paros, and Kresilas of Crete. They continued their creative work with their master's models in mind, adapting their Aegean traditions to the conventions of Athens. Two Parian artists, Thrasymedes and Skopas—the latter a great sculptor and architect—were in turn to carry the torch during the fourth century.

In the fifth century a decisive contribution was made by Aegean artists to the unprecedented and rapid development of monumental painting. Polygnotos of Thasos stood head and shoulders above a crowd of first-rate painters. He dominated the generation that came after the Persian wars and was universally recognized as the most important painter of his time. "The inventor of painting," in the words of Theophrastus, Polygnotos is associated with the radical changes then occurring in the intellectual life of Greece.

In art this change was marked by the abandonment of archaic rigidity and of that air of unconcern portrayed in the fixed smile on the lips of the kouroi and korai. The archaic smile is replaced by a look of meditation, an expression of an ethos which was thought to have been the innovation of

Polygnotos, although it permeated the whole of his generation. It was this spirit that provoked Greeks to examine their inner being, to study that "wondrous" creature that is Man in his three-dimensional tragic existence in space and time; the spirit whose most precious seed gave birth to Tragedy. With this spirit is linked the ideal of Man practicing moderation in all things and shunning all hybris.

These tumultuous but fruitful conquests were to determine developments that occurred through the end of the Classical Age, developments to which the Greeks of the Aegean made their steady and energetic contribution.

The members of the organizing committee are: Mr. Perikles Theocharis, Right Rector of the Technical University of Athens, and Member, Academy of Athens; Mr. Tryphon Karachalios, Air Force General (retired); Mr. George Maraghidis, Director of International Cultural Relations of the Ministry of Culture and Science; Mr. Christos Doumas, Director of Antiquities; Mr. Tassos Margaritof, painter-restorer; Mr. Tonis Spiteris, art historian-art critic; Mr. G. Dontas, General Ephor of the Acropolis Museum; Miss B. Philippaki, General Ephor of the National Museum, Athens; Mr. G. Konstantinopoulos, Ephor of the Sculpture Department, National Museum, Athens; Mr. A. Delivorias, Director of the Benaki Museum; the directors, scientific, and technical staff of the National Museum, Athens, the Acropolis Museum, the Byzantine Museum, and the ephorates of antiquities of Athens, Attica, the Cyclades, the Western Peloponnese, Delphi, Western Crete, Eastern Macedonia, and the Dodecanese.

Professor Nikolaos Yalouris
General Inspector of Greek Antiquities

COLORPLATES

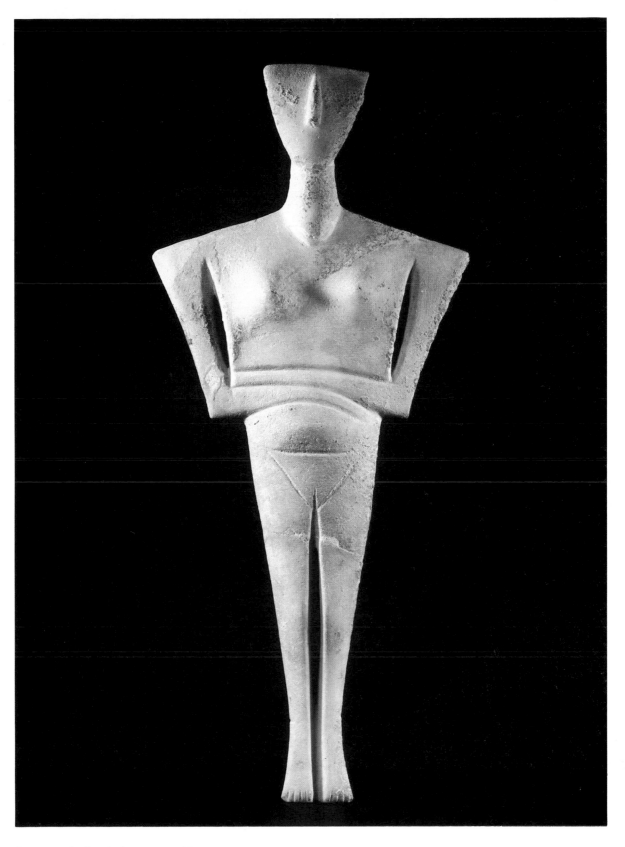

Statuette of a female figure no. 17

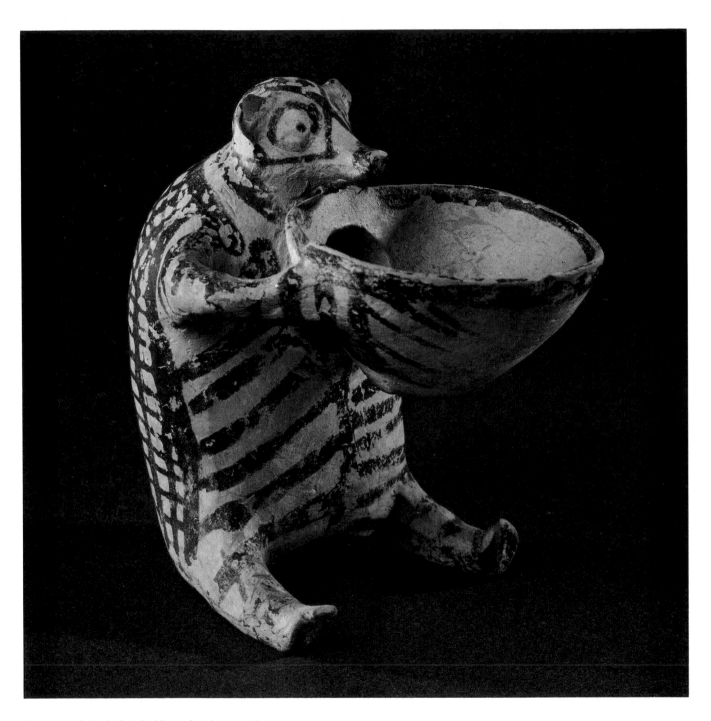

Statuette of a hedgehog holding a bowl no. **18**

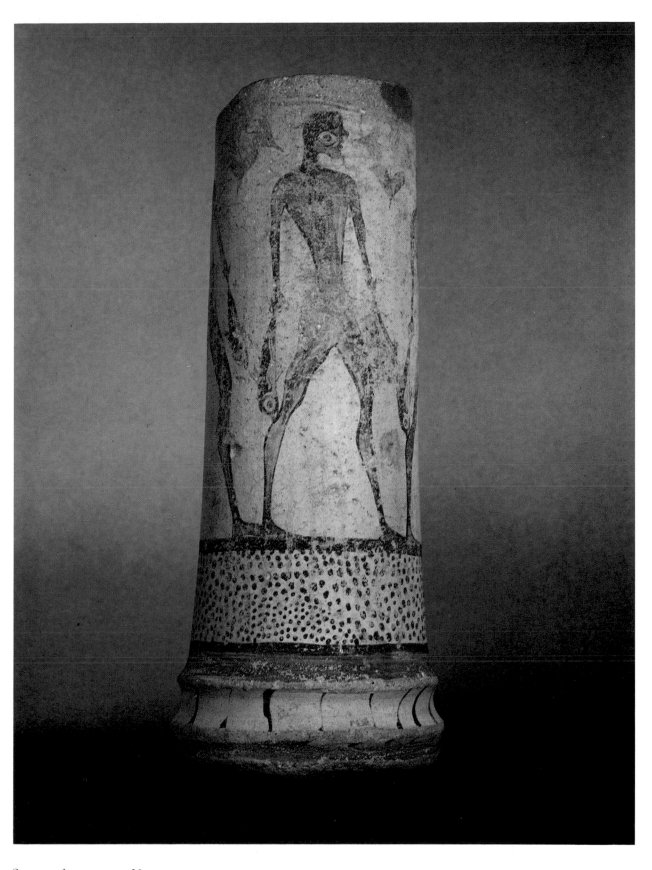

Support of a vase no. 23

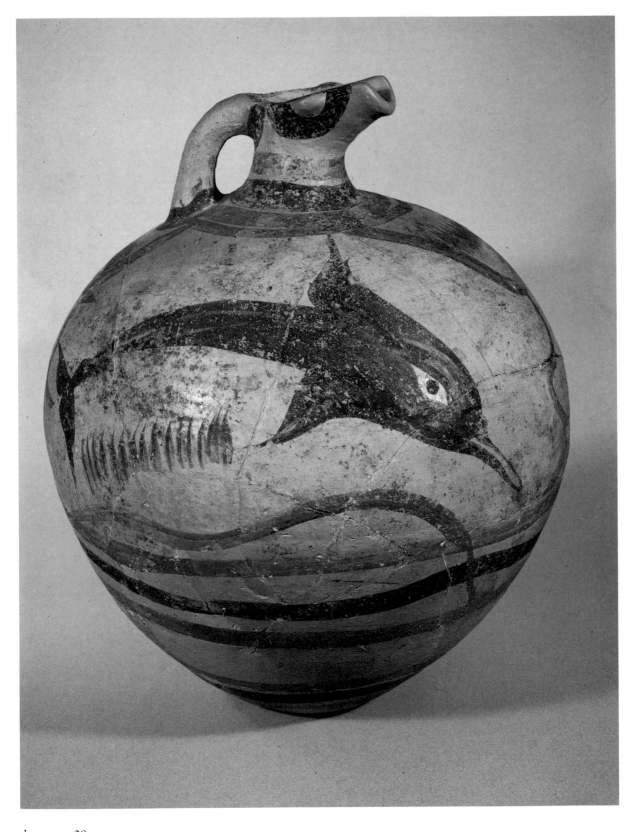

Jug no. 28

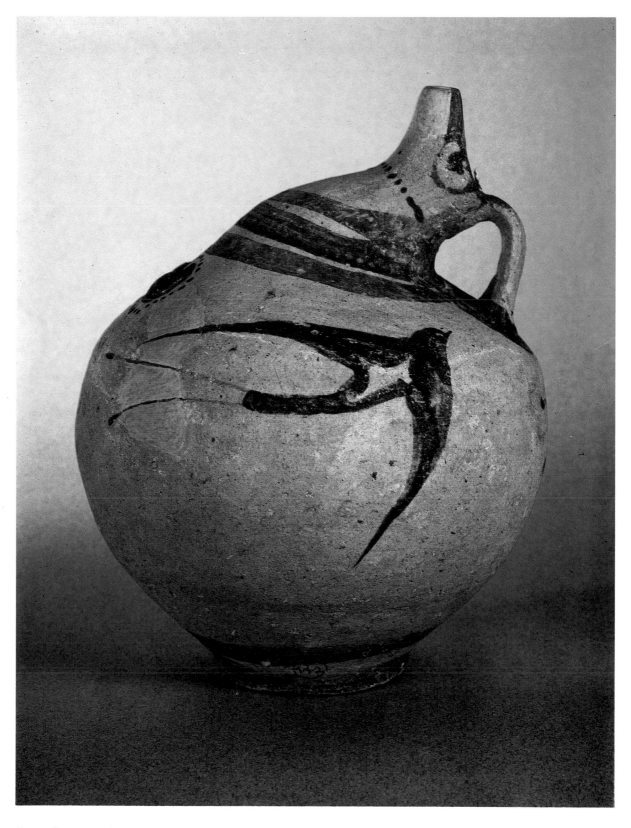

Spouted jar no. 31

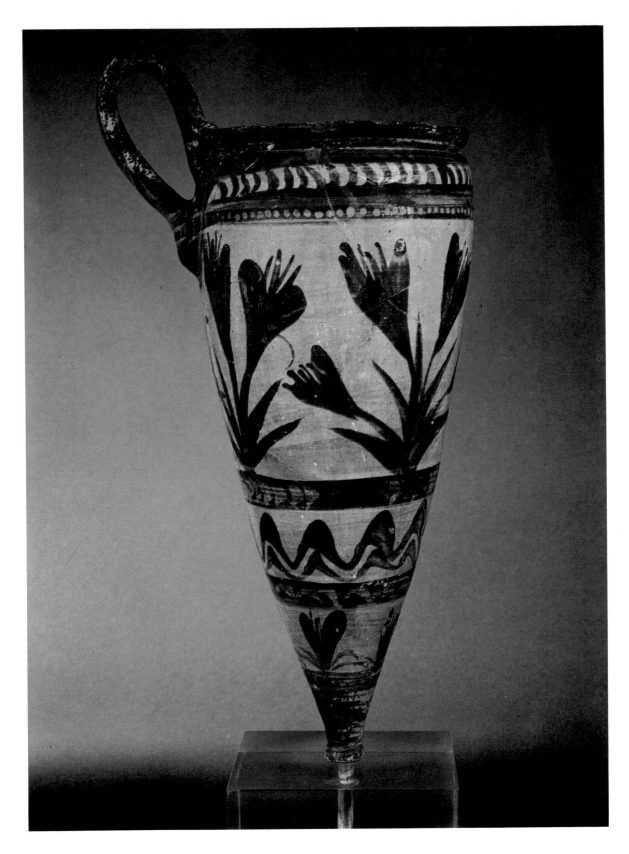

Conical rhyton no. 33

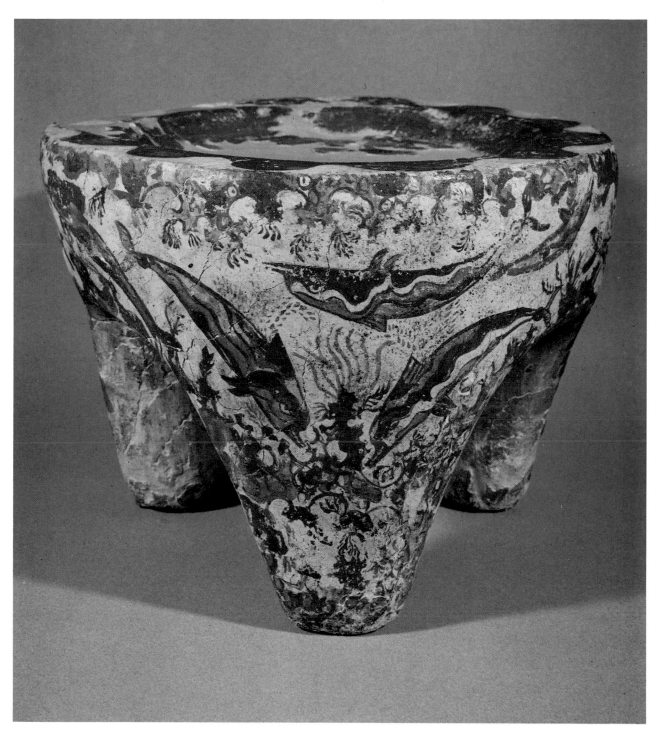

Offering table with polychrome decoration no. 35

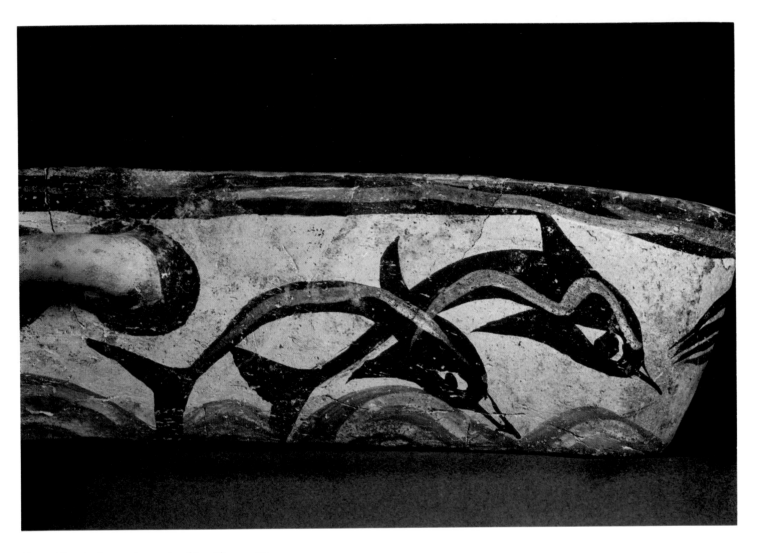

Vase with polychrome decoration (detail) no. 37

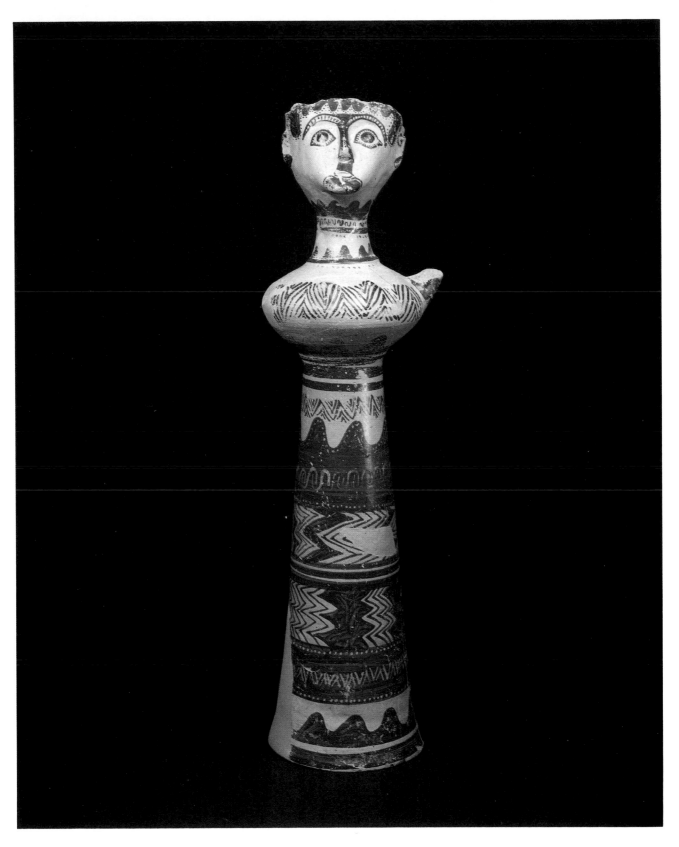

Statuette of a woman no. **40**

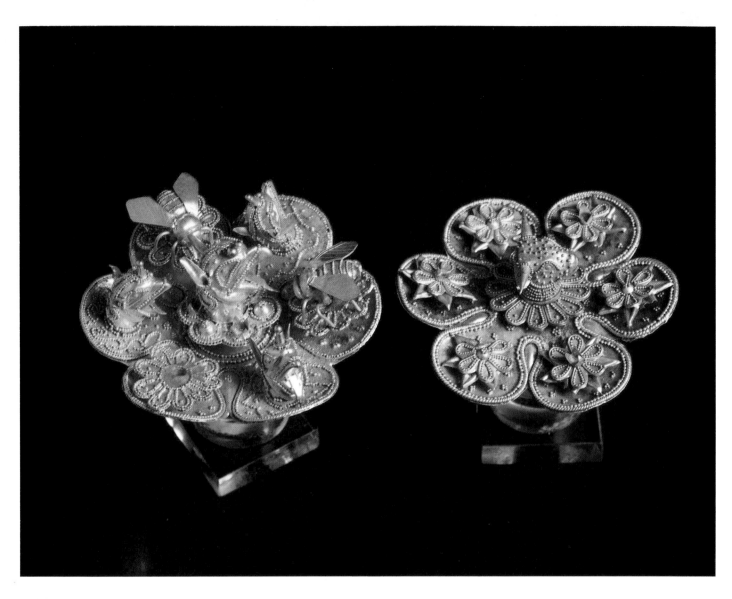

Gold rosettes nos. **101, 104**

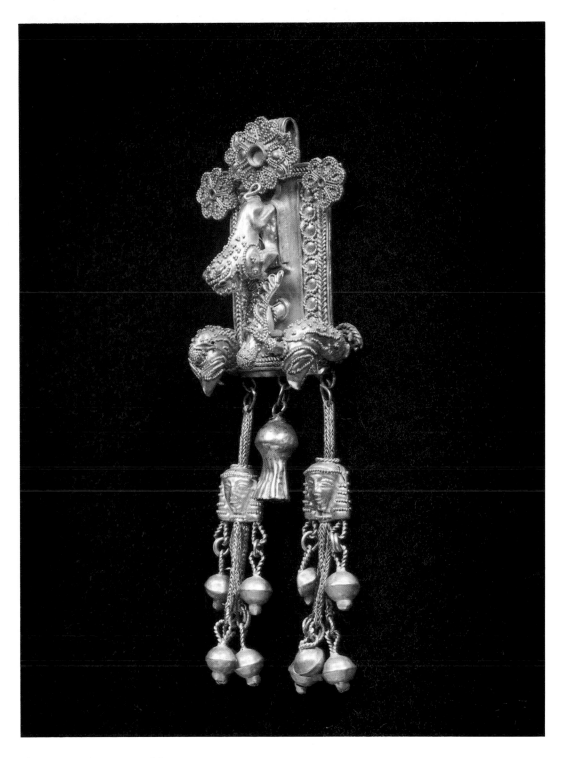

Electrum pendant no. 106

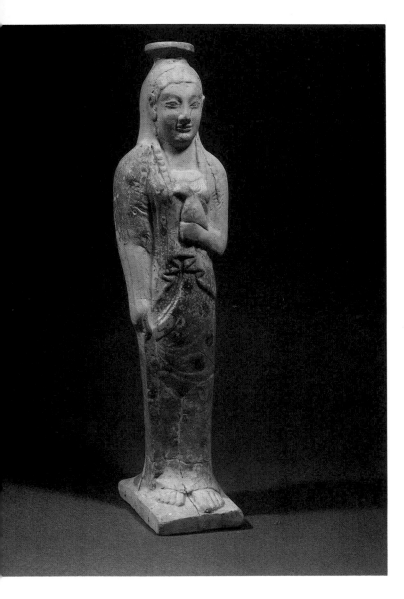

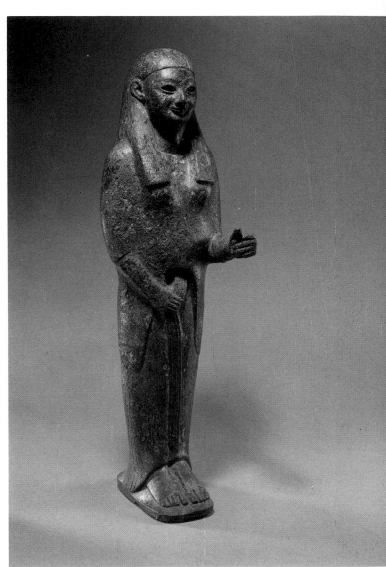

Alabastron in the shape of a standing woman no. **119**

Statuette of a woman no. **151**

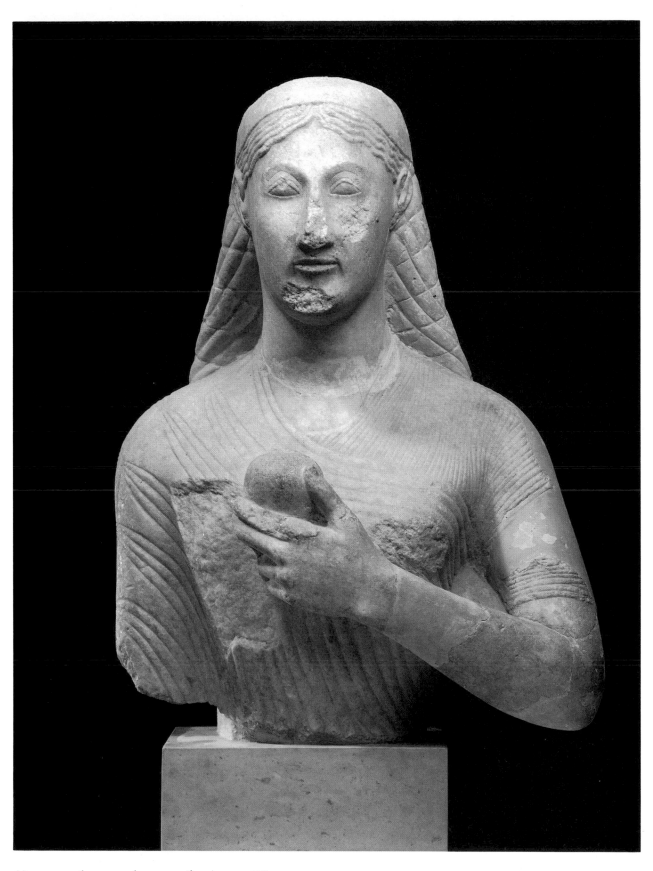

Upper part of a statue of a woman (kore) no. **156**

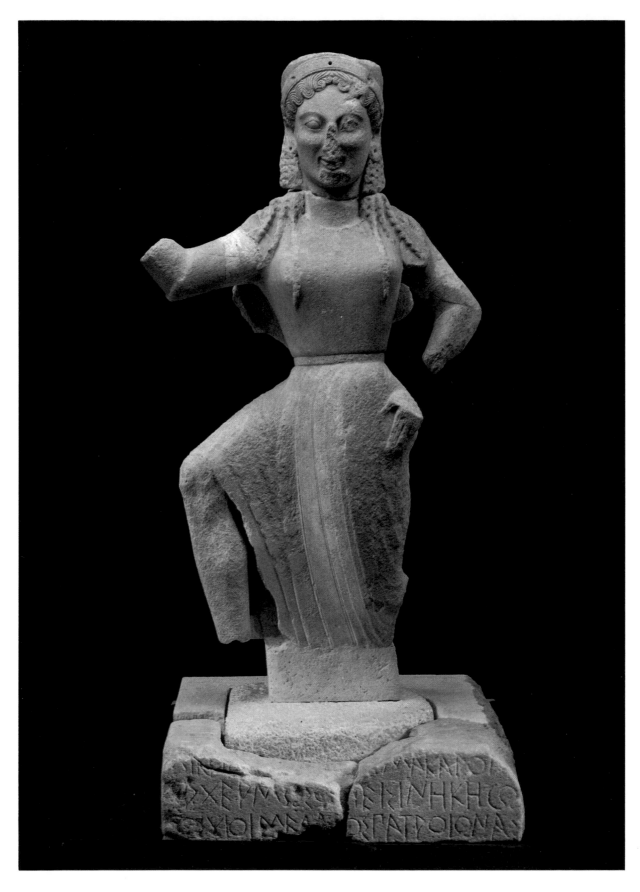

Statue of a running Nike no. **157**

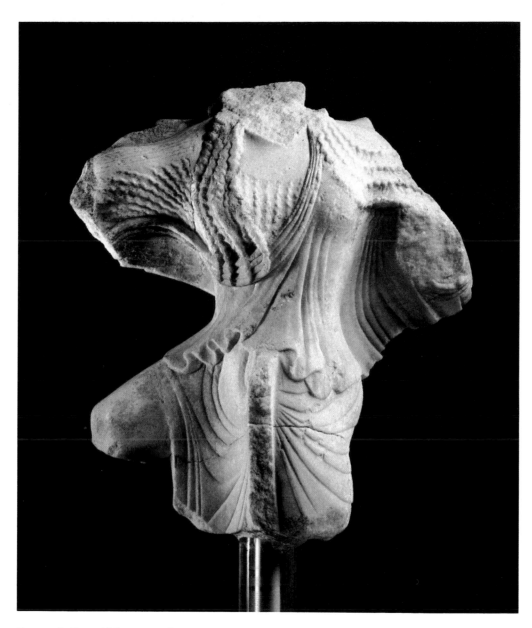

Statue of a flying Nike no. **159**

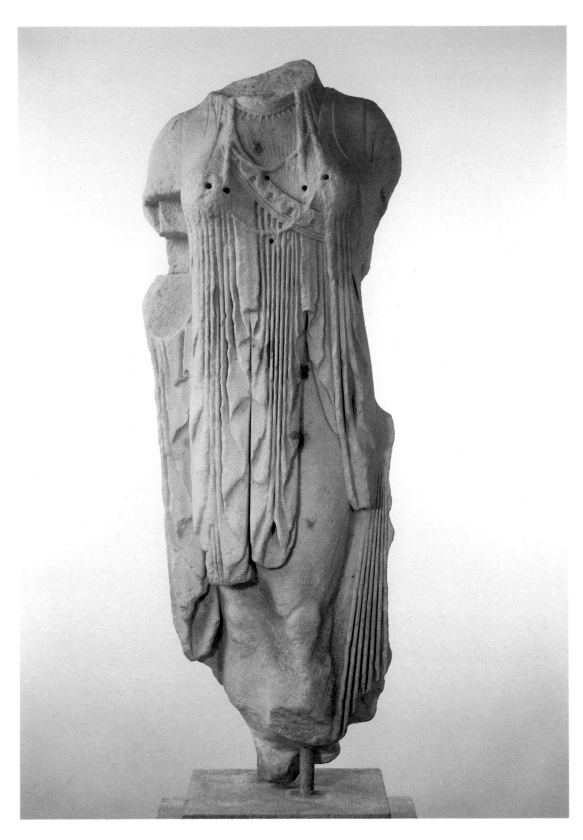

Statue of a woman (kore) no. **162**

CATALOGUE

List of Abbreviations

AA	Archäologischer Anzeiger
AAA	Athens Annals of Archaeology
ABV	J. D. Beazley, Attic Black-figure Vase-painters (Oxford, 1956)
AdI	Annali dell'Instituto di Corrispondenza Archeologica
AEM	Archäologisch-epigraphische Mitteilungen aus Oesterreich-Ungarn
AJA	American Journal of Archaeology
AK	Antike Kunst
AM	Mitteilungen des Deutschen Archäologischen Instituts, Athenische Abteilung
Annuario	Annuario della [R.] Scuola Archeologica di Atene
Arch. Deltion	Archaiologikon Deltion
ARV²	J. D. Beazley, Attic Red-figure Vase-painters, 2nd ed. (Oxford, 1963)
AZ	Archäologische Zeitung
BABesch	Bulletin van de Vereeniging tot Bevordering der Kennis van de Antieke Beschaving
BCH	Bulletin de correspondance hellénique
Bd'A	Bollettino d'Arte
BMMA	Bulletin of The Metropolitan Museum of Art
BSA	British School at Athens, Annual
CRAI	Comptes Rendus de l'Académie des Inscriptions et Belles-Lettres
CVA	Corpus Vasorum Antiquorum
Délos	Exploration archéologique de Délos
EA	P. Arndt and W. Amelung, Photographische Einzelaufnahmen antiker Skulpturen (1893–1940)
Eph. Arch.	Archaiologike Ephemeris
IM	Mitteilungen des Deutschen Archäologischen Instituts, Abteilung Istanbul
JdI	Jahrbuch des [K.] Deutschen Archäologischen Instituts
JHS	Journal of Hellenic Studies
MdI	Mitteilungen des Deutschen Archäologischen Instituts (1948–1953)
MMA Journal	Metropolitan Museum Journal
MMStudies	Metropolitan Museum Studies
Mollard-Besques, Cat.	S. Mollard-Besques, Catalogue raisonné des figurines et reliefs en terre-cuite grecs, étrusques et romains 1 (Paris, 1954)
Mon. Ined.	Monumenti inediti pubblicati dall'Instituto di Corrispondenza Archeologica
Mon. Piot	Monuments et Mémoires publiés par l'Académie des Inscriptions et Belles-Lettres, Fondation Piot
OeJh	Jahreshefte des Oesterreichischen Archäologischen Instituts
Paris Cat.	Mer Égée: Grèce des Îles, 26 avril— 3 septembre 1979, Musée du Louvre (Paris, 1979)
RA	Revue archéologique
REA	Revue des études anciennes
REG	Revue des études grecques
RM	Mitteilungen des Deutschen Archäologischen Instituts, Römische Abteilung

ART OF THE
EARLY CYCLADES

Nos. 1–22 Art of the Early Cyclades

The first great flowering of art in the Aegean occurred in the Cycladic islands between about 3000 and 2000 B.C. The period is known as Early Cycladic and is subdivided into three consecutive phases (I, II, III). The most characteristic works are statuettes of local island marble in the form of a female figure with arms folded across the chest. Hundreds of these statuettes have been discovered, especially in burials in the Cyclades but also on Crete and the Greek mainland. It has been possible to trace their development out of the preceding Neolithic tradition as well as to organize them stylistically; the groups—such as Plastiras, Spedos, and Dokathismata that are represented in the exhibition—are each named after a site particularly rich in a given type. Besides the figures, Early Cycladic art includes vases of marble and steatite in addition to various kinds of objects of metal and clay. Through their decoration, the contexts within which they came to light, and the connections they reveal, these works provide a glimpse of a materially and conceptually developed culture dependent upon the sea for protection, subsistence, and communication.

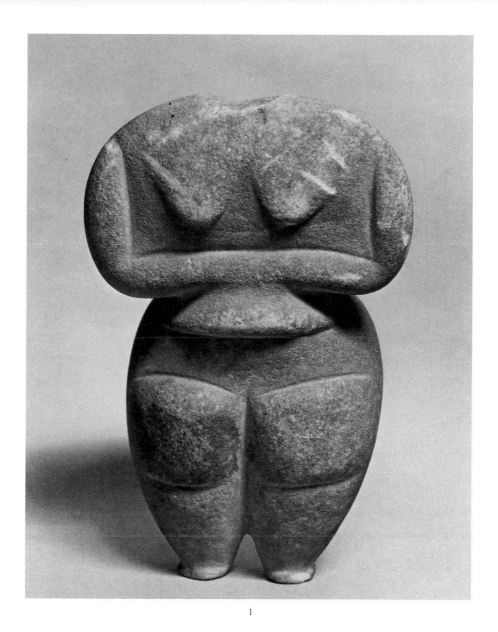

1

1 Marble statuette of a female figure

The head is missing.
Provenance unknown
Cycladic, Neolithic, fourth millennium B.C.
Height, 21.4 cm. (8 7/16 in.)
The Metropolitan Museum of Art 1972.118.104
(Bequest of Walter C. Baker, 1972)

Bibliography: D. von Bothmer, *Greek, Etruscan, and Roman Antiquities . . . from the Collection of Walter Cummings Baker, Esq.* (1950), no. 52; S. S. Weinberg, *AJA* 55 (1951), pp. 125, 126, 128; G. Hanfmann, *Ancient Art in American Private Collections* (1954), no. 127; D. von Bothmer, *Ancient Art from New York Private Collections* (1961), no. 86, pls. 26, 27; M. Mellink and J. Filip, *Frühe Stufen der Kunst* (1974), pls. 156–157, p. 221; J. Thimme, *Art and Culture of the Cyclades* (1977), no. 1.

From the beginning, artists of the Aegean worked in marble, and they seem to have created fully three-dimensional figural representations side-by-side with flat, relatively stylized ones. Though the significance of this imposing figure is unclear, apart from some probable connotation of fertility, she belongs to a type that appears in virtually every available material throughout the eastern Mediterranean and southern Balkan regions in prehistoric times.

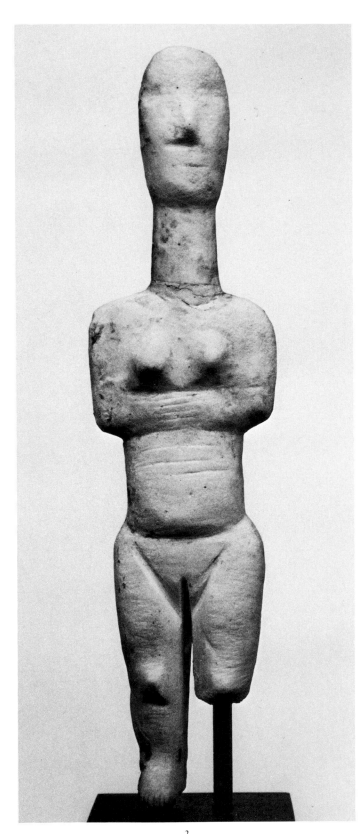

2

2 Marble statuette of a female figure
The left leg below the knee is missing.
Provenance unknown
Cycladic, Early Cycladic I, Plastiras type,
 about 3200 – 2700 B.C.
Height, 20.2 cm. (7 7/16 in.)
Musée du Louvre, inv. MND 2030 (MA 3520;
purchase, 1950)

Bibliography: J. Thimme, *Art and Culture of the Cyclades* (1977), no. 70; *Paris Cat.* (1979), p. 52, fig. 3.

This statuette belongs to one of the earliest standard Cycladic figural types, although in the treatment of the head and neck it has direct Neolithic precursors. Its rather crudely articulated surface suggests that it is unfinished. After the initial steps of marking the shape and proportions on a prepared marble block, chipping out the form, and articulating the major volumes and details, the surface would then have had to be smoothed. The sculptor must have worked mainly by a process of abrasion, using wet sand with an equivalent of string as well as emery, which is plentiful in the Cyclades.

3 Marble statuette of a male figure
Found on Amorgos
Cycladic, Early Cycladic I, Plastiras type,
 about 3200 – 2700 B.C.
Height, 25 cm. (9⅞ in.)
Athens, National Museum, inv. 3911

Bibliography: P. Wolters, AM 16 (1891), p. 51; C. Zervos, *L'Art des Cyclades* (1957), pl. 43; C. Renfrew, AJA 73 (1969), p. 6; E. Sapouna-Sakellarakis, *Die kykladische Sammlung im National Museum von Athen* (1973), pl. 33; P. Getz-Preziosi, AK 18 (1975), p. 49; J. Thimme, *Art and Culture of the Cyclades* (1977), pp. 62, 436, fig. 34; *Paris Cat.* (1979), pp. 52 – 53, fig. 4.

Male figures are rare in Cycladic sculpture, even more so in the earlier phases than later when they appear especially as musicians and vessel-bearers. This example is notable for the domical cap built up of horizontal ridges, a feature that occurs on a few other contemporary pieces (*e.g.*, Zervos, *op. cit.*, pls. 37, 41; Thimme, *op. cit.*, no. 79); otherwise, indications of dress are exceptional.

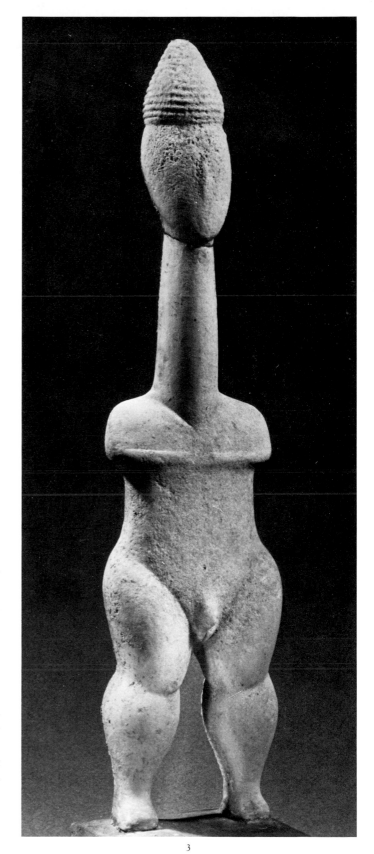

3

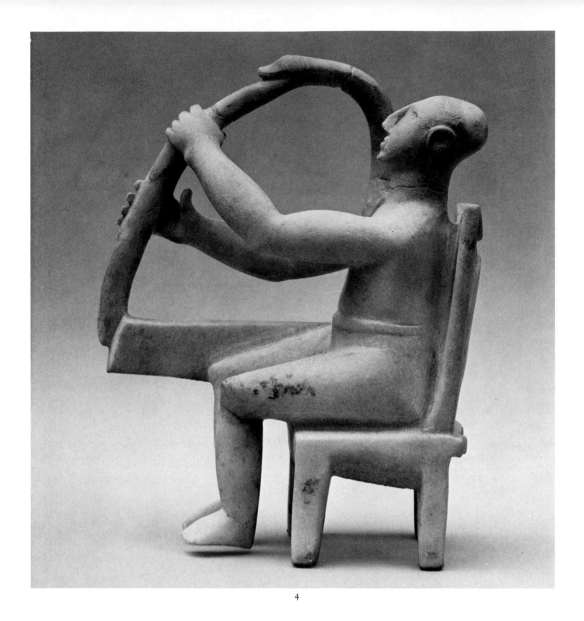

4

4 Marble statuette of a harp player
Provenance unknown
Cycladic, Early Cycladic I, close to the Plastiras
 type, about 3200 – 2700 B.C.
Height, 29.5 cm. (11⅝ in.)
The Metropolitan Museum of Art 47.100.1 (Rogers
Fund, 1947)

Bibliography: G. M. A. Richter, *Handbook of the Greek Collection* (1953), pp. 15, 166, fig. 6; *eadem, The Furniture of the Greeks, Etruscans, and Romans* (1966), pp. 11 – 12, fig. 33; P. G. Preziosi and S. S. Weinberg, *AK* 13 (1970), pp. 10 – 11, pl. 5, 6; P. Hunter, *The Grand Gallery* (1975), p. 4; D. von Bothmer, MMA *Guide to the Collections: Greek and Roman Art*[3] (1975), p. 2, fig. 2, p. 3; J. Thimme, *Art and Culture of the Cyclades* (1977), no. 253, p. 494.

Thanks to the knowledge gained in recent years from new finds and thorough study, the New York harpist has been recognized as the earliest of the series of Cycladic musicians extant and an example of astonishingly naturalistic rendering. This sensitivity to detail, visible in the throne and the frame of the harp, is most evident in the articulation of the figure's arms and hands; his hair, moreover, was originally painted. A small number of harpists and flutists from the succeeding Early Cycladic II period are known, but the exact function and meaning of the whole group eludes us.

5 Marble collared jar
Found on Paros
Cycladic, Early Cycladic I,
 about 3200 – 2700 B.C.
Height, 28.5 cm. (11¼ in.)
Athens, National Museum, inv. 4763

Bibliography: C. Tsountas, *Eph. Arch.* (1898), pl. 10, 16, cols. 158, 184; E. Sapouna-Sakellarakis, *Die kykladische Sammlung im National Museum von Athen* (1973), pl. 19; *History of the Hellenic World: Prehistory and Protohistory* (1974), p. 110; *Paris Cat.* (1979), p. 51, fig. 1.

In addition to statuettes, Island sculptors produced stone vases in a variety of graceful shapes. Made of clay as well as marble, collared jars are typical of the Early Cycladic I period and are characterized by their spreading foot, pierced vertical flanges, offset collar, and considerable weight. While one might expect them to have served for storage, examples with preserved lids are few. Indeed, except for pyxides, which are by definition closed, Cycladic stone vessels consist overwhelmingly of open forms.

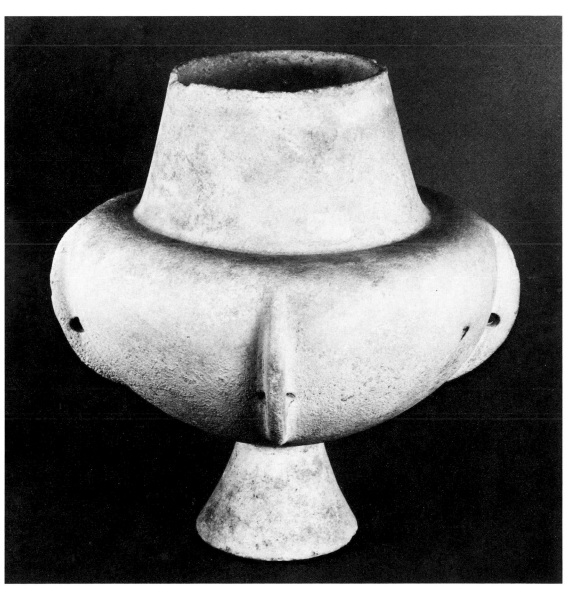

5

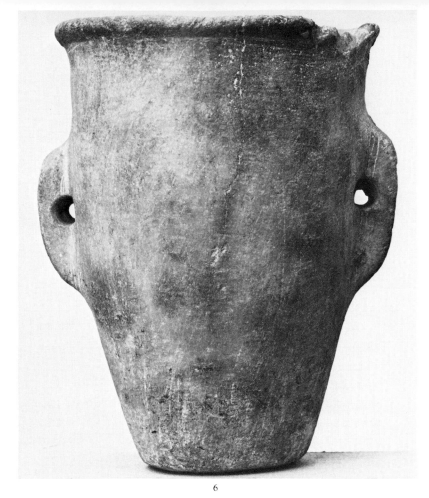

6

6 Marble beaker

Provenance unknown
Cycladic, Early Cycladic I,
 about 3200 – 2700 B.C.
Height, 12 cm. (4¾ in.)
Musée du Louvre, inv. MND 2005 (MA 3502;
Bequest of A. Kann, 1949)

Bibliography: *Paris Cat.* (1979), pp. 51 – 52, fig. 2.

Another shape characteristic of Early Cycladic I
is the beaker, with its tapering body, pierced lugs, and
thickened lip. The existence of two beakers that have
been modified and articulated to represent a human
body (J. Thimme, *Cyclades*, p. 97, fig. 78, no. 281)
suggests that the function of the statuettes and stone
vases may have been connected.

7 Terracotta pan

The decoration, which is stamped and incised,
 consists of a running spiral and other types of
 ornament around a series of concentric star
 motifs.

Possibly found on Syros
Cycladic, transition from Early Cycladic I to II,
 about 2700 B.C.
Height, 5 cm. (2 in.); length, 21 cm. (8¼ in.);
 diameter, 19.8 cm. (7¹³/₁₆ in.)
Musée du Louvre, inv. CA 2991 (purchase, 1937)

Bibliography: C. Zervos, *L'Art des Cyclades* (1957),
pls. 224 – 225; E.-M. Bossert, *JdI* 75 (1960), p. 4, fig.
6; C. Renfrew, *The Emergence of Civilization* (1972),
pl. 4,1, p. 153; J. Thimme, *Art and Culture of the
Cyclades* (1977), no. 400; *Paris Cat.* (1979), pp.
53, 55, fig. 5.

Conventionally identified as pans, objects such
as this are especially characteristic of the Early Cy-
cladic II period and are usually of clay. The outer,
decorated surface is generally convex, while the re-
verse has straight-sided walls that form a shallow
bowl; two projections that may or may not be joined
by a crosspiece provide a handle. Many of the
hypotheses advanced to explain the function of these

pans suggest that they held liquids and may have served, for example, as mirrors.

8 Terracotta pan

The outer surface is bordered by rows of impressed triangles. The main field above contains a ship and a fish within a network of linked spirals; the smaller field below is articulated in a way suggesting female genitalia as they are treated on Cycladic statuettes.

Found in tomb 174 at Chalandriani on Syros, 1899

Cycladic, Early Cycladic II,
about 2700 – 2300 B.C.

Height, 6 cm. (2 ⅜ in.); diameter, 28 cm.
(11 in.)

Athens, National Museum, inv. 4974

Bibliography: C. Tsountas, *Eph. Arch.* (1899), col. 86, fig. 11, cols. 85, 89 ff., 109, *passim*; C. Zervos, *L'Art des Cyclades* (1957), figs. 221–223; P. Demargne, *The Birth of Greek Art* (1964), p. 44, fig. 49; C. Renfrew, *The Emergence of Civilization* (1972), pl. 29,1; H.-G. Buchholz and V. Karageorghis, *Prehistoric Greece and Cyprus* (1973), p. 67, no. 855, p. 297; E. Sapouna-Sakellarakis, *Die kykladische Sammlung im National Museum von Athen* (1973), pl. 6; J. Thimme, *Art and Culture of the Cyclades* (1977), fig. 89, pp. 113–14; *Paris Cat.* (1979), pp. 54–55, fig. 6.

Justifiably well-known, this pan illustrates a vital aspect of Cycladic existence in characteristically Cycladic artistic terms (see E. Vermeule, *Greece in the Bronze Age* [1964], pp. 54–56). It shows a ship with a high prow and short projections that probably indicate oars. Two streamer-like lines issue from the prow; the fish, above, may be the craft's emblem (see Tsountas, *op. cit.*, col. 90 ff.) or it may simply be swimming, in the same direction as the ship. The shape of the craft corresponds well to small extant models made of lead (cf. Thimme, *op. cit.*, p. 51, note 22, no. 457), and may even be compared to the far more elaborately rendered ships on a later painting from Thera (S. Marinatos, *Excavations at Thera* VI [1974], pp. 38 ff.). Spirals, one of the most common Cycladic decorative motifs, here admirably evoke the often stormy waters of the Aegean.

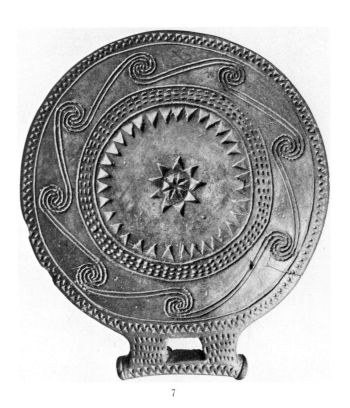

7

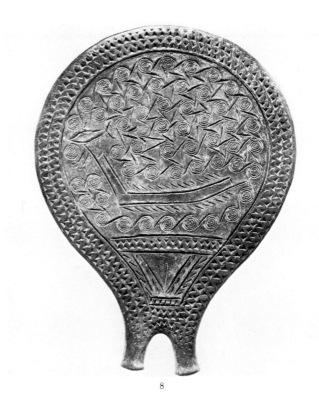

8

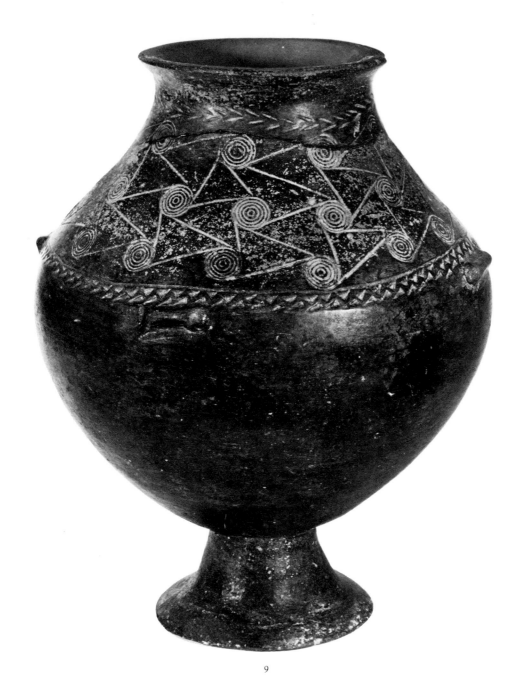

9

9 Terracotta jar

The decoration, restricted to the shoulder and neck of the vase, consists of a network of spirals between two thin bands of ornament.

Found in tomb 351 at Chalandriani on Syros, 1899

Cycladic, Early Cycladic II,
about 2700 – 2300 B.C.

Height, 19 cm. (7½ in.)

Athens, National Museum, inv. 5113

Bibliography: C. Tsountas, *Eph. Arch.* (1899), col. 111; V. Kahrstedt, *AM* 38 (1913), pl. 7,4; D. Fimmen, *Die kretisch-mykenische Kultur* (1921), p. 135, fig. 130; *Paris Cat.* (1979), p. 55, fig. 7.

Collared jars of clay exist in a greater variety of forms than their counterparts of marble. This example, with its continuous contour, horizontal lugs, spreading foot, and decoration of spirals and impressed triangles represents the type prevalent in

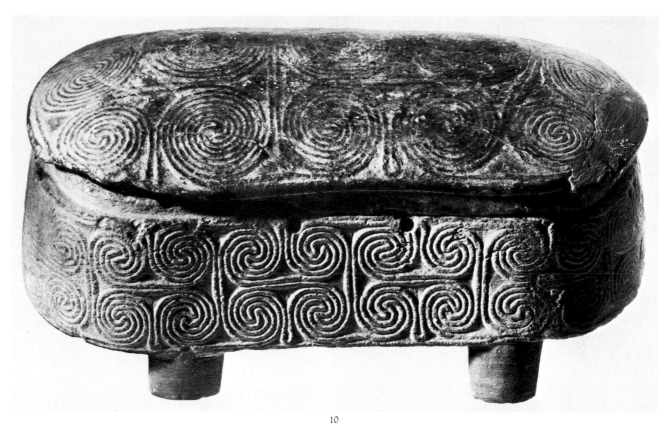

10

Early Cycladic II. Though all pottery at this time was handmade, the jar, like the two pans (**7** and **8**), illustrates the level attained by Cycladic potters with their fine vases, for they produced simpler, unburnished and undecorated wares as well.

10 Steatite pyxis
> The decoration of box and lid consists of spirals
> grouped in roughly square units of four.
> Found on Naxos
> Cycladic, Early Cycladic II,
> about 2700 – 2300 B.C.
> Height, with cover, 7.2 cm. (2^{13}/16 in.);
> length, 14.8 cm. (5^{13}/16 in.)
> Athens, National Museum, inv. 5358

Bibliography: F. Matz, *Die frühkretischen Siegel* (1928), p. 134, fig. 40, p. 135; W. Åberg, *Bronzezeitliche und früheisenzeitliche Chronologie* IV (1933), p. 74, fig. 135, p. 75; H. Kantor, *AJA* 51 (1947), pp. 26–27, pl. IV B; C. Zervos, *L'Art des Cyclades* (1957), fig. 30; C. Renfrew, *The Emergence of Civilization* (1972), p. 519, no. 32; E. Sapouna-Sakellarakis, *Die kykladische Sammlung im National Museum von Athen* (1973), pl. 20; *History of the Hellenic World: Prehistory and Protohistory* (1974), p. 106; J. Thimme, *Art and Culture of the Cyclades* (1977), pp. 103, 128, fig. 109, p. 137; *Paris Cat.* (1979), pp. 55–56, fig. 8.

During Early Cycladic II, steatite came to be used as well as marble for stone vases. Because steatite was easier to work, the shapes tend to be more complex, consisting of pyxides, multiple vases, and remarkable models of architectural ensembles. In contrast to those of marble, the steatite vases also have surface decoration, often of intricate spiral compositions, as on this pyxis. It may once have held jewelry and other small, precious grave offerings.

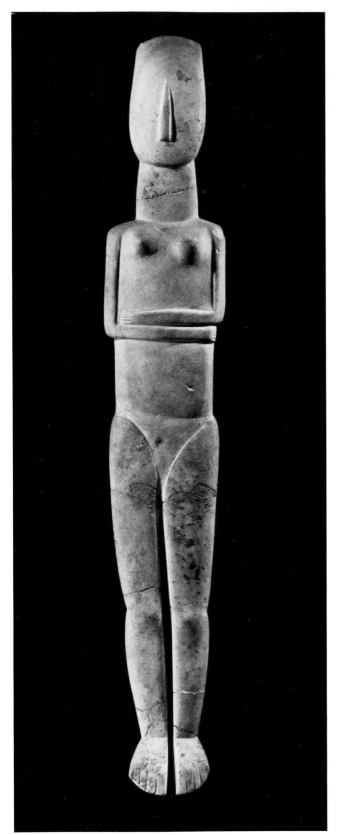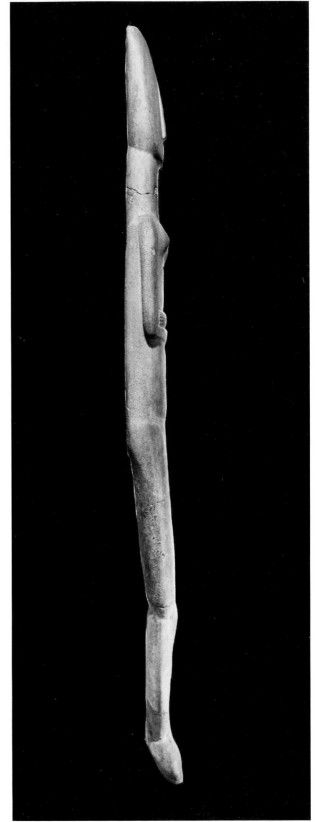

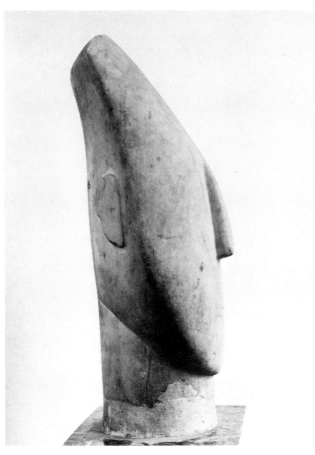
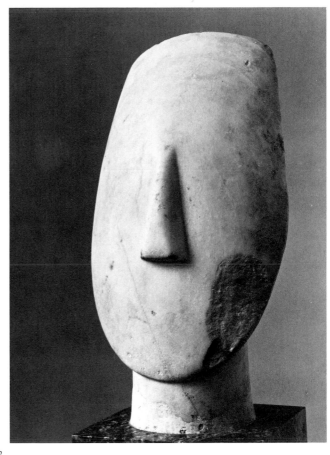

12

11 Marble statue of a female figure
 Found on Amorgos
 Cycladic, Early Cycladic II, Spedos type,
 about 2700 – 2300 B.C.
 Height, 148.5 cm. (58½ in.)
Athens, National Museum, inv. 3978

Bibliography: P. Wolters, AM 16 (1891), p. 47; C. Zervos, *L'Art des Cyclades* (1957), fig. 297; C. Renfrew, AJA 73 (1969), p. 20; E. Sapouna-Sakellarakis, *Die kykladische Sammlung im National Museum von Athen* (1973), pl. 39; *History of the Hellenic World: Prehistory and Protohistory* (1974), p. 111; J. Thimme, *Art and Culture of the Cyclades* (1977), p. 39, fig. 22; *Paris Cat.* (1979), pp. 56 – 57, fig. 9.

Within the generally formulaic character of Cycladic statuary, variation in size as well as form is considerable. This is the largest known example, and noteworthy insofar as its scale presented no apparent difficulty to the sculptor; it is also quite carefully articulated, as indicated, for example, by the fingers, knees, and toes. There is no evidence that the significance of the figure was any different from that of its smaller counterparts; indeed, according to a report made at the time of its discovery, the piece had been broken up to fit a tomb whose dimensions were insufficient to accommodate it.

12 Marble head from a statue
 Found on Amorgos
 Cycladic, Early Cycladic II, Spedos type,
 about 2700 – 2300 B.C.
 Height, 27 cm. (10⅝ in.)
Musée du Louvre, inv. MNC 2108 (MA 3095; Gift of Jules Delamarre, 1896)

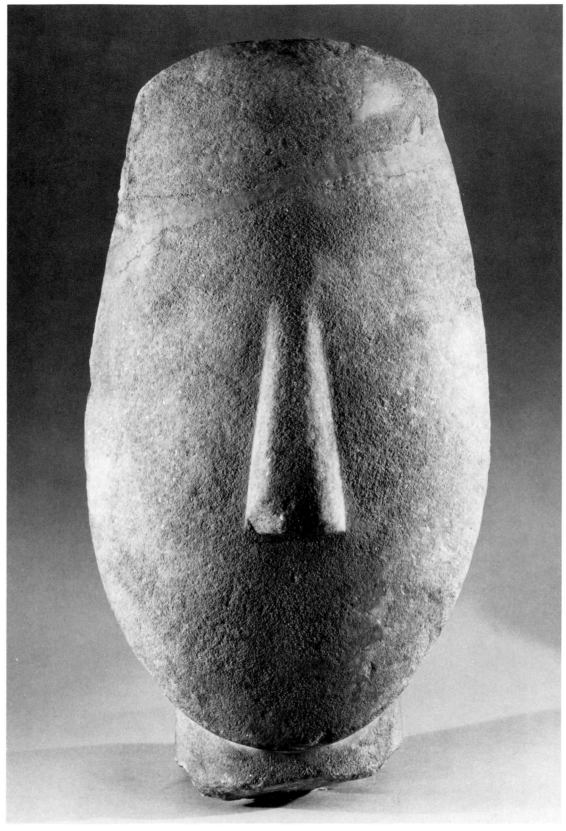

13

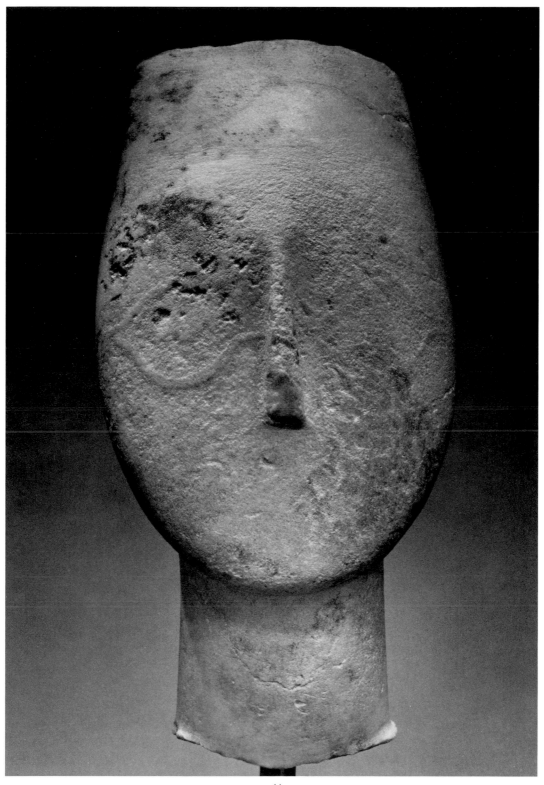

14

Bibliography: C. Zervos, *L'Art des Cyclades* (1957), figs. 159–161; J. Charbonneaux, *Les Merveilles du Louvre* (1958), pl. 42; P. Demargne, *The Birth of Greek Art* (1964), p. 58, fig. 72; C. Renfrew, *AJA* 73 (1969), pp. 16–17; *idem, The Emergence of Civilization* (1972), pl. 32, 3; J. Thimme, *Art and Culture of the Cyclades* (1977), no. 200; *Paris Cat.* (1979), pp. 56, 58, fig. 10.

This head probably belonged originally to a sculpture such as the preceding one (**11**) in Athens. While the head of the latter piece is relatively flat, both in the convexity of the face and in the line of the back, the Louvre example is distinguished by its full form and gradual transitions, its beauty heightened by the polished surface. As only the nose and ears are rendered plastically, it is conceivable that the remaining features were added in paint.

13 Marble head from a statue
Said to be from Herakleia
Cycladic, Early Cycladic II, Spedos type,
 about 2700 – 2300 B.C.
Height, 31.2 cm. (12 5/16 in.)
The Metropolitan Museum of Art L. 55.59
 (Lent by the Guennol Collection)

Bibliography: D. von Bothmer, *Ancient Art in New York Private Collections* (1961), no. 88; H. Hoffmann, *Collecting Greek Antiquities* (1971), p. 5, fig. 4; J. Thimme, *Jahrbuch der staatlichen Kunstsammlungen in Baden-Württemberg* 12 (1975), p. 18, note 20; *idem, Art and Culture of the Cyclades* (1977), no. 199.

In the absence of any ancient written information, everything that is known about Cycladic objects results from excavation and analysis of the material itself. The latter has led, for example, to the recognition of specific—though, of course, anonymous—sculptors, to whom a body of work may be attributed. The similarities in size and style between the Guennol and Louvre (**12**) heads suggest that they, as well as a head now in Norwich, England (Thimme, *Cyclades*, no. 198), all come from a common workshop on Amorgos.

14 Marble head from a statue
Provenance unknown
Cycladic, Early Cycladic II, Spedos type,
 about 2700 – 2300 B.C.
Height, 25.8 cm. (10 1/8 in.)
The Metropolitan Museum of Art 64.246
 (Gift of Christos G. Bastis, 1964)

Bibliography: J. Thimme, *Art and Culture of the Cyclades* (1977), no. 202.

While statuettes with painted decoration still visible are most rare, the former presence of color may be recognized by the way it has protected the underlying surface. Just as the New York harpist (**4**) once had painted hair, so this head preserves the large, strongly curved outlines of two eyes set low in the face; the right eye is the more distinct. However much they differ from Greek sculpture of a later age, one may nonetheless be justified in finding in the Cycladic works the origins of certain long-lived Greek artistic conventions.

15 Marble statuette of a female figure
Provenance unknown
Cycladic, Early Cycladic II, Spedos type,
 about 2700 – 2300 B.C.
Height, 63.5 cm. (25 in.)
The Metropolitan Museum of Art 68.148
 (Gift of Christos G. Bastis, 1968)

Bibliography: D. von Bothmer, *BMMA* 28 (1969–70), p. 78 (ill.); *idem, MMA Guide to the Collections: Greek and Roman Art*[3] (1975), p. 1, fig. 1; J. Thimme, *Art and Culture of the Cyclades* (1977), no. 166.

This figure combines an impression of great elegance—owing to the appreciable size, narrow torso, and taut profile—with one of volume, conveyed by the swelling abdomen and thighs. While every part of the body is clearly differentiated, the sculptor's mastery of transition and contour once again produces a perfectly integrated whole. The artist has become known as the Bastis Master after his hand was recognized in a second piece, as yet unpublished, excavated on Naxos.

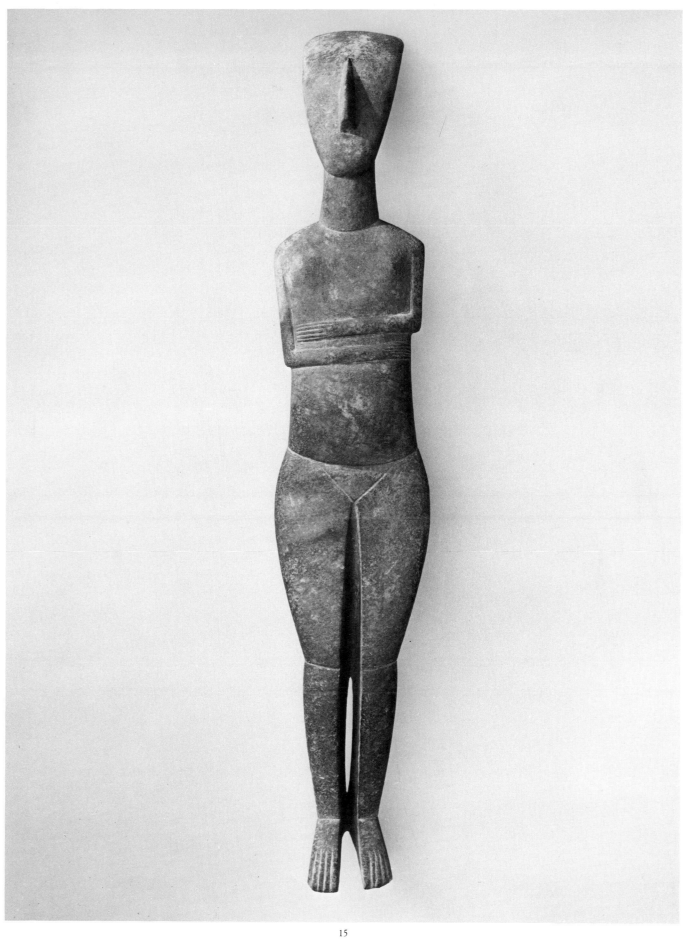

15

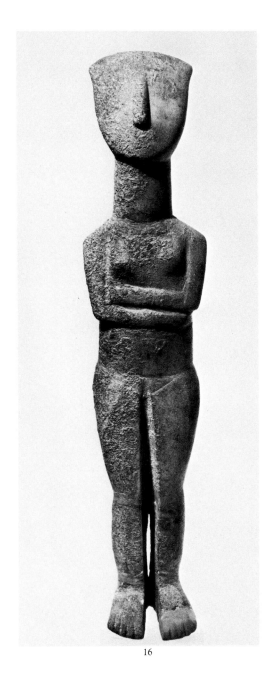

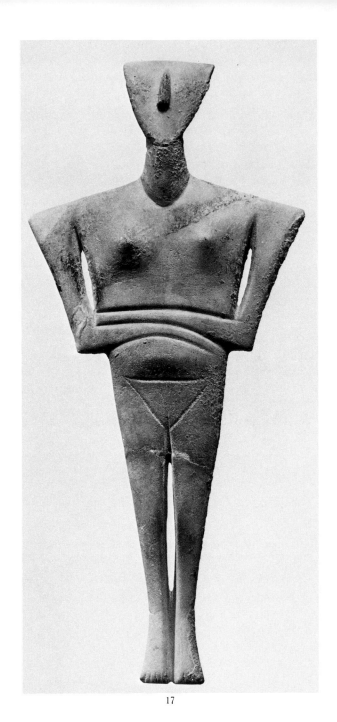

16

17

16 Statuette of a female figure
Found in grave 10 of the Spedos necropolis on Naxos
Cycladic, Early Cycladic II, Spedos type, about 2700–2300 B.C.
Height, 43.8 cm. (17¼ in.)
Athens, National Museum, inv. 6140 (22)

Bibliography: C. Zervos, *L'Art des Cyclades* (1957),

fig. 115 (p. 113); G. A. Papathanassopoulos, *Arch. Deltion* 17 (1961–62), p. 115, pl. 46B; P. Demargne, *The Birth of Greek Art* (1964), pp. 53–54, figs. 66–67; C. Renfrew, *AJA* 73 (1969), p. 11; *Paris Cat.* (1979), pp. 58–59, fig. 11.

This statuette was found on Naxos, in the Spedos cemetery that has given its name to the largest group of canonical Cycladic figures; the five preced-

ing ones (11−15) are of the same type. It is worth emphasizing that works now grouped together on stylistic grounds were made on different islands, among them Naxos and, as we have seen (11−13), Amorgos. This fact helps to account for the many small variations within a given schema, but it also suggests considerable mobility and communication among sculptors.

17 Statuette of a female figure
Found on Syros
Cycladic, Early Cycladic II, Dokathismata type,
 about 2700−2300 B.C.
Height, 46 cm. (18⅛ in.)
Athens, National Museum, inv. 6174

Bibliography: C. Zervos, *L'Art des Cyclades* (1957), fig. 251; P. Demargne, *The Birth of Greek Art* (1964), p. 57, fig. 71; C. Renfrew, *AJA* 73 (1969), p. 16, pl. 5d; H.-G. Buchholz and V. Karageorghis, *Prehistoric Greece and Cyprus* (1973), p. 100, no. 1205; E. Sapouna-Sakellarakis, *Die kykladische Sammlung im National Museum von Athen* (1973), pl. 38; *History of the Hellenic World: Prehistory and Protohistory* (1974), p. 112; *Paris Cat.* (1979), pp. 59−60, fig. 12.

In general, statuettes of the Spedos variety seem directly related to the human figure. By contrast, the Dokathismata type illustrated here suggests considerably more interpretation on the part of the sculptor, whether for artistic or other reasons. One of the best-known examples, this figure is highly accomplished in its integration of hard, stylized contours and incisions with the rounded, more natural forms of the neck, breasts, and belly. In conception and execution it is a virtuoso achievement by an exceptional artist.

see colorplate page 25

18 Terracotta statuette of a hedgehog holding a bowl
Found at Chalandriani on Syros, 1899
Cycladic, Early Cycladic III,
 about 2300−2100 B.C.
Height, 10.8 cm. (4¼ in.)
Athens, National Museum, inv. 6176

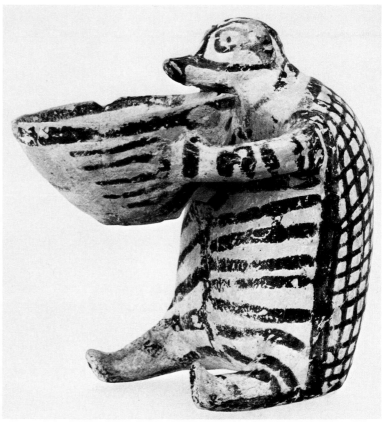

18

Bibliography: C. Zervos, *L'Art des Cyclades* (1957), figs. 238−239; P. Demargne, *The Birth of Greek Art* (1964), p. 45, fig. 50; E. Vermeule, *Greece in the Bronze Age* (1964), p. 50, fig. 8a; R. Higgins, *Minoan and Mycenaean Art* (1967), p. 56, fig. 56; C. Renfrew, *The Emergence of Civilization* (1972), pl. 16,2; H.-G. Buchholz and V. Karageorghis, *Prehistoric Greece and Cyprus* (1973), p. 99, no. 1186; E. Sapouna-Sakellarakis, *Die kykladische Sammlung im National Museum von Athen* (1973), pl. 11; *History of the Hellenic World: Prehistory and Protohistory* (1974), p. 109; J. Thimme, *Art and Culture of the Cyclades* (1977), p. 47, fig. 27, p. 49; *Paris Cat.* (1979), p. 60, fig. 13.

Painted pottery began to appear during Early Cycladic II, especially on Syros, in the form of pyxides and footed cups. During the succeeding period its popularity increased rapidly, leading to the predominance of dark-on-light wares from Middle Cycladic on. This vase belongs to a small group in the form of animals, most of which are of stone, and to an

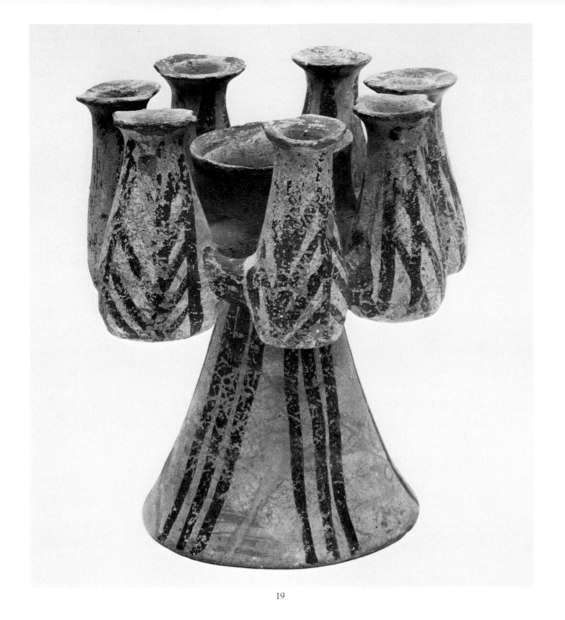

19

even smaller number of zoomorphic rhyta, or offering vases. It represents a hedgehog, or possibly a bear, holding a bowl that is pierced to allow its contents to flow into the animal's body. Although a similar but fragmentary object came to light on Keos (Thimme, *op. cit.*, p. 49, fig. 28), this one remains unique in its immediacy. *see colorplate page 26*

19 Terracotta kernos
Provenance unknown
Cycladic, Early Cycladic III,
 about 2300 – 2100 B.C.
Height, 25.7 cm. (10⅛ in.)
The Metropolitan Museum of Art L.1979.49.1
(Lent by Mr. and Mrs. Norbert Schimmel)

Bibliography: D. von Bothmer, *Ancient Art in New York Private Collections* (1961), no. 95; *Ancient Art, the Norbert Schimmel Collection*[2] (1975), no. 5.

The kernos, a vessel for multiple offerings, was one of the primary shapes that emerged in Early Cycladic III together, one would almost say, with dark-on-light decoration. Melos seems to have been a center for the production of these objects. The Schimmel example is characteristic, with its spreading base and series of small receptacles—here, seven—disposed around a central, larger one. Though limited to very simple linear motifs, the decoration emphasizes the respective forms of the support and the smaller containers.

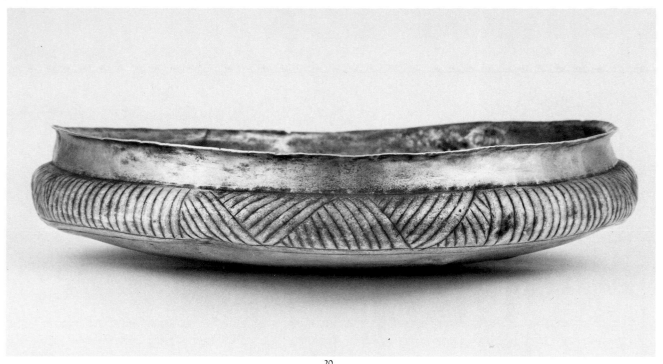

20

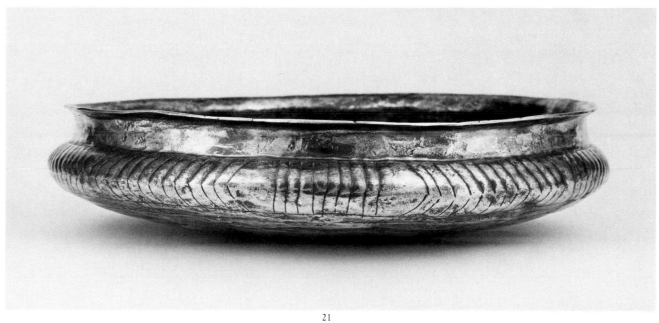

21

20 Silver dish
 Said to be from Euboea
 Cycladic, Early Cycladic I – II,
 about 3000 – 2300 B.C.
 Diameter, 26.6 cm. (10½ in.)
The Metropolitan Museum of Art 46.11.1
(Purchase, Joseph Pulitzer Bequest, 1946)

Bibliography: B. Segall, *Museum Benaki: Katalog der Goldschmiede-Arbeiten* (1938), p. 212, note 1b; G. M. A. Richter, *Handbook of the Greek Collection* (1953), pl. 11i; E. Vermeule, *Greece in the Bronze Age* (1964), pl. VI B, pp. 26, 51; D. Strong, *Greek and Roman Gold and Silver Plate* (1966), pl. 1B, pp. 28 – 29; C. Renfrew, AJA 71 (1967), pl. 10e; H.-G. Buchholz

and V. Karageorghis, *Prehistoric Greece and Cyprus* (1973), p. 86, no. 1078; K. Branigan, *Aegean Metalwork of the Early and Middle Bronze Age* (1974), pl. 36, p. 195, no. 3162; R. Ross Holloway, *Journal of Field Archaeology* 3 (1976), p. 151, fig. 11; J. Thimme, *Art and Culture of the Cyclades* (1977), no. 426, p. 121; E. Davis, *The Vapheio Cups and Aegean Gold and Silver Ware* (1977), p. 62, no. 6.

Finds of copper, bronze, lead, and silver testify to the importance of the metalworker's art, particularly during Early Cycladic II; the ores were at hand and the technical skill, by and large, was probably developed locally. While weapons and implements of copper and bronze make up the largest amount of extant material, some metal vessels are known as well.

This dish and the following one (21) are said to have been found together on the island of Euboea. In their very squat shape as in the way they were made, by raising from a disk of metal, they are related to two pieces excavated on Amorgos (Davis, *op. cit.*, pp. 61–63). The New York examples, however, have chased ornamentation. Here, hatched triangles alternate with groups of vertical lines; on **21** there is a herringbone pattern.

21 Silver dish
Said to be from Euboea
Cycladic, Early Cycladic I–II,
 about 3000–2300 B.C.
Diameter, 20.4 cm. (8 in.)
The Metropolitan Museum of Art 1972.118.152
(Bequest of Walter C. Baker, 1972)

Bibliography (excluding joint references with **20**): D. von Bothmer, *Greek, Etruscan, and Roman Antiquities . . . from the Collection of Walter Cummings Baker, Esq.* (1950), no. 99; *idem, Ancient Art in New York Private Collections* (1961), p. 21; K. Branigan, *Aegean Metalwork of the Early and Middle Bronze Age* (1974), p. 195, no. 3161; J. Thimme, *Art and Culture of the Cyclades* (1977), no. 427; E. Davis, *The Vapheio Cups and Aegean Gold and Silver Ware* (1977), p. 63, no. 7

22 Gold sauceboat
Said to be from Heraia in Arkadia
Early Helladic II, about 2200–2000 B.C.
Height, 17 cm. (6¹¹/₁₆ in.); length, 14.4 cm.
 (5⅝ in.); diameter, 10.6 cm. (4³/₁₆ in.)
Musée du Louvre, inv. MNC 906 (Bj 1885; purchase, 1887)

Bibliography: A. De Ridder, *Catalogue des bijoux antiques* (1924), p. 180; V. Gordon Childe, *JHS* 44 (1924), pp. 163–65; H. T. Bossert, *The Art of Ancient Crete* (1937), fig. 147 [before restoration]; P. Demargne, *The Birth of Greek Art* (1964), p. 76, fig. 98; E. Vermeule, *Greece in the Bronze Age* (1964), pl. VI A, pp. 27, 40; D. Strong, *Greek and Roman Gold and Silver Plate* (1966), pl. 1A, pp. 27–28; R. Higgins, *Minoan and Mycenaean Art* (1967), p. 71, fig. 77; S. S. Weinberg, *AK* 12 (1969), pl. 1; C. Renfrew, *The Emergence of Civilization* (1972), pl. 19,3; H.-G. Buchholz and V. Karageorghis, *Prehistoric Greece and Cyprus* (1973), p. 86, no. 1082; J. Thimme, *Art and Culture of the Cyclades* (1977), no. 428; E. Davis, *The Vapheio Cups and Aegean Gold and Silver Ware* (1977), p. 59, no. 1; *Paris Cat.* (1979), p. 62, fig. 16.

The sauceboat has long been recognized as one of the most typical vessel shapes on the Greek mainland during the middle phase of the Early Bronze period (known as Early Helladic II). More recently, its priority in the Cyclades has become apparent, and thus the probability that the shape spread westward to the Mainland as well as eastward to the Troad. However common sauceboats are in clay, the Louvre example is one of only two known in gold (for the second see Weinberg, *op. cit.*). Although there is less evidence for the use of gold than of silver in the Cyclades, the craftsmanship here is impressive; the body was raised in one piece, the handle riveted on separately.

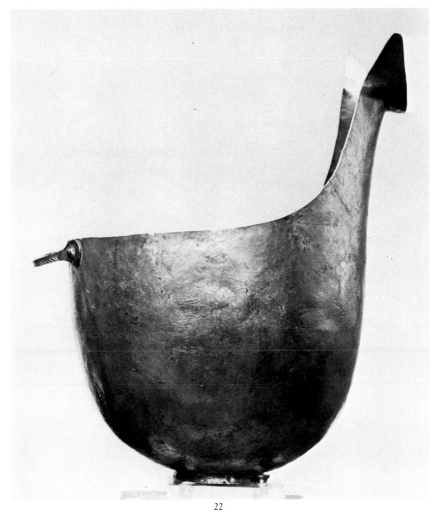

22

LATER CYCLADIC ART: THERA AND PHYLAKOPI

Nos. 23–40 Later Cycladic Art: Thera and Phylakopi

Although the brilliance of Early Cycladic art had waned by about 2000 B.C., life on the islands continued uninterrupted and, indeed, experienced a resurgence of creativity and prosperity between about 1700 and 1450 B.C. This period falls within the Middle (about 2000–1600) and Late (about 1600–1200) Bronze Age and represents the time of greatest Cretan influence on its Aegean neighbors; the chronology and culture of Crete are also known as "Minoan," after Minos, the legendary king of the island.

The existence of Cretan outposts beyond the island's immediate shores has been known since excavation began at Phylakopi on Melos. The richest evidence, however, has appeared at Akrotiri on Thera (Santorini). The finds, notably the pottery, include Minoan imports, local wares, and a great number of vases in which Minoan influence is apparent; as with the wall paintings, however, the origin and training of the artists cannot [yet ?] be determined. While the relative importance of Cycladic and Minoan elements in the art of Akrotiri will long be discussed, the settlement unquestionably mirrors the culture of Crete at its high point.

Between 1500 and 1450 B.C. the volcanic island of Thera erupted, sealing everything on land beneath layers of pumice. Making itself felt as far away as Crete, the cataclysm may have caused or precipitated the destruction that befell all the palaces and settlements on Crete early in the fifteenth century B.C. Although sites like Knossos were reoccupied, they never regained their former power under the Mycenaeans, who dominated the island during most of the Late Bronze Age.

23 Support of a terracotta vase

The decoration shows four men, nude except for their loincloths, with long hair and with their right eyes in the middle of their cheeks, walking toward the right. In each hand, the first, third, and fourth hold a fish by the tail; the second has only one fish in his right hand. Groups of three heart-shaped leaves, perhaps ivy, fill the spaces between the heads. A light band closely covered with dark spots appears below their feet and may represent the shoreline. On the concave zone at the bottom are crescents.

Found at Phylakopi on Melos, 1898
Cycladic, Middle Cycladic III,
 about 1700 – 1600 B.C.
Height, 17 cm. (16 11/16 in.)
Athens, National Museum, inv. 5782

Bibliography: D. G. Hogarth, BSA 4 (1897 – 98), pl. 2, p. 14; C. C. Edgar, in Excavations at Phylakopi in Melos (JHS Suppl. Paper IV) (1904), pl. 22, pp. 123 – 25, 170; C. Zervos, L'Art des Cyclades (1957), figs. 312 – 315; P. Demargne, The Birth of Greek Art (1964), p. 180, fig. 249; A. D. Lacy, Greek Pottery in the Bronze Age (1967), p. 271, fig. 109; C. Renfrew, The Emergence of Civilization (1972), pl. 16, 3; E. Sapouna-Sakellarakis, Die kykladische Sammlung im National Museum von Athen (1973), no. 15; H.-G. Buchholz, et al., Jagd und Fischfang, Archeologia Homerica (1973), p. 139, fig. 49, p. 141, no. 74; H.-G. Buchholz and V. Karageorghis, Prehistoric Greece and Cyprus (1973), p. 68, no. 863; J. Sakellarakis, AAA 7 (1974), p. 371, figs. 1 – 2, pp. 370 – 76; Paris Cat. (1979), pp. 70, 72 – 73, fig. 22.

Many of the ingredients in the decoration of this unique object are familiar to us from Early Cycladic art, such as the representation of the human figure, the observation of other natural forms, the preoccupation with the sea, and the knowledge of painted pottery techniques. This scene remains so astonishing, however, because here, for a moment, all of these elements are united in such a way that the forms virtually come to life. Although the physique and dress of the fishermen suggest some familiarity with the art of Crete (see 46), the bold and vigorous style points to a Cycladic painter. The interpretation, moreover, provides an informative contrast to the more naturalistic yet placid rendering of the boys with fish on a fresco from Thera (S. Marinatos, Excavations at Thera VI [1974], pl. 6). What remains of the Phylakopi vase is only the lower part, which seems to be complete; at the top, there was probably a receptacle in the nature of a lamp or dish.

see colorplate page 27

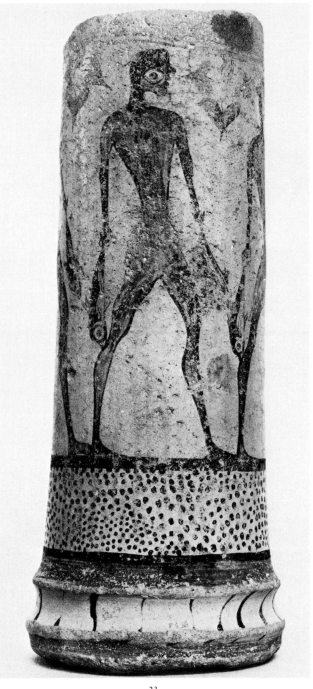

23

24 Terracotta jug

On the belly of each side of the vase a bird
appears with outstretched wing; the space
between is filled by spirals disposed in a
treelike configuration. Large dots surround
the base of the neck, and there is a ring of
glaze around the lower handle attachment.

Found at Phylakopi on Melos

Cycladic, Middle Cycladic III,
about 1700 – 1600 B.C.

Height, 26 cm. (10 ¼ in.)

Athens, National Museum, inv. 5762

Bibliography: C. C. Edgar, in *Excavations at Phylakopi
in Melos* (*JHS* Suppl. Paper IV) (1904), pl. 21,1, pp.
119, 169; K. Scholes, *BSA* 51 (1956), pp. 21, 24; C.
Zervos, *L'Art des Cyclades* (1957), fig. 308; A. D.
Lacy, *Greek Pottery in the Bronze Age* (1967), p. 269,
fig. 108b; E. Sapouna-Sakellarakis, *Die kykladische
Sammlung im National Museum von Athen* (1973), no.
14; *History of the Hellenic World: Prehistory and Pro-
tohistory* (1974), p. 141; *Paris Cat.* (1979), pp. 75 –
77, fig. 26.

The dark-on-light style of decoration that began
in Early Cycladic II (see **18**) flourished during the
Middle Cycladic period, especially at Phylakopi,
where vases showing plant motifs, fish, and birds have
come to light in quantity. In some works, of which
this is a fine example, polychromy is used for addi-
tional effect. One has the impression that the exceed-
ingly disciplined forms of the preceding millennium
were loosening, spreading freely and playfully over
their allotted surfaces.

25 Wall painting with flying fish

Between a dark band at top and bottom, four
fish cavort among indications of rocks and sea
spray.

Found at Phylakopi on Melos, 1898

Transition from Middle to Late Bronze Age,
about 1600 – 1500 B.C.

Original height, 23 cm. (9 ¹/₁₆ in.)

Athens, National Museum, inv. 5844

24

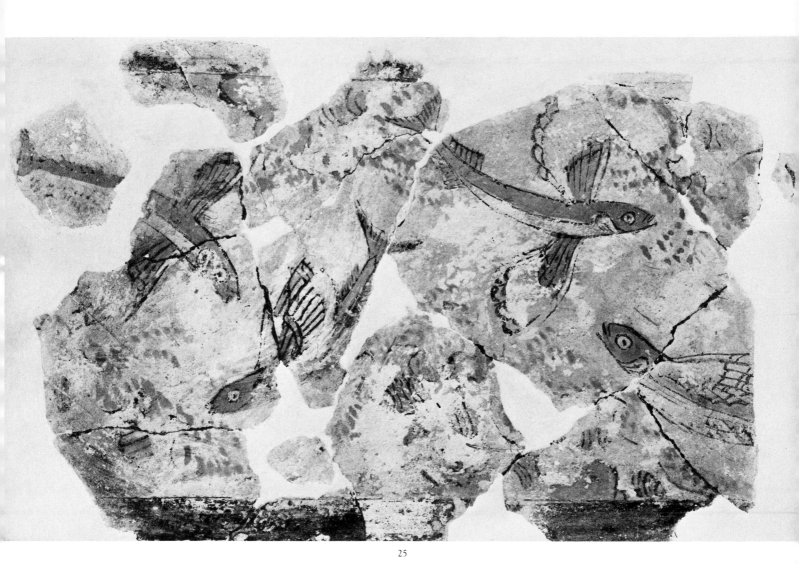

25

Bibliography: D. G. Hogarth, *BSA* 4 (1897 – 98), pl. 3; R. C. Bosanquet, in *Excavations at Phylakopi in Melos* (*JHS* Suppl. Paper IV) (1904), pl. 3, pp. 70 – 72; A. Lesky, *Thalatta* (1948), p. 42, fig. 2; F. Matz, *Kreta-Mykene-Troia* (1956), pl. 49, pp. 99, 104; M. Robertson, *Greek Painting* (1959), p. 21; J. W. Graham, *The Palaces of Crete* (1962), fig. 132; P. Demargne, *The Birth of Greek Art* (1964), pp. 180 – 81, figs. 250 – 251; W. Schiering, *AK* 8 (1965), pl. 1, 3, pp. 3, 11; H.-G. Buchholz and V. Karageorghis, *Prehistoric Greece and Cyprus* (1973), p. 80, no. 1044; E. Sapouna-Sakellarakis, *Die kykladische Sammlung im National Museum von Athen* (1973), no. 27; *History of the Hellenic World: Prehistory and Protohistory* (1974), p. 140; M. Robertson, *A History of Greek Art* (1975), pp. 5 – 6; *Paris Cat.* (1979), pp. 70 – 71, fig. 21.

During the period of Minoan influence on the Cyclades that came to a height c. 1700 – 1450 B.C., Phylakopi seems to have harbored a colony of Cretans, most of them no doubt traders, but certainly including artists as well. This celebrated painting finds such close parallels in the Palace at Knossos— notably in a scene of swimming dolphins (see A. Evans, *The Palace of Minos* III [1930], p. 379, fig. 251)—that since its first publication it has been considered Minoan. The spontaneity of the "swallowfish," as they are sometimes called by modern Greeks, brings to mind the vases and wall decorations from Thera (see **27 – 38**).

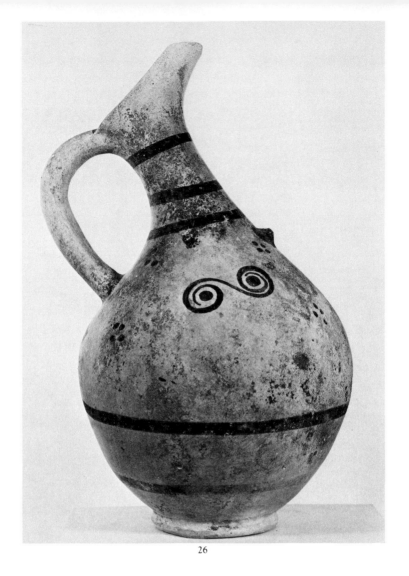

26

26 Terracotta beak-spouted jug

On the front of the body and under the handle are rosettes, each made up of four petals drawn in outline; on either side, two spirals are joined horizontally and surrounded by four dot-rosettes. Below the neck are two breastlike projections.

Found "under pumice" at Akrotiri on
Thera, 1879
Cycladic, Middle Cycladic,
about 1800 – 1600 B.C.
Height, 26 cm. (10¼ in.)
Musée du Louvre, inv. MNB 2058 (A 262; Gift of
F. Fouqué and L. de Cessac, 1880)

Bibliography: F. Fouqué, *Santorin et ses éruptions* (1879), pl. 41, 5; E. Pottier, *Vases antiques du Louvre* 1 (1897), p. 10; *idem*, *CVA Louvre* 1 (1922), II B, pl. 1,1; H. Giroux, in J. des Gagniers, *Musée du Québec: Objets d'Art grec du Louvre* (1969), p. 63; *Paris Cat.* (1979), p. 68, fig. 17.

The beak-spouted jug seems to have come to the Cyclades from Anatolia, complete with such details as the relief "breasts" (see K. Scholes, *BSA* 51 [1956], pp. 18 – 19, 37). The shape was quickly adopted in Melos, which may have been a center of its diffusion. Though not one of the most elaborate examples, the Louvre jug shows the sparseness usual in the decoration, the lines that emphasize neck and lower body, as well as recurrent motifs like the rosette and spiral. The zoomorphic character of the shape is occasionally heightened by a pair of eyes placed on either side of the spout.

It is worth noting that one of the donors of this vase to the Louvre, F. Fouqué, wrote a study of the

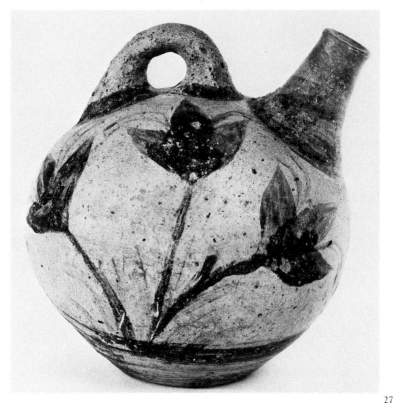
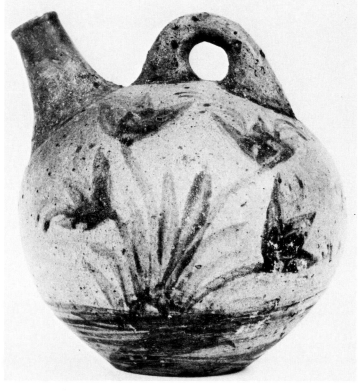

27

geology of Thera that has remained basic to this day (*Santorin et ses éruptions* [1879]; see also *Acta of the First International Congress on Thera* [1971], pp. xxviii, 408, *passim*). French interest in the island, moreover, was not purely scientific, for the volcanic pumice was long known to produce a particularly strong cement when mixed with lime. During construction of the Suez Canal (1859–69), Theran pumice was employed for the buildings in the port and town of Port Saïd (Fouqué, *op. cit.*, pp. 94–95).

27 Terracotta askos

Each side of the body is decorated with crocuses—three flowers on one side, four on the other. There is glaze on the spout, at each of the handle roots, and at the base of the body.

Found at Akrotiri on Thera, 1970

Late Bronze I, about 1600–1500 B.C.
Height, 15.1 cm. (5 15/16 in.); diameter, 11.5 cm. (4½ in.); maximum width, 13 cm. (5¼ in.)
Athens, National Museum, inv. 885

Bibliography: S. Marinatos, *AAA* 4 (1971), p. 71, fig. 21; *idem*, *Excavations at Thera* IV (1971), pl. 80a, pp. 36–37; *Paris Cat.* (1979), p. 68, fig. 18.

The askos is a closed, bag-shaped vase with the spout placed high on the body. By the Late Bronze Age, the shape had enjoyed a long history in the Cyclades, though never had it been given such naturalistic decoration. Placed so that the curve of the underlying surface enhances their own form, the crocuses are brushed on surely but rapidly, in a way that evokes their movement in the wind.

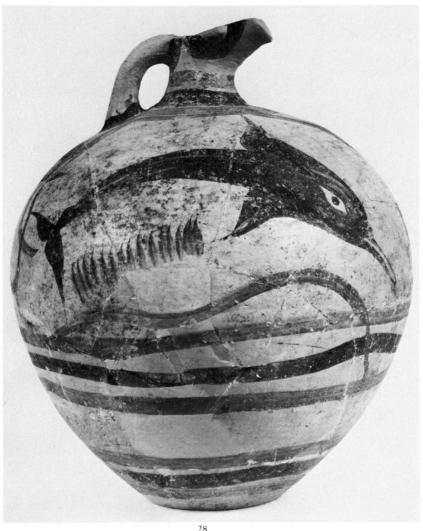

28

28 Terracotta jug

On each side of the body is a dolphin; below are
a series of vertical strokes and wavy or hori-
zontal lines.
Found at Akrotiri on Thera
Late Bronze I, about 1600 – 1500 B.C.
Height, 43.5 cm. (17⅛ in.); diameter, 35 cm.
(13¾ in.)
Athens, National Museum, inv. 1516

Bibliography: S. Marinatos and M. Hirmer, *Kreta,
Thera und das mykenische Hellas* (1973), fig. 162;
Paris Cat. (1979), p. 69, fig. 19.

This jug, of almost spherical form, retains fea-
tures of its beaked antecedents: the channel-shaped
spout, the relief eye emphasized by a black line, and
the stripes at the top and bottom of the body. The
proportionately large head and eye, and the beak-
like mouth, give the dolphin here an almost predatory
character.

see colorplate page 28

29 Terracotta ewer

Bunches of grapes hang from a band at the base
of the neck.
Found at Akrotiri on Thera

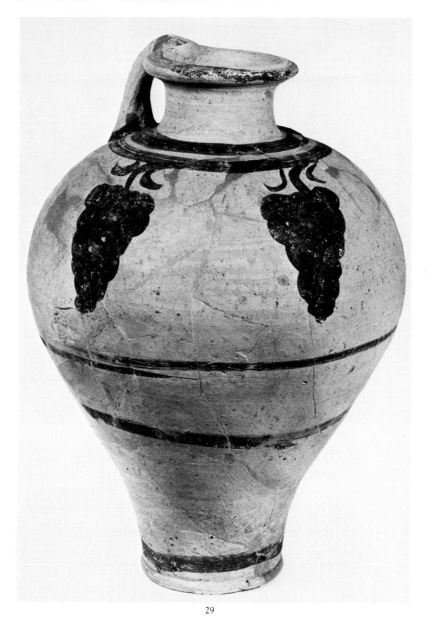

29

Late Bronze I, about 1600 – 1500 B.C.
Height, 50.1 cm. (19 ¾ in.); diameter, 34 cm.
(13⅜ in.)
Athens, National Museum, inv. 623

Bibliography: S. Marinatos, *Excavations at Thera* III
(1970), pl. 56,1, p. 60; *idem* and M. Hirmer, *Kreta,
Thera und das mykenische Hellas* (1973), fig. 160;
Paris Cat. (1979), p. 74, fig. 23.

While the simplicity of its decoration makes the
ewer immediately attractive, it is also of particular
interest. The representation here, and other less-
accomplished ones also from Thera (Marinatos, *Thera* I [1968], p. 32, fig. 44; *Thera* VI [1974], pl.
79a) seem to mark the first appearance of grapes in
Aegean art, although the fruit had already been culti-
vated for over a thousand years. A second point of
note is the similarity of the ewer's shape to an example
of silver from Mycenae, and two of bronze from Knos-
sos and Thera (see E. Davis, *The Vapheio Cups and
Aegean Gold and Silver Ware* [1977], p. 149, no. 43).
The influence of metal and clay shapes on each other
is a recurrent consideration in the study of Bronze Age
vases, and all too often based on hypothesis rather
than tangible evidence. Despite differences in their
decoration, these ewers of metal and clay are clearly
complementary.

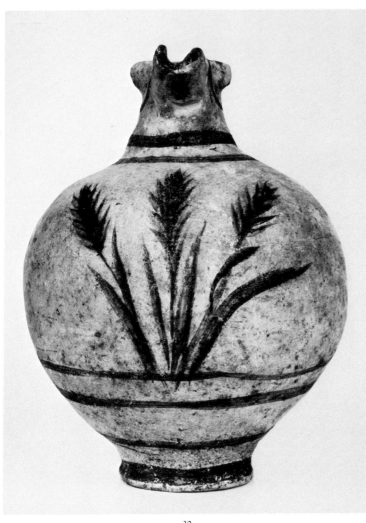

30

A noteworthy feature of the pottery from Thera is the variety of plant life—specifically, "produce"—that appears in the decoration. Although staples of the Minoan repertoire such as crocuses, lilies, and grasses occur as well, the recurrence of barley and, more rarely, of grapes, capers, and vetches seems to be a peculiarity of vases from the site. Owing to the volcanic soil, the island itself was extremely fertile and, in the current excavations, has yielded considerable remains of foodstuffs and other organic material.

31 Terracotta spouted jar

Around the body three swallows fly to right. There is black glaze on the vertical edge of the mouth, at the base of the handle, and at the base of the neck and body.

Found at Akrotiri on Thera, 1968

Late Bronze I, about 1600 – 1500 B.C.

Height, 18.4 cm. (7 ¼ in.); diameter, 14.7 cm. (5 ¹³/₁₆ in.)

Athens, National Museum, inv. 112

Bibliography: S. Marinatos, *AAA* 1 (1968), p. 216, fig. 6 [though note restored spout]; *idem*, *AAA* 2 (1969), p. 66, fig. 2; *idem*, *Excavations at Thera* II (1969), p. 14, fig. 5; *idem* and M. Hirmer, *Kreta, Thera und das mykenische Hellas* (1973), fig. 159; *Paris Cat.* (1979), p. 75, fig. 25.

Another iconographical specialty of Thera was the swallow. While its most prominent representation is the wall painting of swallows among lilies (Marinatos and Hirmer, *op. cit.*, colorplates 36 – 37), the motif also occurs on an elliptical vase (Marinatos, *Thera* II [1969], pl. 17, 2) and a "pyxis" from the site (Marinatos, *Thera* VII [1976], pl. 47c). Marinatos would like to attribute the Thera jug as well as a fragment from Phylakopi (*JHS* Suppl. Paper IV [1904], p. 120, fig. 92) and a jug from Mycenae (see Marinatos, *AAA* 2, p. 68) to a common Theran workshop, if not to a single artist. In the rendering of the bird on the vase exhibited, it is noteworthy how the painter used the clay surface for the center of the body, as was done for the eye of the dolphin (**28**). Moreover, the eye on the spout and the "breasts" on the body give the vase itself a zoomorphic character.

see colorplate page 29

30 Terracotta spouted jar

On the front of the body are three stalks of barley.

Found at Akrotiri on Thera

Late Bronze I, about 1600 – 1500 B.C.

Height, 21.3 cm. (8 ⅜ in.); diameter, 15.7 cm. (6 ³/₁₆ in.)

Athens, National Museum, inv. 928

Bibliography: S. Marinatos, *AAA* 4 (1971), p. 68, fig. 17; *idem*, *Excavations at Thera* IV (1971), colorplate H, pl. 73, p. 36; *idem* and M. Hirmer, *Kreta, Thera und das mykenische Hellas* (1973), fig. 156 right; *Paris Cat.* (1979), pp. 74 – 75, fig. 24.

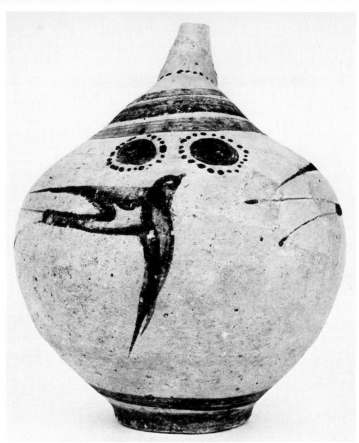

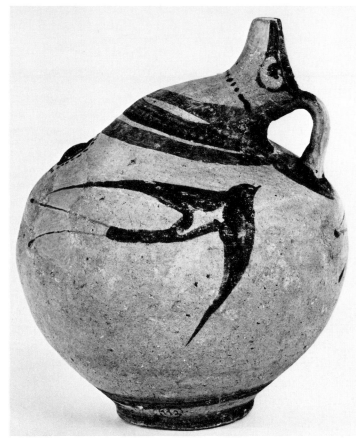

32 Terracotta one-handled cup

On only one side of the body, two clusters of crocuses appear on either side of what is probably a lily. Below are parallel horizontal and vertical lines.

Found at Akrotiri on Thera

Late Bronze I, about 1600 – 1500 B.C.

Height, 11 cm. (4 5/16 in.); width, 13.5 cm. (5 5/16 in.)

Athens, National Museum, inv. 505

Bibliography: S. Marinatos, *Excavations at Thera* V (1972), pl. 62c, p. 31; *Paris Cat.* (1979), pp. 77 – 78, fig. 27.

This is one of a small group of one-handled cups characterized by a constricted base, yellowish fabric, and the application of decoration in a brownish glaze to only one side. Marinatos sees the influence of metalware in their shape, and considers the group imported. A number of features recall the pottery of Middle Minoan Crete; the shape has a counterpart in Kamares Ware (A. Evans, *The Palace of Minos* I [1921], colorplate II), while a style of nonfigural ornament in glaze on a yellowish clay occurs in Middle Minoan III (*e.g.*, Evans, *op. cit.*, pp. 592 – 93; *op. cit.*, IV [1935], pp. 120 – 22; Marinatos, *Thera* III [1970], p. 52). The rendering of the vegetation, however, is strikingly unnaturalistic for either a Theran or Cretan artist.

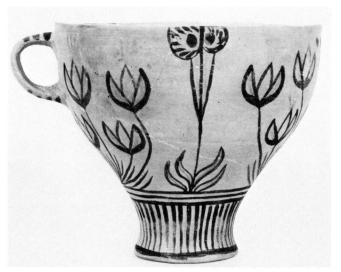

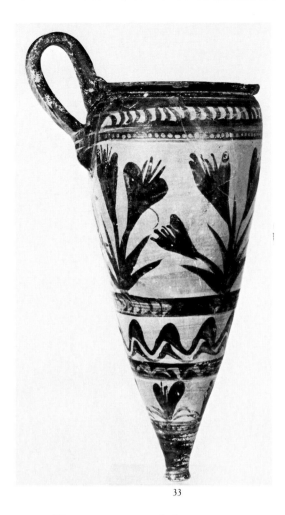

33

33 Terracotta conical rhyton

The top of the body is decorated with bands of crescents and dots. Below, the major zone shows crocus plants; beneath, in smaller registers, are a wave pattern and crocuses.
Found at Akrotiri on Thera
Late Bronze I, about 1600 – 1500 B.C.
Height, 29.4 cm. (11 9/16 in.)
Athens, National Museum, inv. 1494

Bibliography: S. Marinatos, *AAA* 5 (1972), p. 13, fig. 19, p. 14; *idem, Excavations at Thera* V (1972), pl. 64, p. 31; *Paris Cat.* (1979), p. 78, fig. 28.

The most common form of rhyton, a vase for liquid offerings, is the present, conical variety. It is most closely connected with Crete, where its history can be traced back to the Middle Minoan period (A. Furumark, *The Mycenaean Pottery* [1941], pp. 71 – 73). On numerous clay examples, including this one, the form of the handle and the presence of rivet heads on its upper attachment point to metal prototypes; a famous example of silver that came to light in

Mycenae is also considered Minoan (see E. Davis, *The Vapheio Cups and Aegean Gold and Silver Ware* [1977], p. 227, no. 87). The decoration of the Thera rhyton shows both floral and marine motifs that, however familiar, are generally not combined.

see colorplate page 30

34 Terracotta rhyton

The head, cut off at the neck, is that of a lioness.
Found at Akrotiri on Thera, 1971
Late Bronze I, about 1600 – 1500 B.C.
Height, 14 cm. (5 ½ in.); diameter of base, 16.3 cm. (6 ⅜ in.)
Athens, National Museum, inv. 1855

Bibliography: S. Marinatos, *AAA* 5 (1972), p. 15, fig. 21, p. 14; *idem, Excavations at Thera* V (1972), pl. 80; E. Davis, *The Vapheio Cups and Aegean Gold and Silver Ware* (1977), pp. 181 – 82; *Paris Cat.* (1979), pp. 78 – 79, fig. 29.

A rarer variety of rhyton is that in the form of an animal or animal's head. The most notable specimens known are made of stone and metal, and represent principally bulls or felines. Which are of Minoan and which of Mycenaean manufacture, however, remains a matter of discussion (see Davis, *op. cit.*). One of two ceramic examples from Thera (for the other see Marinatos, *Thera* II [1969], p. 37, 1), this rhyton was

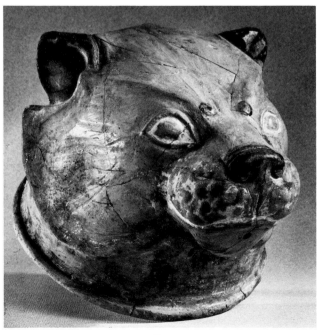

34

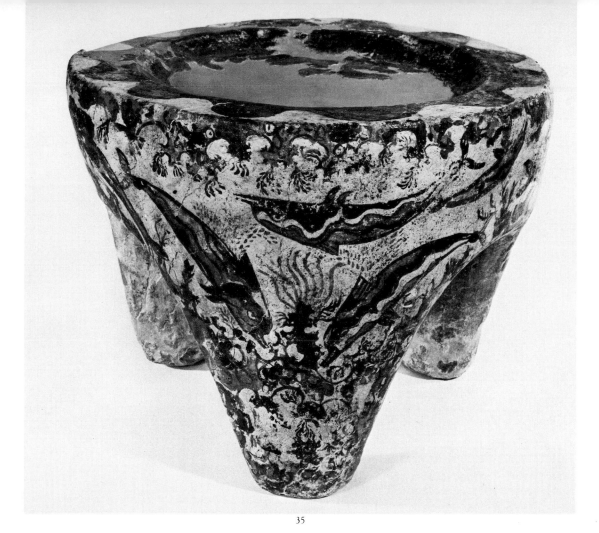

35

originally painted and is interesting, furthermore, for the rolled edge of the neck. Such a detail suggests that the work was conceived more as a vase than as a piece of sculpture (compare, for example, the necks of two rhyta from Knossos, S. Marinatos and M. Hirmer, *Kreta, Thera und das mykenische Hellas* [1973], pls. 98,99).

35 Limestone offering table with polychrome decoration

Applied onto a thin layer of plaster, the representation on the sides and on the three legs of the table shows dolphins swimming and playing within a marine setting of plants and various rocklike formations. A wave motif appears on the upper edge, while the central concavity is plain.

Found at Akrotiri on Thera, 1971
Late Bronze I, about 1600 – 1500 B.C.
Height, 30 cm. (11 13/16 in.); diameter, 40 cm. (15 ¾ in.)

Athens, National Museum, inv. BE 1974/23

Bibliography: S. Marinatos, *Excavations at Thera* V (1972), colorplate C, pl. 102, pp. 43 – 44; *idem* and M. Hirmer, *Kreta, Thera und das mykenische Hellas* (1973), colorplate XLIV below; *Paris Cat.* (1979), pp. 79 – 80, fig. 30.

Offering tables have been found in some number at Akrotiri (Marinatos, *Thera* IV [1971], pp. 31, 37, pls. 81, 82; *op. cit.*, VII [1976], pl. 51), but this is the largest and, without question, the most remarkable. It presents us, for all practical purposes, with a fresco applied to a utilitarian object. The artistry is on a level with that of the wall paintings from the site and, indeed, one wonders whether the painters who decorated the West House (Marinatos, *Thera* VI [1974], pp. 19ff.), for example, might not also have worked on an object like this; interestingly, it was discovered on a sill in that house.

see colorplate page 31

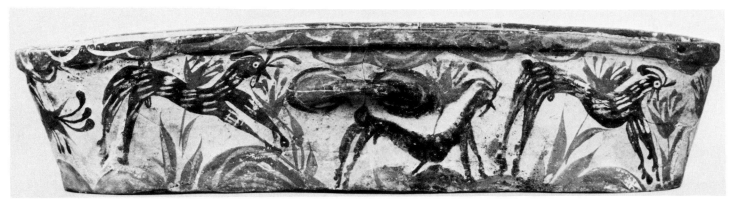

36

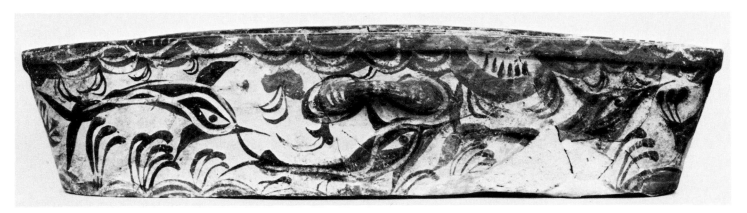

36 Terracotta vase with polychrome decoration
The vase is elliptical, with a pronounced rim and a handle in the middle of each side. On one of the long sides, there are three quadrupeds (possibly mountain goats?) to right, within a setting of grasses and crocuses; on the other side, three dolphins swim among wavy lines and groups of strokes that suggest a turbulent sea.
Found at Akrotiri on Thera, 1972
Late Bronze I, about 1600–1500 B.C.
Height, 12.1 cm. (4¾ in.); length, 53.5 cm. (21 1/16 in.)
Athens, National Museum, inv. 3266

Bibliography: S. Marinatos, *Excavations at Thera* VI (1974), colorplate 11, pl. 80, p. 33; *Paris Cat.* (1979), pp. 80–82, fig. 31.

The shape of this vase and its companion piece (37) is peculiar to Thera; in a general way, however, it recalls the tublike objects used in Crete and on the Mainland for both bathing and burials. Compared with the precise and delicate style of the offering table (35), the painting here is as bold in form as in color. The scene with goats recurs in a much coarser rendering on an oinochoe from Thera, now in the École Française d'Athènes (J.-J. Maffre, *BCH* 96 [1972], p. 37, fig. 23).

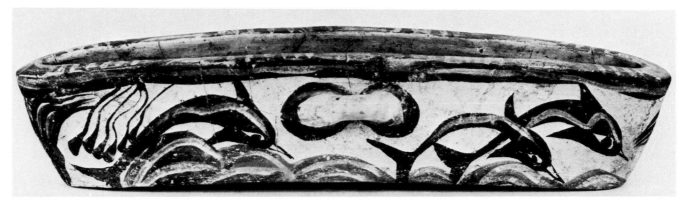

37

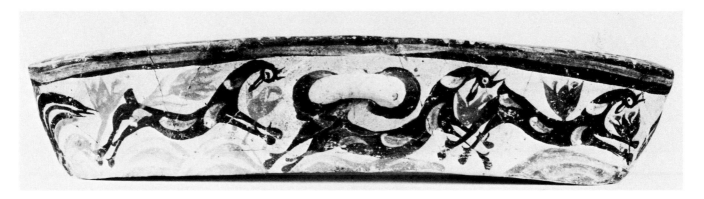

37 Terracotta vase with polychrome decoration

The vase is elliptical, with a handle at each side
but no distinct lip. On one of the long sides
are three quadrupeds in a setting of uneven
terrain and crocuses; on the other side three
dolphins leap over configurations identical to
those on the obverse, but here certainly
meant to indicate waves.

Found at Akrotiri on Thera, 1971
Late Bronze I, about 1600–1500 B.C.
Height, 11 cm. (4 ⁵/₁₆ in.); length, 49 cm.
(19 ⁵/₁₆ in.)
Athens, National Museum, inv. 3267

Bibliography: S. Marinatos, *AAA* 5 (1972), pp.
448–49, figs. 5, 6; *idem, Excavations at Thera* V
(1972), pls. 25, 102; *idem, Excavations at Thera* VI
(1974), colorplate 11, pl. 81, p. 33; *Paris Cat.*
(1979), pp. 81–82, fig. 32.

Despite slight differences in shape, a less densely
covered surface, and its discovery elsewhere on the
site, this vase is certainly the mate to the preceding
one (36) and possibly a work of the same painter.
More than the other, however, the present vase
also recalls the jug (28), for, in both cases, the fore-
part and the eye of the dolphin received the greatest
emphasis. *see colorplate page 32*

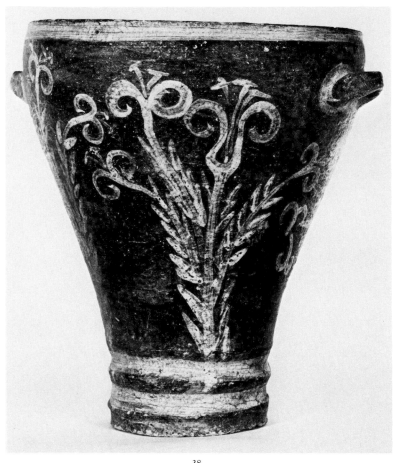

38

38 Terracotta flowerpot

The mouth of the vase is closed by a clay insert that is attached to the walls, open in the center, and pierced by a ring of sixteen smaller holes. On the outside of the vase are lilies painted in white on the brown clay. There are white lines around the lip, handle roots, and base.

Found at Akrotiri on Thera, 1970
Late Bronze I, about 1600–1500 B.C.
Height, 27 cm. (10⅝ in.)
Athens, National Museum, inv. 1280

Bibliography: S. Marinatos, *Excavations at Thera* IV (1971), pls. 83–84, p. 37; *idem* and M. Hirmer, *Kreta, Thera und das mykenische Hellas* (1973), fig. 161; *Paris Cat.* (1979), pp. 82–83, fig. 33.

The use of flowerpots on Thera is documented for us by frescoes showing vases, probably of stone but comparable in shape to this one, filled with lilies (Marinatos, *Thera* VI [1974], colorplate 3). The new evidence neatly confirms Sir Arthur Evans's speculation over fragments of flowerpots that came to light at Knossos (Evans, *The Palace of Minos* III [1930], pp. 277–79). The present vase is further distinguished by the way in which the artist interpreted the time-honored Minoan lily motif. He shows some of the flowers withered and falling, an astonishing conceit that Evans had hesitantly recognized on a fresco fragment from Knossos (*The Palace of Minos* I [1921], pl. VI, p. 537); floating lily flowers recur elsewhere at Akrotiri as well (*e.g.*, Marinatos, *Thera* II [1969], pl. 25).

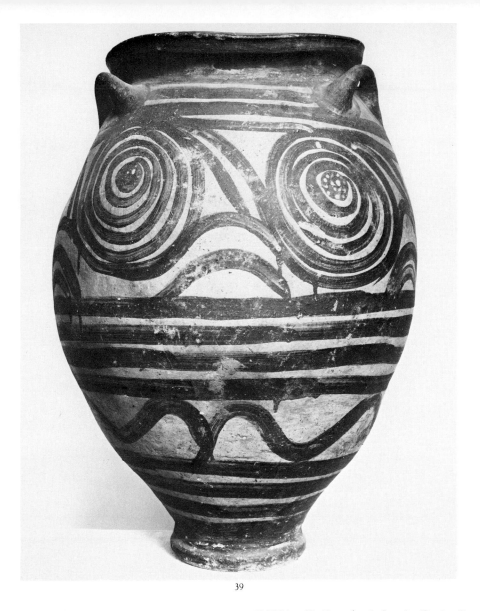

39

39 Terracotta storage jar

Horizontal stripes decorate the body at the top, below its broadest point, and at the bottom; in the main zone are linked running spirals.
Found on Thera, 1866
Late Bronze I, about 1600 – 1500 B.C.
Height, 78 cm. (30 ¹¹/₁₆ in.)
Musée du Louvre, inv. CA 296 (A 265; Bequest of Baron de Witte, 1890)

Bibliography: F. Lenormant, *AZ* 24 (1866), col. 258, ill. opp.; A. Furtwängler and G. Loeschcke, *Mykenische Vasen* (1886), p. 21, fig. 8; *Bulletin des Musées*, 1890, pp. 106 – 12; E. Pottier, *Vases antiques du Louvre* 1 (1897), p. 10; *idem*, CVA Louvre 1 (1922), II B, pl. 1,3 – 4; *Paris Cat.* (1979), pp. 69 – 70, fig. 20.

This storage jar was discovered by F. Lenormant (on whom see N. Oakeshott, in *Studies in Honor of A. D. Trendall* [1979], pp. 1 – 3); as a representative of the Académie des Inscriptions, he accompanied a French scientific team studying the eruption of the Thera volcano in 1866 (F. Fouqué, *Santorin et ses éruptions* [1879], p. 37). Artistically, the piece is average in the quality of its potting and decoration. Especially in the zone of large running spirals, it has counterparts in material from the new excavations at Thera (*e.g.*, S. Marinatos, *Thera* II [1969], pl. 34,a; *idem*, *Thera* IV [1971], pls. 65,a, 70,a).

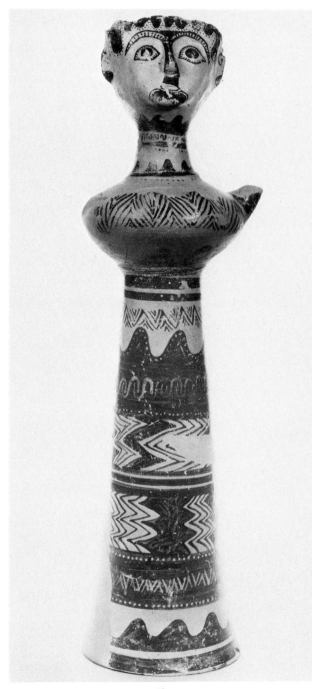

40

40 Terracotta statuette of a woman

The figure consists of a tall conical base sur-mounted by a squat, sharply convex form onto which are set the neck and head. The head is summarily modeled, provided with hair of added clay, and decorated with glaze. Arms were originally attached to the onion-shaped body and breasts are indicated in slight relief. The body and "skirt" are deco-rated with zigzags and wave motifs in glaze with patterns added in white.

Found at Phylakopi on Melos, 1977
Mycenaean, Late Helladic III,
about 1300 – 1100 B.C.
Height, 45 cm. (17¾ in.)
Melos, Archaeological Museum, inv. 653

Bibliography: H. Catling, *Archaeological Reports for 1977 – 1978* (1978), p. 54; G. Touchais, *BCH* 102 (1978), p. 741, fig. 205, p. 742; *Paris Cat.* (1979), pp. 94 – 95, fig. 42.

During the Late Bronze Age, distinctions in re-gional styles became blurred as the power of Mycenae extended eastward, imposing relatively greater artis-tic homogeneity as well. This point seems to emerge ever more clearly as new discoveries come to light. Besides the pieces from Keos (J. L. Caskey, *Hesperia* 33 [1964], pp. 328 ff., pls. 57 – 61), sculpture of any size from the end of the Mycenaean period was, until recently, virtually unknown. The present example is an important new discovery. Moreover, it may be compared with an equally remarkable terracotta from Mycenae (P. M. Fraser, *Archaeological Reports for 1968 – 1969* [1969], p. 12). In the context of this exhibition, the Melian statuette seems particularly significant as testimony to the vitality of an indige-nous sculptural tradition.

see colorplate page 33

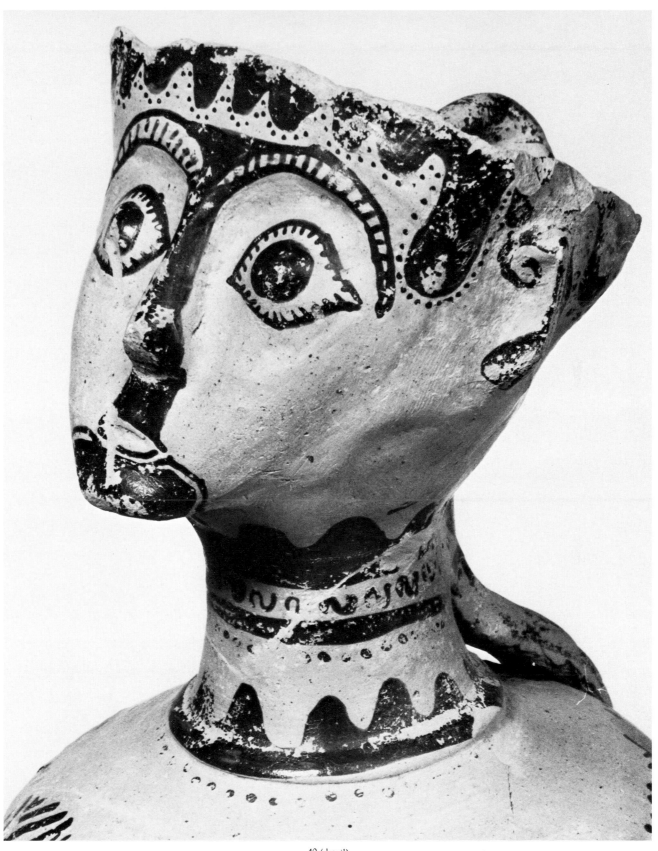

40 (detail)

ART OF
THE MYCENAEAN AGE
FROM CRETE AND RHODES

Nos. 41–56 Art of the Mycenaean Age from Crete and Rhodes

Throughout the period covered by this exhibition, close connections existed among the islands of the Aegean and also between them and the Greek mainland. Until the very end of the Middle Bronze Age, the Mainland saw the influx of new populations, the rise and fall of scattered towns, changing pottery styles, some external contacts especially with the Cyclades, but none of the rich creativity of the early Cyclades and Crete.

During the sixteenth century B.C., with the transition from the Middle to Late Bronze Age (known as "Helladic" in Greece), Greek influence manifests itself ever more strongly in Crete. Whether this presence was accompanied by the use of force, and how its effects relate to those of the Thera eruption are unclear. In any case, for about three centuries the Mycenaeans controlled Crete and the island's former trade network in the Aegean, Egypt, and the Levant. One of the most important centers in this network was Rhodes. Although little is known of Mycenaean settlements there, the cemeteries at the coastal sites of Ialysos and Kameiros have yielded quantities of pottery and other finds.

Compared to the concentrated, decisive blows dealt Minoan Crete, the decline of the Mycenaean empire — as a sphere of influence extending from Italy to Syria may be called — was a slow and uneven process, with major population movements playing a significant part. By the eleventh century B.C., the Bronze Age in the Greek world had come to an end.

41 Alabaster chalice
Found on Thera
Cretan, Middle Minoan III – Late Minoan I,
 about 1700 – 1500 B.C.
Height, 22 cm. (8 11/$_{16}$ in.)
Athens, National Museum, inv. 3964

Bibliography: N. Åberg, *Bronzezeitliche und früheisen-
zeitliche Chronologie* IV (1933), pp. 75 – 76, fig. 137;
C. Zervos, *L'Art des Cyclades* (1957), fig. 9; P. De-
margne, *The Birth of Greek Art* (1964), p. 46, fig. 53;
P. Warren, *Minoan Stone Vases* (1969), pp. 36 – 37;
E. Sapouna-Sakellarakis, *Die kykladische Sammlung im
National Museum von Athen* (1973), no. 21; *Paris Cat.*
(1979), p. 83, fig. 34.

The production of stone vases, by no means
limited to the Cyclades, flourished in Crete from early
Minoan times on, reaching a climax in the period c.
1800 – 1500 B.C. Made primarily for the great palaces
where, notably at Zakro, they have come to light in
appreciable number, the objects were exported to
surrounding islands and the Mainland as well. This
chalice from Thera is one of four from the island; the
others are of clay (L. Renoudin, *BCH* 46 [1922], p.
127, fig. 16; S. Marinatos, *Thera* V [1972], pl. 61b)
and of alabaster (*Thera* V, pls. 16 – 17, p. 32). The
latter is interesting for, like the present chalice, the
stem and the cufflike container were made separately
and joined. The material of the Athens example was
evidently imported from Egypt.

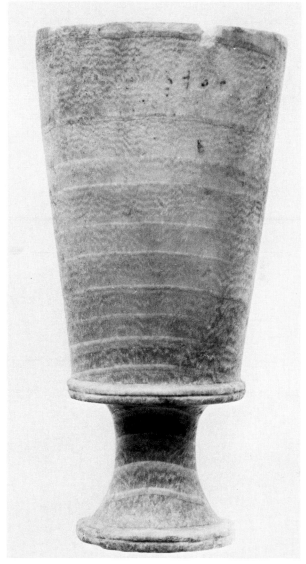

41

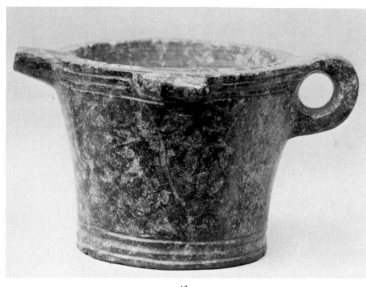

42

42 Serpentine bowl with spout and handle
Found on Crete, possibly at Pseira
Cretan, Middle Minoan III – Late Minoan I,
 about 1700 – 1500 B.C.
Height, 14.9 cm. (5⅞ in.)
The Metropolitan Museum of Art 26.31.430
 (Bequest of Richard B. Seager, 1926)

Bibliography: G. M. A. Richter, *Handbook of the Greek Collection* (1953), pl. 8d; P. Warren, *Minoan Stone Vases* (1969), p. 31.

This bowl represents a shape found primarily in eastern Crete. Despite its considerable weight, it probably served a utilitarian function, for the lugs at the rim, in addition to the handle, helped to make the vase more manageable. The piece belongs to the collection of small bronzes, stone vessels, and gems left to the Museum by Richard B. Seager. Together with Harriet Boyd Hawes (see **49**), Seager pioneered American archaeological investigations in eastern Crete, notably at the sites of Mochlos, Pseira, and Pachyammos (*AJA* 29 [1925], pp. 330 – 31).

43 Serpentine bowl
Perhaps found on Crete
Cretan, Late Minoan I, about 1600 – 1500 B.C.
Height, 10.8 cm. (4¼ in.)
The Metropolitan Museum of Art 26.31.433
 (Bequest of Richard B. Seager, 1926)

Bibliography: P. Warren, *Minoan Stone Vases* (1969), p. 17.

The blossom bowl, with a carination high on the body and petals carved around the exterior, is one of the most typical forms of later Minoan stone vase. It was widely exported, even as far east as Byblos and Troy; moreover, ceramic imitations of these stone bowls have now come to light on Kythera (J. N. Coldstream and G. L. Huxley, *Kythera* [1972], pp. 246, 255, 286).

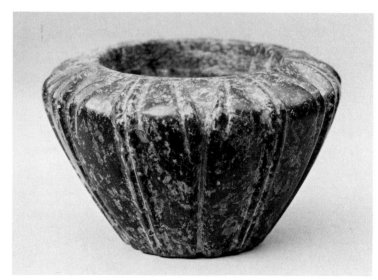

43

44

45

44 Red marble or jasper block with engraved roundels

Three animals, each within a circular frame, are carved into the block. On the topside are a kneeling goat and a kneeling bull; on the underside is a standing quadruped. In addition, there are incised circles and tool marks.

Found in the harbor town of Knossos on Crete

Cretan, Late Minoan II, about 1500 – 1400 B.C.

Maximum height, 8.5 cm. (3 ⅜ in.); maximum width, 6.5 cm. (2 ⁹/₁₆ in.)

The Metropolitan Museum of Art 26.31.392 (Bequest of Richard B. Seager, 1926)

Bibliography: A. Evans, *The Palace of Minos* II (1928), p. 237, fig. 134, p. 238; G. M. A. Richter, *Handbook of the Greek Collection* (1953), pl. 8i; V. E. G. Kenna, *Cretan Seals* (1960), p. 77, fig. 170; *idem, Corpus of Minoan and Mycenaean Seals: The Metropolitan Museum of Art* (1972), no. 262; H.-G. Buchholz and V. Karageorghis, *Prehistoric Greece and Cyprus* (1973), under no. 459.

From the circles and tool marks on its surface, this block certainly served as a trial piece. For the three animals cut in relief, three possibilities suggest themselves. They may have been an artist's preliminary designs, molds to make gems of glass paste, or forms over which to work sheet metal in repoussé. In any case, the block provides important information on Minoan stone-working practices for small-scale luxury objects, whether gems or jewelry. A similar object is in the Ashmolean Museum, Oxford (Kenna, *Cretan Seals*, p. 77).

45 Serpentine mold

Perhaps found on Crete

Cretan, Late Minoan, about 1600 – 1200 B.C.

Height, 3.1 cm. (1 ³/₁₆ in.); width, 4.5 cm. (1 ¾ in.)

The Metropolitan Museum of Art 26.31.393 (Bequest of Richard B. Seager, 1926)

Bibliography: G. M. A. Richter, *Handbook of the Greek Collection* (1953), pl. 9; J. Boardman, *The Cretan Collection in Oxford* (1961), p. 44, note 1.

The surface of the mold shows a circular and an elliptical depression for the casting of beads; a channel for introducing the hot liquid leads into each. Serpentine, and the related material steatite, whose use we have seen in the Cyclades (10), was greatly favored in Crete both because of its availability (see P. Warren, *Minoan Stone Vases* [1969], pp. 138 – 41) and the ease with which it could be worked.

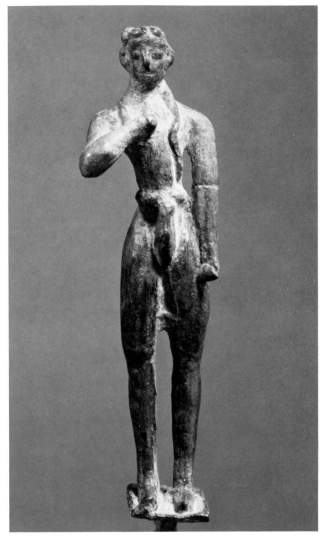

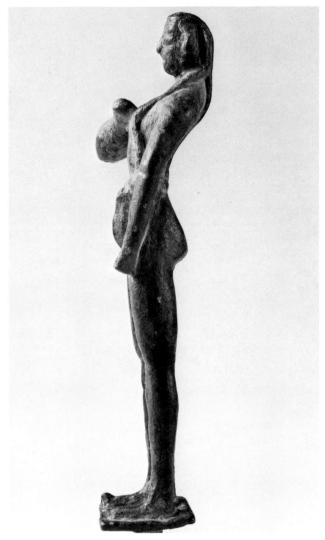

46

46 Bronze statuette of a votary
Provenance unknown
Cretan, Late Minoan I, about 1600 B.C.
Height, 19.8 cm. (7 13/16 in.)
The Metropolitan Museum of Art 1972.118.45
(Bequest of Walter C. Baker, 1972)

Bibliography: D. von Bothmer, *Greek, Etruscan, and Roman Antiquities . . . from the Collection of Walter Cummings Baker, Esq.* (1950), no. 1; G. M. A. Hanfmann, *Ancient Art in American Private Collections* (1954), no. 129; F. Eckstein, *Gnomon* 31 (1959), p. 640; D. von Bothmer, *Ancient Art from New York Private Collections* (1961), no. 97.

This bronze represents the type of Cretan figure with long hair, broad shoulders, and diminutive waist that left its mark on the fishermen (**23**) from Phylakopi. He wears the typical Cretan belt and loincloth (see S. Marinatos, *Kleidung, Haar- und Barttracht*, *Archaeologia Homerica* [1967], pp. 22 – 24; E. Sapouna-Sakellarakis, *Minoikon Zoma* [1971]), and holds one hand before his chest in an equally familiar gesture of devotion. Although bronze-working had already enjoyed a long history in Crete, fully three-dimensional figures of human beings and animals do not appear much before the Late Minoan period (R. Higgins, *The Greek Bronze Age* [1970], pp. 16 – 17).

47 Terracotta spouted jug

On the neck and shoulder is a tongue motif; on
the body are nautili among rocks, octopuses,
and marine flora.

From Lower Egypt (acquired by Dr. H. Abbott
in Egypt between 1843 and 1852)

Height, 22 cm. (8 11/16 in.); diameter, 25.3 cm.
(10 in.)

Cretan, Late Minoan I, about 1600 – 1500 B.C.

The Brooklyn Museum 37.13E (Charles Edwin
Wilbour Fund)

Bibliography: *Catalogue of a Collection of Egyptian
Antiquities, the Property of Henry Abbott M.D.* (1854),
p. 10, no. 77; A. S. Murray, AJA 6 (1890), pp.
437 – 44; G. Perrot and C. Chipiez, *Histoire de l'Art
dans l'Antiquité* 6 (1894), p. 869, fig. 436; R. Dussaud,
*Les civilisations préhelléniques dans le bassin de la mer
égée* (1914), p. 114, fig. 85; *Catalogue of the Egyptian
Antiquities of the New York Historical Society* (1915), p.
6, no. 78; C. R. Williams, *The New York Historical
Society: Catalogue of Egyptian Antiquities* (1924), p.
148; E. H. Dohan, *The New-York Historical Society
Quarterly Bulletin* 12 (1929), pp. 127 – 33; W. B.
Dinsmoor, *Proceedings of the American Philosophical
Society* 87 (1943), p. 103, fig. 23; H. Kantor, AJA 51
(1947), p. 36, pl. VII D; D. M. Robinson, AJA 54
(1950), p. 5, note 27; A. Furumark, *Opuscula Ar-
chaeologica* VI (1950), p. 211, fig. 19 B; F. H. Stub-
bings, *Mycenaean Pottery from the Levant* (1951), p.
58; *Brooklyn Museum Handbook* (1967), pp. 108 – 9;
B. V. Bothmer and J. L. Keith, *Brief Guide to the
Department of Ancient Art: The Brooklyn Museum*
(1970), pp. 7, 42 – 43; R. S. Merrillees, AJA 76
(1972), p. 284; *idem* and J. Winter, *Miscellanea Wil-
bouriana* I (1972), pp. 101 – 6; H.-G. Buchholz and
V. Karageorghis, *Prehistoric Greece and Cyprus*
(1973), no. 912.

Connections between Crete and Egypt existed
throughout the Bronze Age, as we know not only
from finds that can be readily identified as imports but
also from Egyptian tomb paintings and texts. Some of
the Minoan ceramic imports, like Middle Minoan
Kamares Ware or the present jug, may well have been
appreciated on aesthetic grounds; at least as impor-
tant, however, must have been their contents (see
Merrillees and Winter, *op. cit.*). The composition of

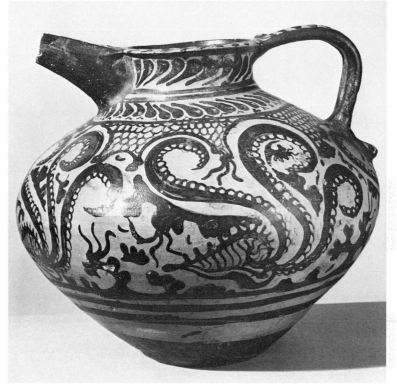

47

the marine scene here, as, for instance, on the Ak-
rotiri offering table (35), is framed above and below
by flora and other details that suggest a view from
above; the main forms, whether nautili or dolphins,
are shown from the side. Though not limited to mate-
rial from the site, this combination of viewpoints is a
recurrent feature of both the pottery and frescoes from
Thera. The Brooklyn vase finds a close counterpart in
a jug discovered on Pseira (R. B. Seager, *Excavations
on the Island of Pseira, Crete* [1910], p. 32, fig. 13). It is
also worth noting that the neck and shoulder orna-
ment of the jug(s) reappears on the following jar (48).

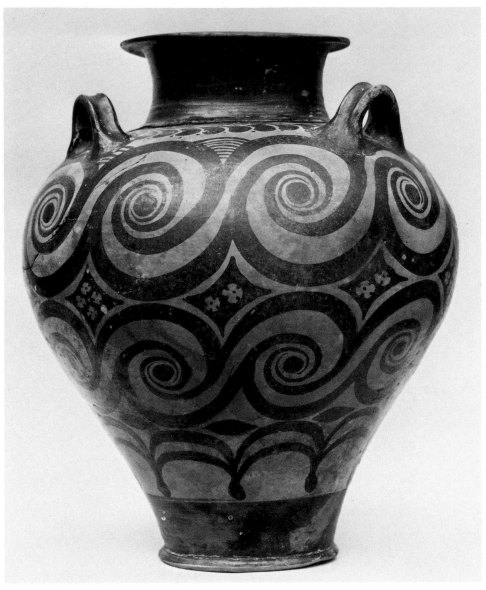

48

48 Terracotta jar with spiral decoration

The vase, with three handles that rise appreciably above the shoulder, has two bands of running spirals as its main decoration; in the interstices are quadrilaterals filled with reserved flowers. Around the neck is a thickened tongue motif; at the base of the body is an arcade pattern.

Found at Knossos on Crete
Cretan, Late Minoan I, about 1600 – 1500 B.C.
Height, 34.3 cm. (13½ in.)

The Metropolitan Museum of Art 22.139.76 (Rogers Fund, 1922; Ex coll. Heinrich Schliemann)

Bibliography: G. Karo, AM 34 (1909), p. 307; R. C. Bosanquet, in *The Unpublished Objects from the Palaikastro Excavations 1902 – 1906 (1923)* (BSA Suppl. Paper I), p. 44; G. M. A. Richter, BMMA 19 (1924), p. 97, fig. 1; *eadem, Handbook of the Classical Collection* (1927), p. 38; C. F. Binns and A. D. Fraser, AJA 33 (1929), p. 6; H. J. Kantor, AJA 51 (1947), p. 61, pl. XII, E; G. M. A. Richter, *Handbook of the Greek Collection* (1953), pl. 2f.

The Brooklyn jug (47) and the selection of pottery from Akrotiri (27–38) are outstanding examples of the floral and marine styles characteristic of the early Late Bronze period. This jar complements the pithos from Thera (39) in illustrating types of non-representational decoration as well as the frequency of spirals and other continuous motifs. Not only does the potting display greater control here, but the ornament is also carefully executed and adapted to its position on the vase; note, for instance, that the largest spirals are placed at the greatest diameter. Even here, however, the natural world appears, in the form of the floral fillers. The combination of motifs on the New York vase reappears on a jug found near Pylos on the Mainland (S. Marinatos and M. Hirmer, *Kreta, Thera und das mykenische Hellas* [1973], fig. 254 above) and, without the floral rhomboids, on several pieces from Zakro (N. Platon, *Zakros* [1971], pp. 108, 111, 114, 118).

49 Terracotta conical rhyton

The vase is divided into horizontal registers by glaze bands; the decoration of the two major and two minor zones consists of a zigzag pattern.

Found at Gournia on Crete
Cretan, Late Minoan I, about 1600 – 1500 B.C.
Height, 28.6 cm. (11¼ in.)
The Metropolitan Museum of Art 07.232.26 (Gift of the American Exploration Society, 1907)

Bibliography: H. B. Hawes, *Gournia* (1908), pl. 8,19; G. M. A. Richter, *BMMA* 7 (1912), p. 34.

Though much simpler, this rhyton is contemporary with the one from Thera (33) and a precursor of the attenuated example from Rhodes (53). It comes from Gournia, a site in eastern Crete that remains the only important town, as opposed to palace or villa, known from Minoan times. Gournia was excavated by Harriet Boyd Hawes between 1901 and 1904, under the auspices of the American Exploration Society of Philadelphia (see K. Page, *Archaeology* 31, 2 [1978], pp. 4–11; J. S. Soles, *AJA* 83 [1979], pp. 149–67). The government in Crete at the time gave a share of finds to the Society, that in turn made a portion available to the Metropolitan Museum.

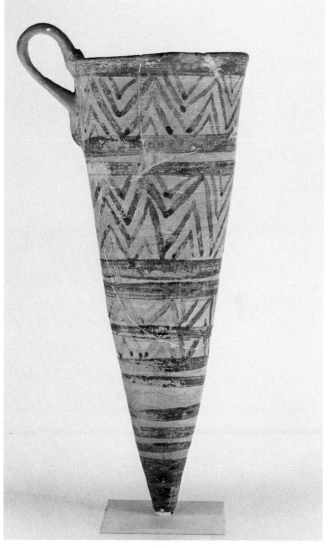

49

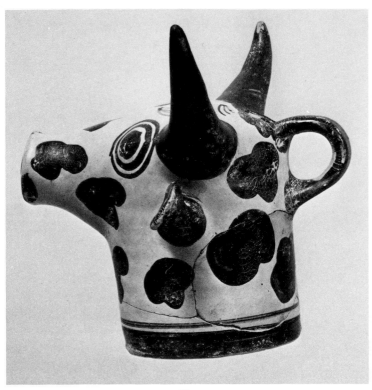

50

50 Terracotta rhyton

The vase, in the form of a bull's head, is articulated with ears and horns in relief as well as glaze strokes indicating the forelock and dark markings on the hide. There is a handle at the back of the head.

Said to be from Attica

Probably Cretan, Late Minoan III,
about 1400 – 1200 B.C.

Height, 9.5 cm. (3¾ in.); width, 13.9 cm. (5½ in.)

The Metropolitan Museum of Art 1973.35 (Gift of Alastair B. Martin, 1973)

Bibliography: D. von Bothmer, *Ancient Art in New York Private Collections* (1961), no. 98; *The Metropolitan Museum of Art: Notable Acquisitions 1965 – 1975* (1975), p. 129.

While the lion-head rhyton from Akrotiri (34) suggests an attempt to evoke more precious equivalents, notably of metal, this rhyton is straightforwardly ceramic. It was made on the wheel, at least in part, has a form of handle usually found on cup shapes, and is decorated in a standard glaze technique. It is impossible to establish whether the piece is Mycenaean or Minoan, a distinction that, in any case, becomes difficult to maintain for the period after the Greeks had acquired control of the island. Nonetheless, in view of the consistent importance of the bull in Cretan art, a point that has recently been reemphasized (E. Davis, *The Vapheio Cups and Aegean Gold and Silver Ware* [1977], p. 182), and in view of the evidence for ceramic Cretan bull rhyta (see Bothmer, *op. cit.*), it seems justifiable to associate this piece with the Minoan tradition.

51 Terracotta sarcophagus

The sloping lid is decorated with stylized shell forms placed in the angles of a latticework of oblique lines. On one short end are "horns of consecration" and a double ax; on the other end are three stylized goats. The box of the sarcophagus is rectangular and stands on four feet. In the center of the long side is a scene consisting of three large quadrupeds each with a smaller one, two birds, and three human figures. One figure appears within a wicket-like frame, of which there are two more at the left. The pointed forms on the backs of two of the quadrupeds suggest that the scene depicts a hunt. On the other long side are two zones of ornament: above, "horns of consecration" and double axes over a chain of lozenges; below, running spirals and hatched triangles. On the short sides are papyrus plants.

Found in tomb 11 at Armeni, near Rethymnon, on Crete

Cretan, Late Minoan III,
about 1400 – 1200 B.C.

Height, 95 cm. (37⁷/₁₆ in.); width, 94 cm. (37 in.)

Chania, Museum, inv. 1707

Bibliography: J. Tzedakis, *AAA* 4 (1971), p. 217, fig. 4; J.-P. Michaud, *BCH* 96 (1972), pp. 805, 811, fig. 510; C. Long, *The Ayia Triadha Sarcophagus* (1974), p. 36, pl. 16, fig. 40; *Paris Cat.* (1979), pp. 90 – 91, fig. 39.

Until the end of the Bronze Age in Crete, inhumation rather than cremation was the standard method of burial. The deceased were placed in large or small household pottery jars, in tubs also used for washing, or in lidded chests that were specifically made to serve a funerary purpose and that often suggest a wooden prototype. Best known from Late Bronze Age examples, the chests tend to be decorated, some in a ceramic technique of glaze on clay, others in various colors on a plaster surface. The most famous of the latter type is the Haghia Triada sarcophagus (see Long, *op. cit.*). The present piece from Armeni well represents the alternative. While vessels of an ostensibly ritual nature do not always reflect their function in their decoration (*e.g.*, **33**, **35**, **49**), processions, or scenes of ceremonial and mourning frequently occur on the sarcophagi.

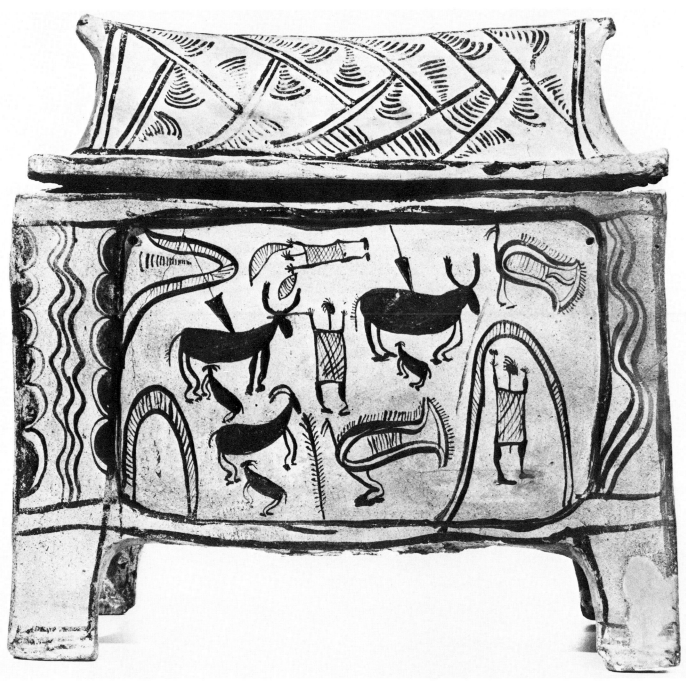

51

52 Terracotta pyxis

The cover is missing. Four handles, alternately horizontal and vertical, subdivide the surface of the box. Ornamental bands of varying widths separate the two scenes. One shows, at the left, two "horns of consecration," one above the other, each with a double ax placed upright, within. A large seven-stringed lyre stands next to a figure whose arms are raised but whose body below the shoulders is hidden, probably by a garment. The figure seems to hold the lyre with his right hand and to carry a branch in his left. Above, two birds fly downward. In the other panel, a large bird with wings outstretched seems suspended in mid-air; below, two birds stand and look upward. Projecting from the upper and left frame and, in one case, floating, are the heads of three birds similar to the others.

Found at Chania on Crete, 1969

Cretan, Late Minoan III,
 about 1300 – 1150 B.C.

Height, 13.9 cm. (5½ in.); diameter at base,
 16.5 cm. (6½ in.)

Chania, Museum, inv. 2308

Bibliography: J. Tzedakis, *AAA* 2 (1969), p. 365, fig. 2; *idem, ibid.* 3 (1970), p. 111, figs. 1 – 2; J.-P. Michaud, *BCH* 94 (1970), p. 1159, figs. 591 – 592; S. Marinatos and M. Hirmer, *Kreta, Thera und das*

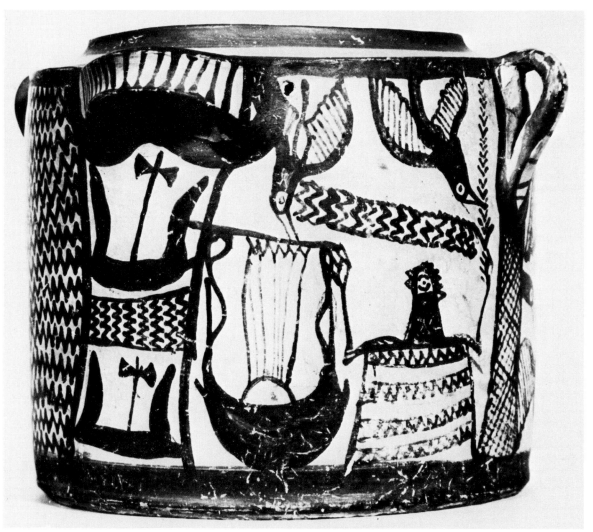

52

mykenische Hellas (1973), pl. 128 below; C. Long, *The Ayia Triadha Sarcophagus* (1974), p. 38, pl. 18, fig. 48; *Paris Cat.* (1979), pp. 91—93, fig. 40.

The decoration on this pyxis points both forward and backward. Motifs like the "horns of consecration," double ax, and birds come directly out of Minoan iconography. Moreover, there is evidence from Crete—and in a famous fresco from Pylos on the Mainland (M. L. Lang, *The Palace of Nestor at Pylos* II [1969], pp. 79—80)—for the association of musician and bird. On the other hand, the prefiguration of an Orpheus or Apollo figure and the elementary but graphic style of representation look forward to Greek Geometric and Early Orientalizing art.

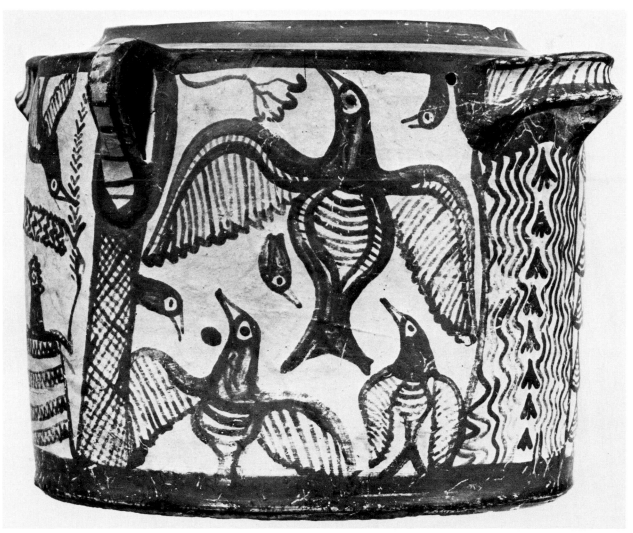

52

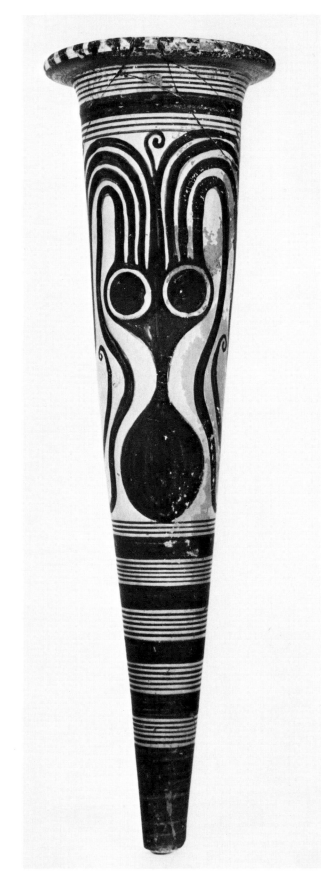

53

53 Terracotta conical rhyton

The main zone, framed by horizontal bands and groups of glaze lines, shows an octopus.

Found during the excavations of Salzmann at Kameiros on Rhodes

Mycenaean, Late Helladic III, about 1400 – 1200 B.C.

Height, 38 cm. (14 $^{15}/_{16}$ in.); diameter, 11 cm. (4 $^{5}/_{16}$ in.)

Musée du Louvre, inv. MNB 1743 (A 276; purchase, 1879; Ex coll. Parent)

Bibliography: A. Furtwängler and G. Loeschcke, *Mykenische Vasen* (1886), pl. 11,71, pp. 17 – 18; A. Baumeister, *Denkmäler des klassischen Altertums 3* (1889), p. 1941, fig. 2062, p. 1938; G. Perrot and C. Chipiez, *Histoire de l'Art dans l'Antiquité 6* (1894), p. 919, fig. 473; E. Pottier, *Vases antiques du Louvre 1* (1897), p. 11; A. D. Lacy, *Greek Pottery in the Bronze Age* (1967), p. 200, fig. 78b; *Paris Cat.* (1979), p. 88, fig. 35.

One of the most fundamental differences between Minoan and Mycenaean art is a predilection in the former for naturalistic forms, rather free composition, and movement—whether implied or expressed. In Mycenaean art, form and composition tend to be more rigid and systematized. Though this rhyton dates to the period when Mycenaean art was, itself, beginning to decline, the long slender shape of the rhyton and highly stylized octopus illustrate the point to an exaggerated degree. The octopus and the tradition from which it stems remain recognizable—which is not the case later; the rendering, however, with its disconcertingly large eyes, suggests the absence of any direct observation.

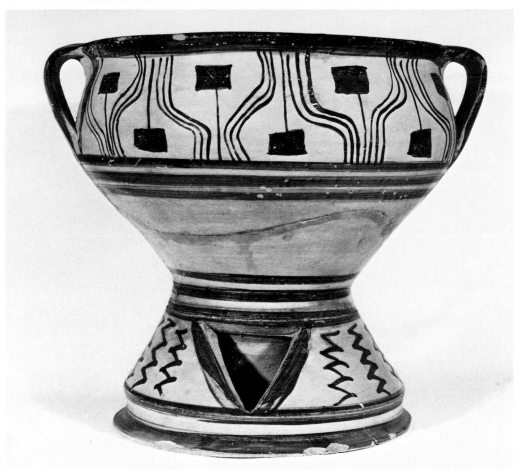

54

54 Terracotta krater

The vase and stand form one piece. In the handle zone are a series of ogival configurations composed of three roughly parallel lines. Within each ogee is a black quadrilateral hanging from a line and, between ogees, the same motif set upright. Glaze lines appear at the widest part of the body; the lip and handles are black. Above its profiled base the foot has three cut-out triangles with vertical zigzags in between. There are glaze lines between the bowl and base, outlining the cut-outs, and on the base.

Found on Rhodes

Mycenaean, Late Helladic III,
 about 1400 – 1300 B.C.

Height, 26 cm. (10 ¼ in.); width, 30 cm. (11 ¹³/₁₆ in.)

Musée du Louvre, inv. AM 1121 (Gift of M. Arapides, 1902)

Bibliography: *Paris Cat.* (1979), pp. 88 – 89, fig. 36.

Besides Crete, which because of its Minoan history occupies a special position, Rhodes was perhaps the most important Mycenaean outpost in the Aegean. By virtue of its location, it was a center for trade with Asia Minor, Cyprus, and the Levant. The Mycenaean presence on the island is documented by a wealth of finds, mostly from tombs at Ialysos and Kameiros. This krater represents a very rare shape, paralleled by another from Rhodes now in Copenhagen (inv. 5786: CVA, pl. 62,2). Vessels of bronze or clay, for instance, without a suitable foot, were placed in stands; the Louvre and Copenhagen examples are literal translations of this arrangement, although the two parts have been joined, for the bottom of the bowl continues into the stand. Whether the "square-and-shaft" motif represents a degeneration of another form, or a decorative invention in its own right, is unclear.

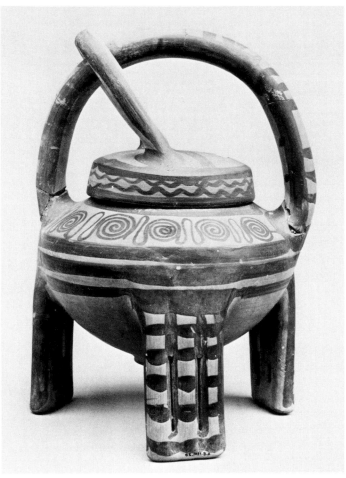

55

55 Terracotta basket vase

The bowl, with a carination high on the body, stands on three legs and has a tall overarching handle. There are linked spirals on the shoulder, glaze lines on the legs and handle. The lid has a handle of its own that loops around that of the bowl so that the two parts cannot become separated. Around the side of the lid are wavy lines.

Found on Rhodes
Mycenaean, Late Helladic III,
 about 1400 – 1200 B.C.
Height, 27 cm. (10 ⅝ in.)
The Metropolitan Museum of Art 06.1021.3
 (Rogers Fund, 1906)

Bibliography: *Collection E. G. Cat. Vente Hôtel Drouot, 19 – 20 mai 1904*, p. 8, no. 47, pl. 2; A. Sambon, *Collection Canessa* (1904), p. 5, no. 2, pl. 1; G. M. A. Richter, *Handbook of the Greek Collection* (1953), pl. 3h.

The so-called basket vase is a special shape that appears in Late Helladic III and seems to have been favored on the Mainland and on Rhodes. It is striking that lidded vessels occur rarely in the Mycenaean repertoire (cf. A. Furumark, *The Mycenaean Pottery* [1941], p. 78). This small class, however, presents an ingenious solution to the problem of keeping a container and its cover together. The model may well have been in basketry, and it finds a few rare successors in Greek art (*e.g.*, The Metropolitan Museum of Art, 68.11.18).

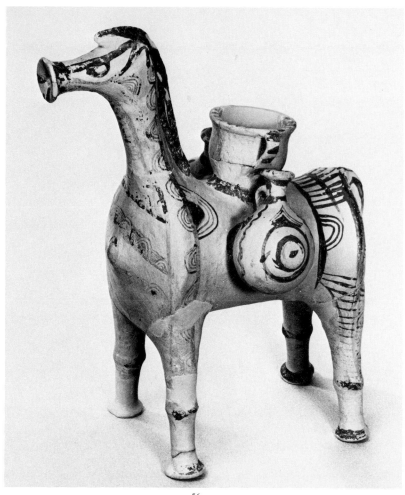

56

56 Terracotta vase in the form of a mule or donkey

From the shape of the muzzle and the stripes on the legs the animal is more probably a mule or donkey than a horse. There is a miniature krater on its back, and a miniature flask to either side. The forelock, mane, and harness of the animal are indicated in glaze; various ornamental patterns incorporating wavy lines and concentric circles decorate the body.

Found at Ialysos on Rhodes
Mycenaean, Late Helladic III,
 about 1300 – 1100 B.C.
Height, 25 cm. (9 13/16 in.); length, 18 cm.
 (7 1/16 in.)
Rhodes, Museum, inv. 12727

Bibliography: G. Jacopi, *Annuario* 13/14 (1930 – 31), p. 295, fig. 39, pl. 22; E. Vermeule, *Greece in the Bronze Age* (1964), pl. 42A; R. A. Higgins, *Greek Terracottas* (1967), pl. 5B, p. 13; J. L. Benson, *AJA* 72 (1968), p. 206, pl. 66,4; H.-G. Buchholz and V. Karageorghis, *Prehistoric Greece and Cyprus* (1973), fig. 1266; *Paris Cat.* (1979), pp. 93 – 94, fig. 41.

This figure is unusual among Mycenaean terracottas on account of its fully three-dimensional form and considerable detail. However "unreal" the ornament may be, the piece illustrates the vitality and spontaneity that almost invariably accompanies a subject that an artist knows well. The three vases on the animal's back are faithful reductions of contemporary shapes.

THE GEOMETRIC PERIOD

Nos. 57–65 The Geometric Period

Following the decline of Late Bronze Age art in Greece, a new style slowly developed that takes its name from the geometrical ornaments (circle, triangle, rectilinear patterns, straight or wavy lines) all austere and highly disciplined. The main manifestations of Geometric art are pottery, small bronze sculptures, terracotta statuettes, and gold jewelry. The style seems to have originated on the Greek mainland, chiefly in Attica and in the Peloponnese, whence it spread across the Aegean to the Greek foundations in Anatolia, to the island of Cyprus, and beyond. Similarly, in the West, the Geometric Style spread to Southern Italy, Sicily, and Etruria.

The many different local styles are slowly being isolated and recognized, but some attributions (cf. **63**) continue to pose vexing problems.

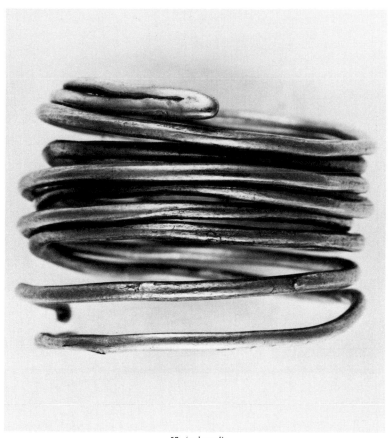

57 (enlarged)

57 Gold spiral

Found on Amorgos
Geometric period, about 800 B.C.
Height, 2.3 cm. (⅞ in.); diameter, 1.6 cm.
(⅝ in.)
Athens, Benaki Museum, inv. 2052

Bibliography: B. Segall, *Katalog der Goldschmiede-Arbeiten Museum Benaki* (1938), pp. 212–13, suppl. 3; L. Marangou, *BCH* 99 (1975), p. 373, fig. 15; *Paris Cat.* (1979), p. 100, fig. 43.

While spirals often are found in sub-Mycenaean and Early Geometric tombs (cf. *AA* [1934], col. 91), this spiral is of a rarer construction. Gold wire about 1 mm. thick was doubled up, and the twin strands were then turned into a spiral. In Greece this technique occurs first at Tiryns (*AM* 55 [1930], pp. 127 ff., Beilage 30a) and as late as the Isis tomb at Eleusis (cf. R. S. Young, *Hesperia*, Suppl. 2 [1939], pp. 234–36). The latter has been dated by comparison with the jewelry found in a Late Geometric tomb in Spata (Attica; *Arch. Deltion* 6 [1920–21], p. 136, fig. 10), but the dates are not certain.

Spirals are at times found near the ear in undisturbed tombs (*e.g.*, *AM* 51 [1926], p. 137), and it can therefore be argued that they were worn in the hair (cf. Marangou, *op. cit.*, p. 372, note 19).

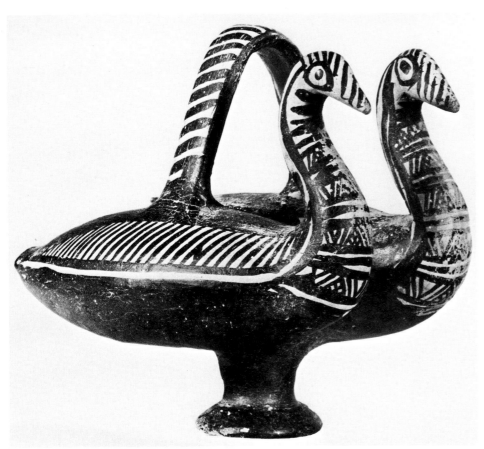

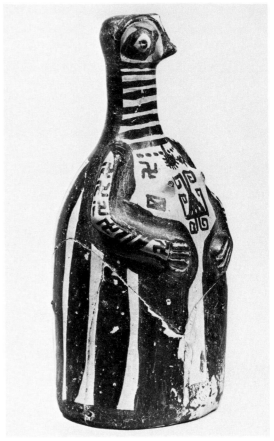

58

59

58 Terracotta vase in the shape of two ducks
Found in a tomb at Seraya on Kos
Middle Geometric period, early
 8th century B.C.
Height, 15.5 cm. (6⅛ in.); length, 14.6 cm.
 (5¾ in.)
Kos, Museum

Bibliography: J. N. Coldstream, *Greek Geometric Pottery* (1968), pp. 267, 269, 339; C. Zervos, *La civilisation hellénique* (1969), p. 93; *Paris Cat.* (1979), p. 100, fig. 44.

The sparse decoration is limited to the heads, necks, breasts, and wings of the ducks and to the bail handle connecting the two bodies. The two ducks share a conical base that was turned on the wheel. An earlier duck vase from Vizikia near Kameiros on Rhodes (CVA Karlsruhe 2 [1952], pl. 46,4) has, instead, three stubby feet. A third duck vase, from Massari-Mallona on Rhodes (CVA Copenhagen 2 [1927], pl. 65,8) is even more abstract. Coldstream sees Attic influences in the decoration and Cypriot borrowings in the shape.

59 Terracotta statuette of a woman
Found at Seraya on Kos, between 1935 and
 1943
Late Geometric, about 720 – 710 B.C.
Height, 15.5 cm. (6⅛ in.)
Kos, Museum

Bibliography: L. Morricone, *Bd'A* 35 (1950), p. 320, fig. 93; C. Zervos, *La civilisation hellénique* 1 (1969), pl. 142; *Paris Cat.* (1979), pp. 100 – 101, fig. 45.

This much-simplified rendition of a standing woman has a small head, a long neck, and a bell-shaped body hugged by her arms. The breasts are relatively small. The black glaze is applied quite effectively: solidly for most of the mantle, and in patterns

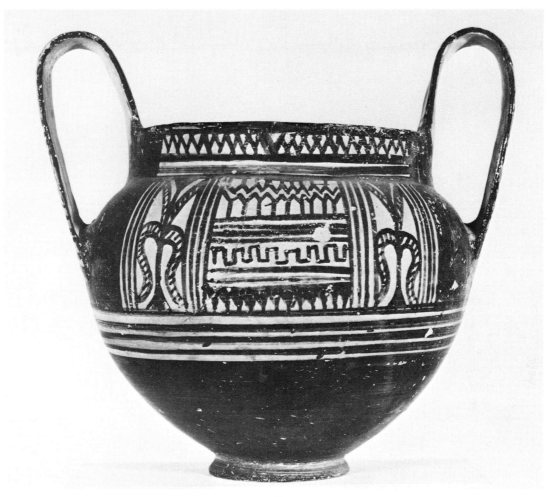

60

on the neck and arms. The chest is decorated with a necklace and pendant and has other ornamental designs, as do the wrists. The statuette was found in tomb number 14 (of a child) and may have been a toy rather than a cult object.

60 Terracotta kantharos

Found at Kameiros on Rhodes, 1864
Late Geometric, about 740 B.C.
Height, 18.7 cm. (7⅜ in.); width, 16.8 cm. (6⅝ in.)
Musée du Louvre, inv. N III 2370 (A 288; purchase, 1864)

Bibliography: E. Pottier, *Vases antiques du Louvre 1* (1897), p. 11, pl. 11, no. A 288; C. Dugas, *BCH 36* (1912), p. 500, no. 24, fig. 6; S. Zervos, *Rhodes* (1920), fig. 143; J. N. Coldstream, *Greek Geometric Pottery* (1968), p. 285, no. 3; B. Schweitzer, *Geometrische Kunst Griechenlands* (1969), p. 90, pl. 92; A. Kauffmann-Samaras, *CVA Louvre 18* (1976), pl. 36; *Paris Cat.* (1979), p. 101, fig. 46.

The stylized palm trees that flank the central panel on this kantharos are clearly borrowed from Near Eastern ivories. They are close to similar palm trees on a Rhodian krater in Berlin (V.I. 2941: A. Furtwängler, *JdI* 1 [1886], pp. 135–36; N. Kunisch, *CVA Berlin 4* [1971], p. 16, pl. 154), which Furtwängler (*JdI, loc. cit.*) had already associated with the Louvre kantharos. On the kantharos, however, the leaves have disappeared from the trunks, which Coldstream (*op. cit.*) takes to be an indication of a later date.

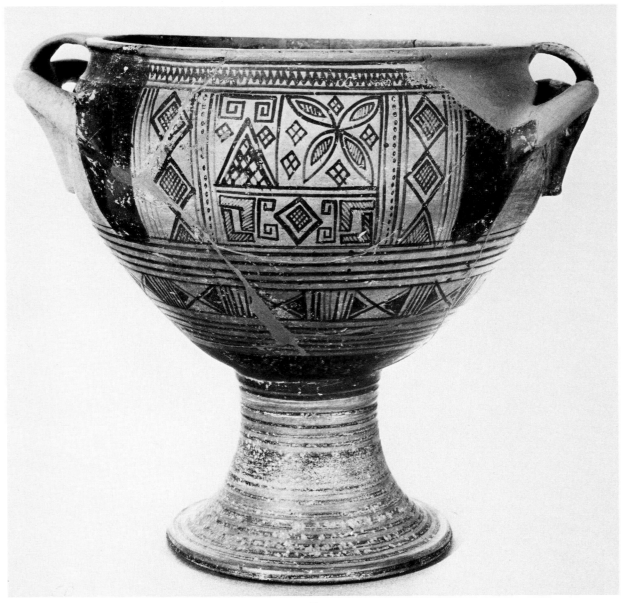

61

61 Terracotta krater

Found at Myrina in Anatolia, 1880–82
Late Geometric (Rhodian), about 725 B.C.
Height, 37.7 cm. (14⅞ in.); diameter, 34.5–
36 cm. (13⁹/₁₆–14³/₁₆ in.); width, 41 cm.
(16⅛ in.)
École Française d'Athènes, inv. V. 67

Bibliography: C. Dugas, *BCH* 36 (1912), pp. 507–
10, no. 36, pls. 9–10; J. N. Coldstream, *Greek
Geometric Pottery* (1968), p. 277, no. 14, p. 282, no.
4; J.-J. Maffre, *BCH* 96 (1972), pp. 38–40,
figs. 25–27; *Paris Cat.* (1979), p. 102, fig. 47.

Shape, clay, glaze, and system of decoration
confirm the attribution of this vase to a Rhodian
workshop. The central panel on the shoulder differs
on the two sides of the krater, that on the obverse
being more ambitious. The "metopal" system of deco-
ration is also found on other shapes, notably on
kotylai. Coldstream (*op. cit.*) has attributed this kra-
ter to his Bird-kotyle Workshop, in its first phase;
vases from this workshop were widely exported. The
shape of the krater, with its distinct pedestal foot, is
descended from Middle Geometric imitations of
Attic models, and survived in the East longer than in
Attica.

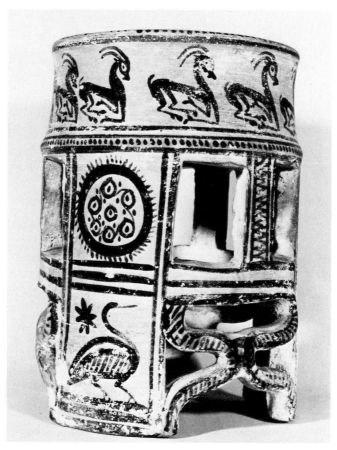

62

62 Terracotta tripod stand

Provenance unknown
Late Geometric (Melian),
 about 730 – 720(?) B.C.
Height, 20 cm. (7 ⅞ in.); diameter, 13 cm.
 (5 ⅛ in.)
Musée du Louvre, inv. Cp 20 (A 491)

Bibliography: A. Conze, *Sitzungsberichte der Kaiser-lichen Akademie der Wissenschaften, Wien* 64,1 (1870), p. 515, pl. 8; E. Pottier, *Vases antiques du Louvre* 1 (1897), p. 22, pl. 19; P. Amandry, *Journal of Near Eastern Studies* (1965), p. 175, no. 28; J. N. Coldstream, *Greek Geometric Pottery* (1968), p. 182, (i) no. 3, pl. 39d; A. Kauffmann-Samaras, *CVA Louvre* 18 (1976), pl. 43,4; *Paris Cat.* (1979), pp. 102–3, fig. 48.

The fenestrated stand is a characteristic shape in Melian Geometric pottery. Here, the feet of the tripod are reinforced by curvilinear X-shaped wedges that span the intervals between them. The upper zone, which goes all around the vase, shows kneeling goats, perhaps derived from Attica; their eyes are reserved. Attic by origin, too, are the "sun bursts" on the upper metopes. Coldstream (*op. cit.*) has attributed the tripod stand to his Rottier Painter (named after the Dutch colonel whose collection, presented in 1826 to the museum in Leyden, included two vases by this painter).

The Campana inventory number must be a mistake, for Conze saw this vase exhibited in the *Louvre* in 1862, before the Campana Collection was transferred from the *Palais de l'Industrie* (the so-called Musée Napoléon III) in the winter of 1862/1863. Hence, the alleged Etruscan provenance can be ignored.

63

63 Terracotta krater with cover surmounted by a small hydria

Found at Kourion on Cyprus, before 1876
Euboean or Cycladic Geometric,
 about 750 – 740 B.C.
Height, with lid, 114.9 cm. (45 ¼ in.)
The Metropolitan Museum of Art 74.51.965 (The Cesnola Collection, purchased by subscription, 1874 – 76)

Bibliography: L. P. di Cesnola, *Cyprus* (1877), pp. 332 – 33, 407, pl. 29; *idem, Atlas* 2 (1894), pls. 104 – 105, nos. 855 – 856; G. Perrot and C. Chipiez, *Histoire de l'Art dans l'Antiquité* 3 (1885), pp. 702 – 4, fig. 514; B. Graef, AM 21 (1896), pp. 448 – 49; A. Hoeber, *The Treasures of the Metropolitan Museum of Art* (1899), p. 39; A. Furtwängler, *Sitzungsberichte der philos.-philol. und der histor. Klasse der Kgl. Bayer. Akademie der Wissenschaften* (1905), p. 279; J. L. Myres, *Handbook of the Cesnola Collection of Antiquities from Cyprus* (1914), pp. 286 – 87, no. 1701; H. R. W. Smith, AJA 39 (1935), p. 415; C. Alexander, *Early Greek Art* (1939), fig. 14; R. S. Young, *Hesperia,* Suppl. 2 (1939), pp. 85, 97, 196, note 1; N. Kontoleon, *Eph. Arch.* 1945 – 1947 (1949), p. 11, fig. 4; G. M. A. Richter, *Handbook of the Greek Collection* (1953), p. 25, note 14, pl. 14c; T. Kraus, AM 69 – 70 (1954 – 55), p. 120, note 82; P. E. Arias, M. Hirmer, B. Shefton, *A History of 1000 Years of Greek Vase Painting* (1961), p. 278, pl. 24; J. N. Coldstream, *Greek Geometric Pottery* (1968), pp. 172 – 74, pl. 35; *idem, Institute of Classical Studies (University of London) Bulletin* 18 (1971), pp. 1 – 15, pl. 1a; W.-H. Schuchhardt, *Geschichte der griechischen Kunst* (1971), p. 72, fig. 45; B. Schweitzer, *Greek Geometric Art* (1971), p. 69, fig. 82; E. Walter-Karydi, AA (1972), pp. 402 – 16, figs. 30 – 32; P. P. Kahane, AK 16 (1973), pp. 114 ff., pls. 25 – 26; P. Hommel, *Festschrift für Gerhard Kleiner* (1976), p. 18, note 17, p. 20, note 20; J. N. Coldstream, *Geometric Greece* (1977), p. 192, pl. 61c.

This truly monumental vase has undergone many changes of labels. A. S. Murray (*apud* Cesnola, *Cyprus*, p. 407) calls it an Athenian import and Myres (*op. cit.*) speaks of the characteristic "Dipylon" (*i.e.* Attic) form—which can no longer be maintained. In 1939 (Alexander, *op. cit.*) it was still published as Attic Geometric, though as long ago as 1905 Furtwängler (*op. cit.*) had linked the krater with a Geometric oinochoe, likewise from the Cesnola Collection (74.51.838: Myres, *op. cit.*, pp. 286, 288, no. 1702), and declared both to be "certainly not Attic of the Dipylon class." Furtwängler had thought of a connection with Corinthian Geometric; Myres suggested the Argolid for the oinochoe because of the clay. Yet, C. Dugas (*Délos* 15 [1934], p. 85, note 5) clung to an Attic attribution, and Smith's strong plea against this (*op. cit.*) went largely unheeded (cf. Young, *op. cit.*, p. 97, especially p. 196, note 1). Later, however, Kontoleon (*op. cit.*) proposed a Cycladic workshop, and Coldstream (*Greek Geometric Pottery* [1968], p. 172) accepted Kontoleon's nucleus and made the "Cesnola Painter"—as he calls the painter of this vase—the chief artist of a Naxian Geometric school. A new find from Chalkis on Euboea, and its publication by P. G. Themelis (*AAA* 2,1 [1969], pp. 27 – 29, figs. 6 – 7), however, provided such strong pictorial and technical parallels that Coldstream felt compelled to move the Cesnola Painter and his workshop from Naxos to the island of Euboea, a move beautifully argued and supported in his article "The Cesnola Painter: a Change of Address" (*Institute of Classical Studies* [*University of London*], *Bulletin* 18 [1971], pp. 1 ff.). Here, for the moment, the Cesnola Painter would seem to have come to rest, after long cyclical peregrinations, but Mrs. Walter-Karydi (*op. cit.*) has countered Coldstream's new evidence for Euboea with new material from Naxos, and it is hard to decide from a distance whose arguments are weightier.

Overshadowed by the difficulties of localizing the origin of the Cesnola krater, its subject matter has not always received the attention it deserves. The decoration has, nonetheless, been fully explored by Kahane (*op. cit.*), who has not only examined each iconographic detail—the goats, or stags, nibbling at the tree, the horses, the aquatic birds, and the double axes—but has also dealt with each motif in the larger context of Geometric art and its Near Eastern connections.

64

65

64 Terracotta amphora

Said to be from Boeotia(?)
Late Geometric, about 700 B.C.
Height, 64.5 cm. (25 ⅝ in.); diameter, 36 cm.
(14 ⅜ in.)
Athens, National Museum, inv. 895

Bibliography: S. Wide, *JdI* 12 (1897), p. 196; *idem*, *ibid.* 14 (1899), pp. 79–80, fig. 32; M. Collignon and L. Couve, *Catalogue des vases peints du Musée National d'Athènes* (1902), p. 47, no. 211; H. Dragendorff, *Thera* 2 (1903), pp. 199–200, fig. 398; I. Strøm, *Acta Archaeologica* 33 (1962), p. 225, fig. 2; J. N. Coldstream, *Greek Geometric Pottery* (1968), p. 179, note 6; *Paris Cat.* (1979), pp. 105–6, fig. 52.

The provenance of this amphora—formerly given (by Wide, *op. cit.*, and Collignon and Couve, *op. cit.*) as Boeotia—has been doubted, and even when the provenances of vases of this class are known, they have not been of much help in localizing its workshop. Chronologically, this amphora straddles the Late Geometric and Early Orientalizing periods of the Cyclades, and there is less of a stylistic and chronological break in this part of the Greek world than elsewhere. The alternation of vertical lines—here, on the neck and in the frames of the metopes on the shoulder—with horizontal lines on the belly continues well into the first quarter of the seventh century B.C. This emphasis on linear patterns has prompted the title "Linear Island Style" for these vases (H. Payne, *JHS* 46 [1926], pp. 204–8).

65 Terracotta amphora

Found in the necropolis of Messavouno on
Thera, 1902

Late Geometric, about 700 B.C.
Height, 42 cm. (16⁹/₁₆ in.); diameter, 36 cm.
(14³/₁₆ in.)
Thera, Museum, inv. 788

Bibliography: E. Pfuhl, AM 28 (1903), p. 184, no. J3, Beilage 27,1; *Paris Cat.* (1979), p. 106, fig. 53.

Unlike the previous amphora (**64**), this one does not have a fenestrated foot. The central metope is decorated with a bird flanked on each side by an hourglass pattern.

ORIENTALIZING STYLES OF THE CYCLADES

Nos. 66–76 Orientalizing Styles of the Cyclades

Contacts with the Eastern civilizations, notably in Asia Minor and in Syria, were already established in the Geometric period. They become more common and more profound in the seventh century B.C. For these contacts, the islands played an especially important role. No single style dominates (as had Attic, in the Geometric period): instead, the proximity of one island to another led to liberal borrowings and produced a healthy climate of artistic rivalry. The break with Geometric principles, however, was neither abrupt nor universal, and the Linear Island Style, in particular (64–69), seems to progress without any marked caesura from the Late Geometric to the Early Orientalizing period.

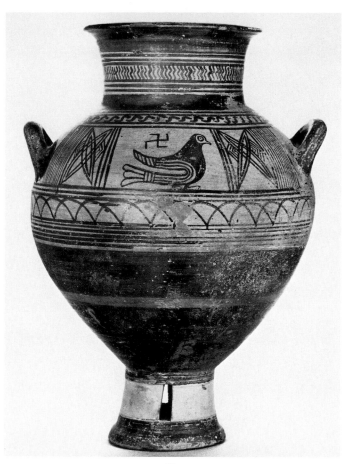

66

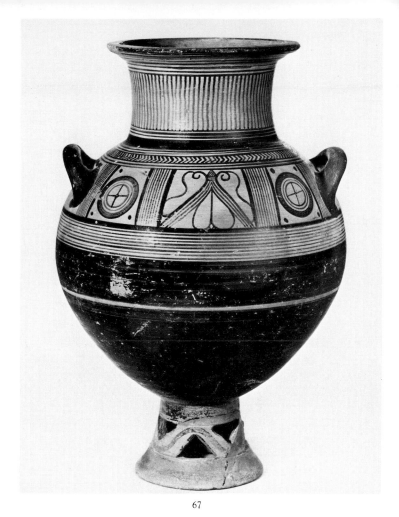

67

66 Terracotta amphora
 Found in the necropolis of Messavouno on
 Thera, 1902
 Early Orientalizing, early 7th century B.C.
 Height, 54 cm. (21¼ in.); diameter, 35 cm.
 (13¾ in.)
Thera, Museum, inv. 783

Bibliography: E. Pfuhl, AM 28 (1903), p. 184, no.
J 4, Beilage 27,2; I. Strøm, *Acta Achaeologica* 33
(1962), p. 229, fig. 4; J. N. Coldstream, *Greek
Geometric Pottery* (1968), p. 379; *Paris Cat.* (1979),
pp. 112–13, fig. 54.

Curvilinear patterns predominate on this vase.
Here, the wing of the bird is no longer set apart, but
merges with the rest of the body and the tail in an
ornamentalized fashion. The rows of horizontal lines
below the decorated panel are interrupted by a band
of arcs. The patterns framing the bird are elliptical.

67 Terracotta amphora
 Found in the necropolis of Messavouno on
 Thera, 1902
 Early Orientalizing, early 7th century B.C.
 Height, 59 cm. (23¼ in.); diameter, 37 cm.
 (14⁹/₁₆ in.)
Thera, Museum, inv. 782

Bibliography: E. Pfuhl, AM 28 (1903), p. 185, no. J 8,
Beilage 29, 1–2; H. Payne, *JHS* 46 (1926), p. 204 (on
the class); *Paris Cat.* (1979), pp. 113, 115, fig. 55.

The fenestration on the foot of this amphora is
triangular. The shoulder decoration features, on the
obverse, curvilinear floral volutes between two panels
of wheels and, on the reverse, two volutes between
crosshatched lozenges in the central panel and
hourglass patterns and crosshatched panels on either
side. The other patterns conform to the Linear Island
Style.

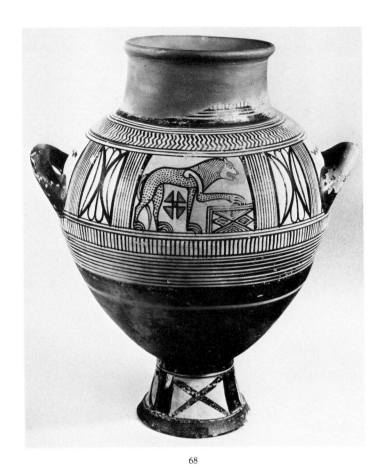

68

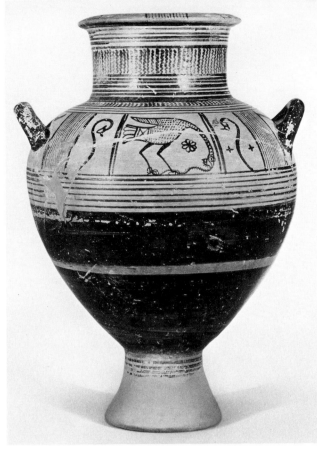

69

68 Terracotta amphora

Found in the necropolis of the Sellada on
Thera, 1896
Early Orientalizing, first quarter of the 7th
century B.C.
Height, as restored, 48 cm. (18⅞ in.);
diameter, 35 cm. (13¾ in.)
Athens, National Museum, inv. 11709

Bibliography: H. Dragendorff, *Thera 2* (1903), pp.
60–61, fig. 209, pp. 203–4, figs. 409–410, no. 11;
Paris Cat. (1979), pp. 114–15, fig. 56.

This amphora had already lost most of its neck
and mouth when it was used as a cinerary urn in
antiquity. The central metope, on the obverse, shows
a lion putting its right front paw onto a step, or box.
The reverse, less ambitious and less well preserved,
has a floral ornament between two panels with wheels
in the lion's place. Two small proto-Corinthian
lekythoi found with the amphora (Dragendorff, *op.
cit.*, p. 61, fig. 210) confirm its date.

69 Terracotta amphora

Found in the necropolis of Messavouno on
Thera, 1902
Developed Orientalizing, about 675 B.C.
Height, with restored foot, 53 cm. (20⅞ in.);
diameter, 40 cm. (15¾ in.)
Thera, Museum, inv. 1303

Bibliography: E. Pfuhl, AM 28 (1903), p. 184, no.
J 5, Beilage 27,3; A. Lembesi, *Arch. Deltion* 22
(1967), pp. 116 ff., pl. 82,2; *Paris Cat.* (1979), pp.
115–16, fig. 57.

The obverse has kept the tripartite division of
the panel zone with an engaging picture, in the
center, of a bird struggling with a snake, but on the
reverse there are only two metopes that repeat the
floral panels of the obverse. The vertical, wriggly
lines on the neck are limited to the obverse. This is
one of the latest amphorae of the Linear Island Style.

70 Terracotta plate with Bellerophon and the Chimaera

Found in the Artemision on Thasos, 1958–59

Orientalizing (Cycladic Polychrome),
about 660 B.C.

Diameter, 28 cm. (11 in.)

Thasos, Museum, inv. 2085

Bibliography: *BCH* 83 (1959), pp. 780–81, fig. 11; F. Salviat and N. Weill, *BCH* 84 (1960), pp. 347–86, figs. 1, 3, 4, 10, 11, pls. 4–6; S. Hiller, *Bellerophon* (1970), p. 15, pl. 1, fig. 1; N. Yalouris, *Pegasus* (1975), no. 8; *Paris Cat.* (1979), pp. 117–18, fig. 59.

Like other plates found on Thasos, this one has rudimentary handles in the shape of spools attached to the rim, perhaps in imitation of metal prototypes. The bottom of the plate is richly profiled. As often in tondo compositions, a ground line, here composed of slanted hatched maeanders, bisects the field. The combat of Bellerophon, mounted on Pegasos, and the Chimaera is the principal scene, while the exergue shows a bush and a running dog. Pegasos and Bellerophon are aloft; the Chimaera, closer to the rim of the plate on the left, assumes the stance of a rampant lion, its head turned back. Note that Bellerophon attacks with a spear in his *left* hand. His flesh is painted in light ochre and is thus contrasted with the black body of his mount, and the same light color is used to differentiate the goat protome from the lion of the Chimaera.

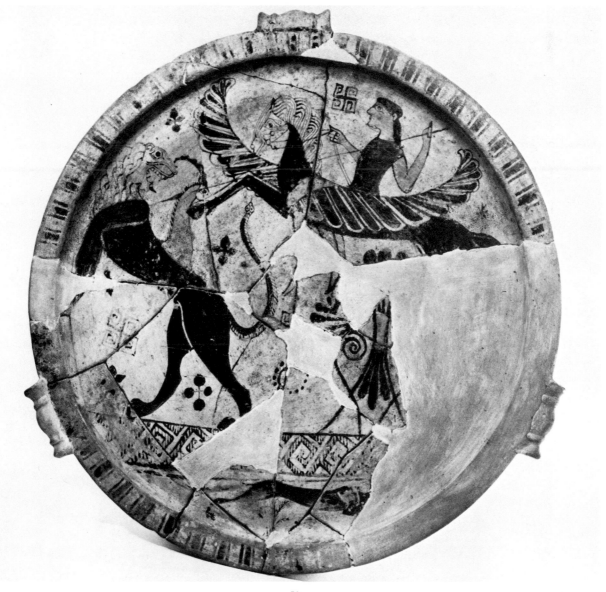

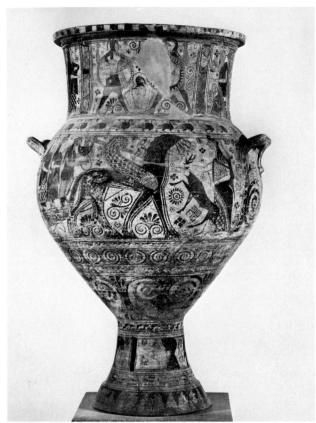

71

71 Terracotta krater

On the neck, A shows the duel of two warriors who are flanked by women; B is ornamental; on the shoulder are geese. On the body, A depicts Apollo's arrival on Delos in his chariot, accompanied by two Hyperborean maidens, being welcomed by Artemis; on B there is the head of a woman flanked by two horses. Heads of women also decorate the base. Under each handle are eyes.

Said to have been found on Melos, before 1860
Orientalizing (Cycladic Polychrome),
 about 640 B.C.

Height, 97.8 cm. (38½ in.)
Athens, National Museum, inv. 911

Bibliography: A. Conze, *Melische Thongefässe* (1862), pls. 3–4; R. Nierhaus, *JdI* 53 (1938), pp. 104–5, fig. 8, pp. 111–14; P. E. Arias, M. Hirmer, B. Shefton, *A History of 1000 Years of Greek Vase Painting* (1961), figs. 22–23,1; D. Papastamos, *Melische Amphoren* (1970), pp. 12 ff., pls. 1–3; N. Yalouris, *Pegasus* (1975), no. 10; M. Andronicos, M. Chatzidakis,

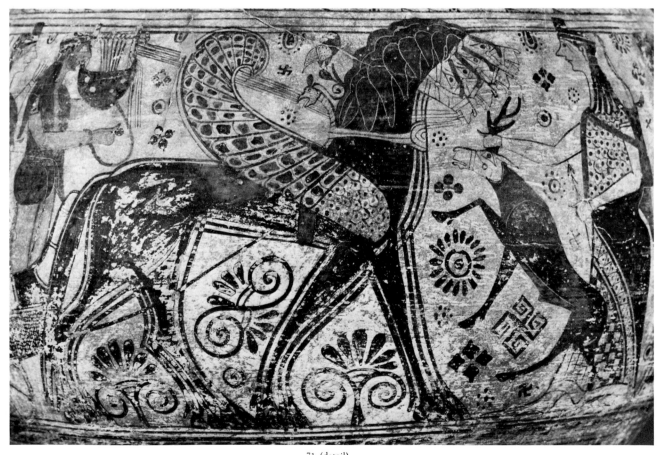

71 (detail)

V. Karageorghis, *The Greek Museums* (1975), pp. 66–67, no. 44; E. Simon and M. Hirmer, *Die griechischen Vasen* (1976), fig. 23, pp. 46–47; *Paris Cat.* (1979), pp. 118–20, fig. 60.

When Conze saw this vase in 1860 in the Royal Palace in Athens he was assured that, together with two other vases, it had been found on Melos. This has subsequently been doubted, but N. Kontoleon (*Fondation Hardt* 10 [1963], p. 58, note 58) has categorically come out in favor of the traditional provenance. In spite of its poor preservation, the majestic sweep of the composition shows how, in little more than one generation, the artists of the Cyclades developed a narrative style without giving up all earlier traditions. The frieze on the neck maintains the tripartite division and the strong vertical frames that date back to the Linear Island Style, and there is also much in the potting (note the fenestration of the foot) that continues the older tradition.

The present condition of the surface no longer brings out the full polychromy—the generous application of added red that, originally, contrasted

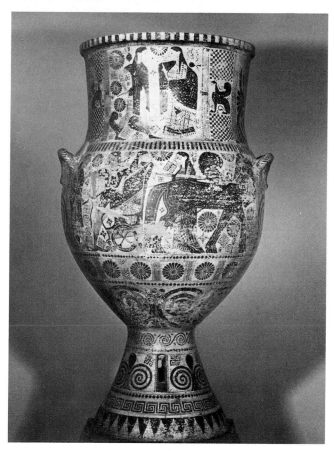

72

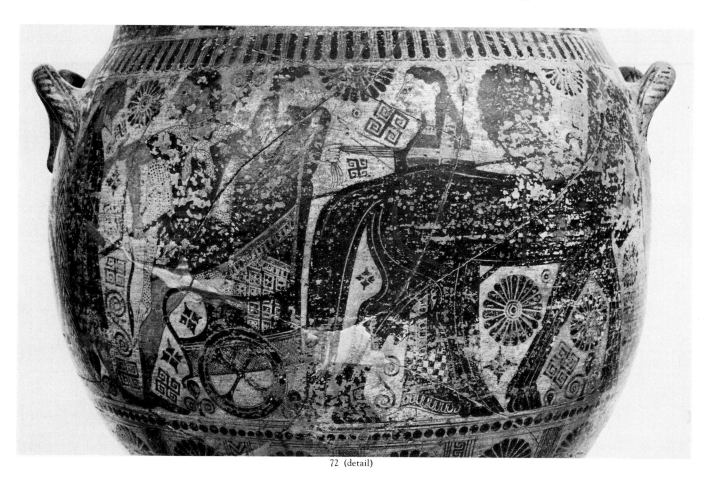

72 (detail)

123

strongly with the black glaze. A pinkish light brown is used for the flesh of the warriors (in the scene on the neck) and of Apollo, and white is used in the painting of their eyes. Details are rendered by reserved lines and incisions.

While there is reasonable agreement as to the subject of the main picture, the duel of the hoplites who are flanked by two women is not totally clear. It evokes the combat of Achilles and Memnon that was watched by their divine mothers, Thetis and Eos. On archaic vases Achilles is often on the right, and can thus show his shield device which is not infrequently—as here—a gorgoneion. The two warriors usually fight over the body of Antilochos; here, however, Antilochos's place is taken by a complete suit of armor that fits admirably into the space between the advanced legs of the combatants. Nierhaus (*op. cit.*) therefore proposed to call the scene Ajax and Diomed at the funeral games of Patroklos, fighting over Sarpedon's armor which Achilles had put up as a prize, an interpretation that Miss Simon (*op. cit.*) accepts. The goddesses would then be Athena and Hera. The shield device of the hero on the right, however, as well as a lack of attributes in the onlookers, favor the older explanation of the duel between Achilles and Memnon.

Even if a Melian provenance is accepted, we still are not certain of the place of manufacture of the krater. Among the islands of the Cyclades Paros is perhaps the most likely center, especially since so many contacts with its colony on Thasos and the town of Neapolis (Kavala, on the Mainland) have recently come to light.

72 Terracotta krater

On the neck are, A, Hermes and a woman (Maia?), and, B, floral ornaments; on the body are, A, Herakles mounting a winged chariot with a woman, in the presence of a man and a woman (her parents?), and, B, two confronted horses. Under each handle are eyes.

Found at Aptera on Crete
Late Orientalizing (Cycladic Polychrome), about 610 B.C.

Height, 102.5 cm. (40⅜ in.); diameter, 52 cm. (20½ in.)
Athens, National Museum, inv. 354

Bibliography: K. Mylonas, *Eph. Arch.* (1894), pp. 225–38, pls. 12–14; E. Pottier, *REG* 8 (1895), p. 389; E. Pfuhl, *Malerei und Zeichnung der Griechen* (1923), pp. 132–35, pls. 24–25, figs. 109–110; C. Dugas, *La céramique des Cyclades* (1925), pp. 214–15, 223–25, pls. 9–10,2; D. Papastamos, *Melische Amphoren* (1970), pp. 47–55, pls. 8–9; *Paris Cat.* (1979), pp. 120–21, fig. 61.

K. Mylonas (*op. cit.*) took the main scene to be the abduction of Iole in the presence of her parents, Eurytos and Antiope, but Pottier (*op. cit.*) rightly stressed the peaceful character of the departure, which favors, as a possible subject, the wedding of Herakles and Deianeira, with Oineus on the left and Althaia on the right. This interpretation was accepted by Papastamos and F. Brommer (*Vasenlisten*[3] [1973], p. 36, C 1). The polychrome style is here fully developed, and there is more detail and ornamentation in the drapery. On the krater from Melos (**71**) incised lines and reserved lines went side-by-side; here, however, there are no incisions, and the reserved lines are remarkably thin. The hands are less clumsy, and the faces are endowed with more pleasing profiles.

73 Terracotta lekanis with two grazing stags

Found in the Heraeum on Delos, 1911
Late Orientalizing, about 620 B.C.
Diameter, 30 cm. (11¹³/₁₆ in.)
Delos, Museum, inv. B 6148

Bibliography: C. Dugas, *La céramique des Cyclades* (1925), p. 191, pl. 8,2; *idem*, *Délos* 10 (1928), p. 20, no. 26, pl. 4; *Paris Cat.* (1979), p. 122, fig. 62.

The decoration is limited to the exterior and should be viewed with the handles in a 12 o'clock– 6 o'clock position. Two crosshatched boundaries separate the floral, top half of the dish from the heraldic animal composition in the lower half. The two stags have locked horns but they do not appear to be fighting. Details are rendered by white lines rather than incisions.

73

74

74 Terracotta lekanis with a phallos-bird in flight
Found in the Heraeum on Delos, 1911
Late Orientalizing, about 620–610 B.C.
Diameter, 25.8 cm. (10³/₁₆ in.)
Delos, Museum, inv. B 6149

Bibliography: C. Dugas, *Délos* 10 (1928), p. 20, no. 28, pl. 4; *Paris Cat.* (1979), pp. 122–23, fig. 63.

Three quarters of the outside decoration of this dish is given over to three interconnected double volutes to which a half-palmette has been attached at one extremity. If, like the other lekanis (**73**), we think of it as habitually suspended from one of its handles, the phallos-bird would be seen soaring on the left half. Such fanciful creatures are often shown on Greek vases, especially on Attic red-figure cups of one hundred years later (*e.g.*, a kylix in the Villa Giulia, Rome [Beazley, *ARV²*, p. 163, no. 10]; the kylix Louvre G 14 [*ibid.*, p. 85]; the kylix Villa Giulia 57912 [*ibid.*, p. 72, no. 24]). The later examples usually show a goose- or swan-like bird whose long neck has been transformed into a phallos, whereas the Delian hybrid is a phallos, complete with testicles, that is joined to the shoulders of a bird in flight whose avian body resembles that of an eagle.

125

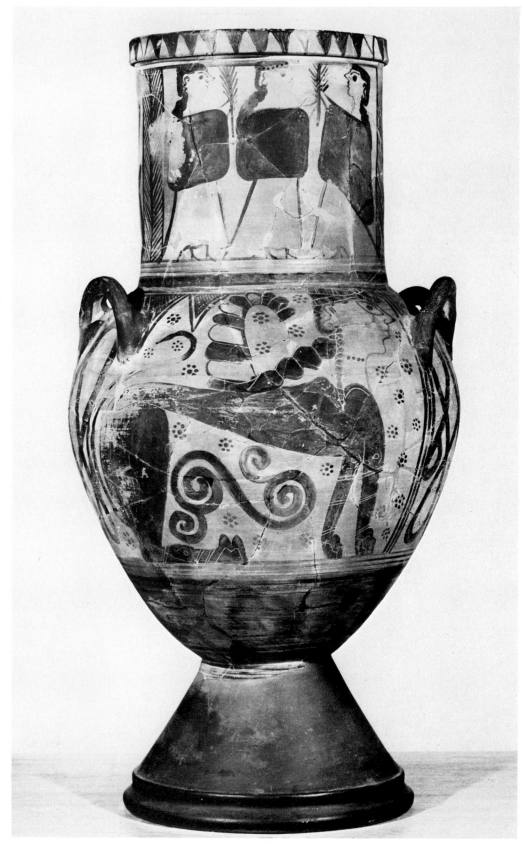

75

75 Terracotta krater with women on the neck and a sphinx on the body

Found at Eretria on Euboea, 1898
Late Orientalizing, about 620–600 B.C.
Height, with restored foot, 76 cm. (29 15/16 in.)
Athens, National Museum, inv. 12129

Bibliography: M. Kouroniotis, *Praktika* (1898), pp. 95–100; C. Dugas, *Mélanges Holleaux* (1913), pp. 71–76, pl. 3; J. Boardman, *BSA* 47 (1952), pp. 26–27, C 6, pl. 6; P. Arias, M. Hirmer, B. Shefton, *A History of 1000 Years of Greek Vase Painting* (1961), p. 273, pl. III; E. Simon and M. Hirmer, *Die griechischen Vasen* (1976), p. 46, pl. VI; *Paris Cat.* (1979), p. 123, fig. 64.

Eretrian vases were much influenced by Attic pottery, and the use of incision here for the anatomical markings on the sphinx, in lieu of thin white lines, may be a borrowing from Attica. A rustic simplicity pervades the pictures on this vase. The glowering sphinx is most curiously put together, with her wings rising Chimaera-like from the middle of her back and her unequal tresses. The women on the neck, whose branches so conveniently hide the hands that hold them, are most probably mourners, as Boardman notes (*op. cit.*, p. 21); they occur frequently in this group of vases.

76 Terracotta oinochoe (wine jug) with two women

Provenance unknown (probably Greece)
Late Orientalizing (Euboean), last quarter of the 7th century B.C.
Height, 26.3 cm. (10 ⅜ in.)
Musée du Louvre, inv. CA 2365 (purchase, 1921)

Bibliography: D. Burr, *Hesperia* 2 (1933), p. 608; J. Boardman, *BSA* 47 (1952), pp. 26–27, C 12, pl. 7; *idem* and F. Schweizer, *BSA* 68 (1973), p. 276, note 19; A. Waiblinger, *CVA Louvre* 17 (1974), p. 50, pl. 48,1–3; *Paris Cat.* (1979), p. 124, fig. 65.

The mourning women of the Athens krater (**75**) recur here, with slight modifications; this time they do not hold branches, but are busy with a snake that uncoils between them. The woman on the left seems to stand on tiptoe; the one on the right has, inadvertently, not been given any feet by the painter.

76

CRETAN DAEDALIC

Nos. 77–94 Cretan Daedalic

After a long eclipse, Cretan art emerges in the seventh century with a vigorous style so strong and distinctive that it has received a name of its own, Daedalic (after Daedalus, the mythical architect and master craftsman of King Minos). Greek sculpture owes much to the Daedalic Style, and the limestone statues of Crete are the significant precursors of the archaic marble sculptures of the sixth century that are the chief glory of Greek art.

77

77 Bronze votive shield
Found in the cave of Mount Ida on Crete
Cretan, late 8th or first half of the 7th
century B.C.
Diameter, 34.5 cm. (13⁹/₁₆ in.)
Athens, National Museum, inv. 17762

Bibliography: E. Kunze, *Kretische Bronzereliefs* (1931), no. 26, p. 18, pls. 33, 36; A. M. Snodgrass, *Early Greek Armour and Weapons* (1964), p. 53, pl. 23; F. Canciani, *Bronzi orientali e orientalizzanti a Creta* (1970), p. 24; *Paris Cat.* (1979), p. 131, fig. 67.

This hammered bronze disk is decorated with reliefs in repoussé. Ornamental bands frame a circular frieze in which grazing or running deer alternate with trees.

78 Bronze statuette of a warrior
Said to be from Crete
Cretan, 675–650 B.C.
Height, 10.6 cm. (4³/₁₆ in.)
The Metropolitan Museum of Art 1972.118.47
(Bequest of Walter C. Baker, 1972)

Bibliography: D. von Bothmer, *Greek, Etruscan, and Roman Antiquities . . . from the Collection of Walter Cummings Baker, Esq.* (1950), p. 7, no. 3.

This statuette retains many of the powerful conventions of the Geometric Style: the upper part of the body in the shape of a triangle, the narrow waist, the strong legs, and the jutting features of the face and helmet.

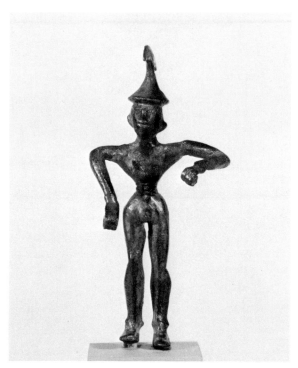

78

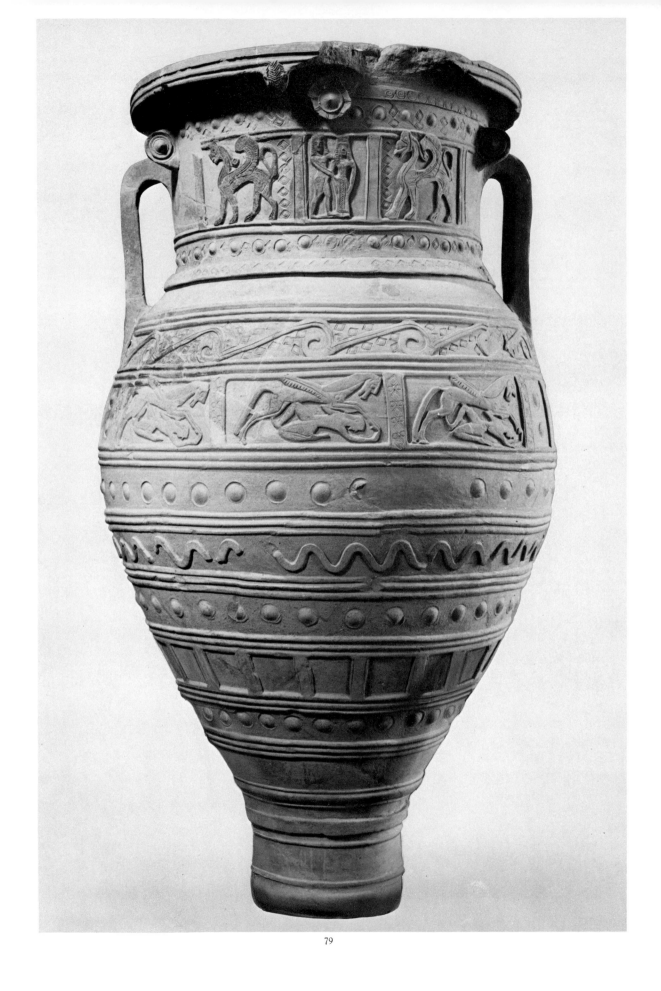

80

79 Terracotta relief pithos
Said to be from Archanes
Cretan, about 675 B.C.
Height, 156 cm. (61⁷/₁₆ in.);
diameter, 87 cm. (34¼ in.)
Musée du Louvre, inv. CA 4523 (purchase, 1968)

Bibliography: P. Demargne, *RA* (1972), pp. 35–46, figs. 1–9; *Paris Cat.* (1979), pp. 132–33, fig. 69.

The figural decoration is limited to stamped panels on the neck and shoulder of the obverse, and a panther's head in the round on the rim. The central panel on the neck shows a nude youth, his head and chest in front view, who has placed his left arm on the shoulders of a draped frontal female figure. His right arm cuts diagonally across his body, his hand reaching for the belly and the sex of the woman—perhaps a primitive rendition of the *hieros gamos* of Zeus and Hera. This couple is flanked on either side by a griffin walking toward the left. The three panels on the

shoulder represent a man supine below a galloping winged horse.

80 Terracotta head of a woman
Broken from a large statuette
Found at Axos on Crete, 1899
"Daedalic Style," about 650 B.C.
Height, as preserved, 13.7 cm. (5⅜ in.)
Chania, Museum, inv. 1002

Bibliography: G. Rizza, *Annuario* 29–30 (1967–68), p. 232, no. 77, p. 233, fig. 1a; *Paris Cat.* (1979), p. 133, fig. 70.

Cretan art of the seventh century B.C., so different from other Greek styles of that period, is often called Daedalic in memory of the legendary universal genius who worked for King Minos. In spite of a certain harshness of contours, Daedalic sculptors achieved an unforgettable impressiveness in these sober faces.

81 (detail)

81 Limestone statue of a woman ("Dame d'Auxerre")

Provenance unknown
"Daedalic Style," about 640–630 B.C.
Height, with base, 75 cm. (29 9/16 in.); without base, 65 cm. (25 9/16 in.)
Musée du Louvre, inv. MND 847 (MA 3098; until 1909 the statue was in the museum at Auxerre, from which it was acquired, by exchange, for a painting by Harpignies, *Torrent dans le Var.*)

Bibliography: M. Collignon, *RA* (1908), pp. 153–70, pl. 10; S. Reinach, *Gazette des Beaux-Arts* (1908), p. 192; A. Héron de Villefosse and E. Michon, *Bull. de la Société des Antiquaires de France* (1909), pp. 316–19, 396–97; M. Collignon, *Mon. Piot* 20 (1913), pp. 5–38, figs. 6–7, 12, pls. 1–2; R. H. Jenkins, *Dedalica* (1936), p. 42; M. Chevallier-Vérel, in *Encyclopédie photographique de l'art* 3 (1938), p. 133; G. Lippold, *Die griechische Plastik* (1950), p. 22, note 1, pl. 2, 3; G. M. A. Richter, *Korai* (1968), p. 32, figs. 76–79; C. Davaras, "Die Statue aus Astritsi" (*AK* Beiheft 8 [1972]), p.13, figs.9–10; E. Harrison, *The Journal of the Walters Art Gallery* 36 (1977), pp. 38–46, figs. 1–2, 7B; L. Adams, *British Archaeological Reports*, suppl. 42 (1978), pp. 32–34, pl. 13a; *Paris Cat.* (1979), pp. 133–35, fig. 71.

Though of unknown provenance, this famous statue has been securely attributed to the Cretan Middle Daedalic period. It is less than half life-size, and yet the sculptor succeeded in creating a monumental figure by masterful articulation and an economy of detail. The lower part of the body is tubular, and most of the modeling is reserved for the body above the narrow, high waist. The sinuous contours of the drapery that falls over the shoulders and arms softens the severe silhouette of the peplos, an angularity that is further stressed by the incised rectangular patterns below the belt. Other female sculptures of this period show the arms either flat against the sides of the body or bent at the elbows with the hands cupping the breasts (cf. Richter, *op. cit.*, figs. 45–75). The departure from this rigid symmetry—the right hand held flat against the chest below the breasts and the left, flat against the left thigh—opens the way to the greater freedom of stance and gesture that distinguishes the great statues of the sixth century from their predecessors.

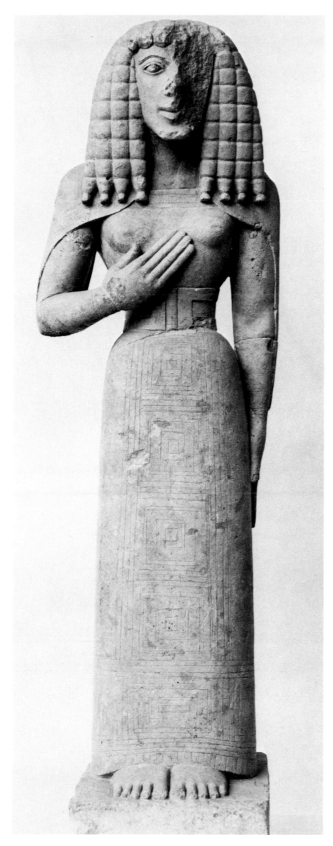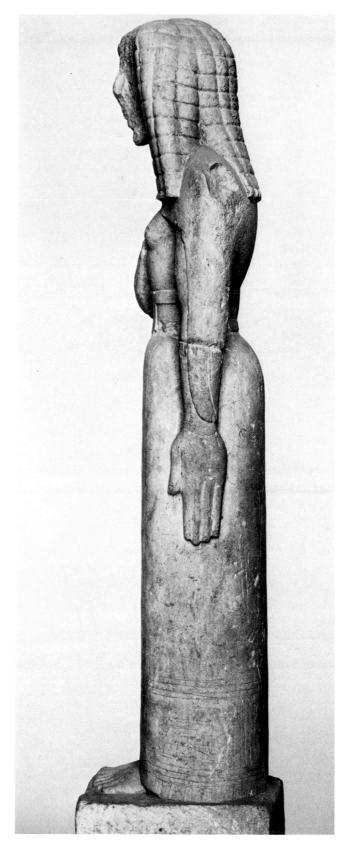

81

82

83

82 Terracotta relief of a frontal woman
Said to be from Crete
Cretan, about 650–640 B.C.
Height, 23.7 cm. (9 5/16 in.); width, 5.5 cm.
(2 3/16 in.)
Musée du Louvre, inv. AM 1698
(B 167; purchase, 1914)

Bibliography: M. Collignon, *CRAI* (1914), p. 243;
V. Müller, *Frühe Plastik in Griechenland und Kleinasien*
(1929), pp. 181 ff., 191, 211, 213 f., pl. 30, fig. 333;
M. Hartley, *BSA* 31 (1930–31), p. 106, fig. 31;
H. Payne, *Necrocorinthia* (1931), p. 233, pl. 47,2;
P. Demargne, *BCH* 55 (1931), p. 397, pl. 15,1;
S. Mollard-Besques, *Cat.* 1 (1954), no. B 167, pl. 21;
Paris Cat. (1979), pp. 135–36, fig. 72.

This relief is mold pressed. Except for the head
and the high polos, it is rather flat, but the articula-
tion, as often in Cretan art, is already developed. The
arms, stretched out along the hips and thighs, are set
apart from the body at waist level, and the shoulders
are covered by sleeves, two features that relate this

statuette to the "Dame d'Auxerre" (81). For the high
polos, compare the terracotta from Praisos (83).

83 Terracotta statuette of a nude woman
Excavated at Praisos on Crete, 1894
Cretan, second half of the 7th century B.C.
Height, as preserved, 20.3 cm. (8 in.)
The Metropolitan Museum of Art 53.5.23
(Gift of the Archaeological Institute
of America, 1953)

Bibliography: F. Halbherr, *AJA* 5 (1901), pl. 10,1;
E. Kunze, *AM* 55 (1930), p. 154, note 5; G. M. A.
Richter, *Sculpture and Sculptors of the Greeks*[2] (1930),
p. 337, fig. 14; E. H. Dohan, *MMStudies* 3 (1931),
p. 219, fig. 25; F. Matz, *JdI* 65–66 (1950–51), p. 94,
note 1.

The statuette was a votive gift, one of hundreds
found in the trenches at Vaveloi, the village near
Praisos, during Halbherr's excavations. It is excep-
tional in that the woman wears a very high polos.

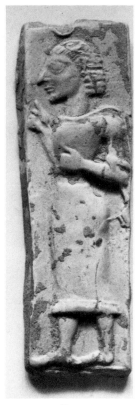

84

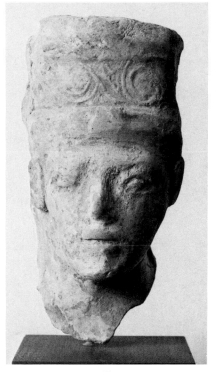

85

84 Terracotta relief of a male votary
Excavated at Praisos on Crete, 1894
Cretan, second half of the 7th century B.C.
Height, 13.9 cm. (5 ½ in.); width, 4.4 cm.
(1 ¾ in.)
The Metropolitan Museum of Art 53.5.11
(Gift of the Archaeological Institute
of America, 1953)

Bibliography: E. H. Dohan, *MMStudies* 3 (1931),
p. 313, fig. 10; F. Matz, *JdI* 65–66 (1950–51), p.
102, note 1; G. M. A. Richter, *Handbook of the Greek
Collection* (1953), p. 29, note 3, pl. 18b; *Dädalische
Kunst auf Kreta im 7.Jahrhundert* (Hamburg, 23. Sep-
tember – 27. Dezember 1970), p. 103, D 41; L. Bon-
fante, *Etruscan Dress* (1975), p. 176, fig. 66.

Many plaques of this type—a male votary in
profile—are known. The position of the right arm
and hand seems to imply that the figure originally
held something—perhaps a spear, that was once
painted. The hairstyle (*Etagenperücke*) is typically
Daedalic, of the period.

85 Terracotta head of a large statuette of a woman
Excavated at Praisos on Crete, 1894
Cretan, second half of the 7th century B.C.
Height, as preserved, 13.9 cm. (5½ in.);
width, 6.7 cm. (2⅝ in.)
The Metropolitan Museum of Art 53.5.36
(Gift of the Archaeological Institute
of America, 1953)

Bibliography: F. Halbherr, *AJA* 5 (1901), p. 387,
pl. 11, 1 a-b.

From the shape of the head and the polos deco-
rated with a spiral pattern, this sculpture cannot be
mistaken for anything but a Cretan work of the
seventh century B.C. The severe look and the strong
profile stand in marked contrast to contemporary
works from the islands of Samos or Rhodes. As often
on terracottas of this size, the ears were added after
the head had been modeled.

86 Terracotta relief of a warrior dragging a captive
 Excavated at Praisos on Crete, 1894
 Cretan, about 540–520 B.C.
 Height, 20.3 cm. (8 in.); width, as preserved,
 12 cm. (4¾ in.)
The Metropolitan Museum of Art 53.5.19
 (Gift of the Archaeological Institute
 of America, 1953)

Bibliography: F. Halbherr, *AJA* 5 (1901), p. 390, pl. 12, no. 4; W. Helbig, *OeJh* 12 (1909), p. 64, fig. 45; E. H. Dohan, *MMStudies* 3 (1931), p. 209, fig. 39; G. M. A. Richter, *Handbook of the Greek Collection* (1953), p. 70, note 40, pl. 52j; *Dädalische Kunst auf Kreta im 7.Jahrhundert* (Hamburg, 23. September–27. Dezember 1970), p. 104, D 48, pl. 44a; F. Brommer, *Denkmälerlisten zur griechischen Heldensage* (1976), p. 55, Astyanax, no. 2.

Not enough is left of the surface to tell whether the young and helpless naked figure dragged by the warrior is a boy or a girl. Three possible interpretations have been offered: Achilles and Troilos, Neoptolemos and Astyanax, or Ajax and Cassandra (the first suggested by Frances van Keuren Stern in a letter of March 27, 1978, to the Museum's Greek and Roman Department).

86

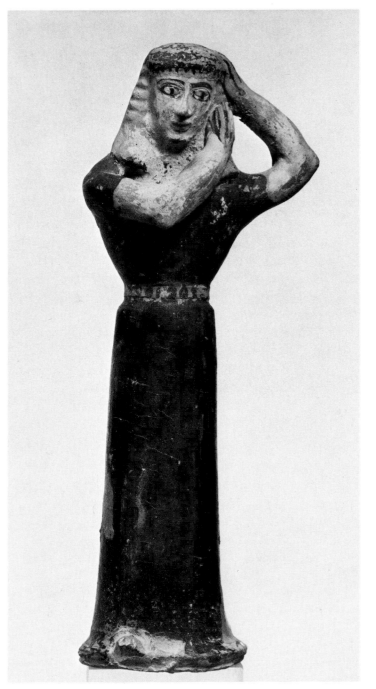

87

87 Terracotta statuette of a mourning woman
Found in the necropolis of the Sellada on
Thera, August 15, 1896
Last quarter of the 7th century B.C.
Height, 31 cm. (12 3/16 in.)
Thera, Museum, inv. 392

Bibliography: H. Dragendorff, *Thera 2* (1903), p. 24, fig. 56; N. Kontoleon, *AM* 73 (1958), p. 119, Beilage 83; R. A. Higgins, *Greek Terracottas* (1967), p. 40, pl. 15H; G. M. A. Richter, *Korai* (1968), p. 34, no. 27, figs. 101–102; *Paris Cat.* (1979), pp. 136–37, fig. 74.

This large statuette is exceptionally well preserved and, moreover, has kept much of its original coloring, which was limited to its front. The flesh is white; the eyebrows, pupils, and hair are black; the garment is reddish brown; and the lips are red. The traditional pose of the mourning woman reveals unexpected naturalistic detail, such as the right hand pulling at the hair while the left hand presses against the scalp. The body below the belt was thrown on the wheel and is hollow; the upper body was modeled freehand.

No exact parallels exist for this statuette; it must have been made on Thera, perhaps under Cretan influence.

88 Bronze cut-out plaque of two hunters
Said to be from Crete
Cretan Orientalizing, about 630 B.C.
Height, 18.3 cm. (7 3/16 in.)
Musée du Louvre, inv. MNC 689
(Br. 93; purchase, 1884)

Bibliography: A. Milchhoefer, *AdI* 52 (1880), pp. 213–22, pl. T; *Cat. Vente Hôtel Drouot 12–16 mai 1884 (Alessandro Castellani)*, p. 51, no. 433; A. De Ridder, *Les Bronzes antiques du Louvre 1* (1913), no. 93, p. 20, pl. 11; W. Lamb, *Greek and Roman Bronzes* (1929), p. 60, pl. 19; S. B. Benton, *BSA* 40 (1939), p. 53; P. Amandry, *BCH* 68–69 (1944–45), p. 48, note 6; H. Hoffmann, in *Dädalische Kunst auf Kreta im 7. Jahrhundert* (Hamburg, 23. September–27. Dezember 1970), pp. 41–42, pl. 12; *idem* [and A. E. Raubitschek], *Early Cretan Armorers* (1972), pp. 28, 32–33, pl. 49, 2; *Paris Cat.* (1979), p. 138, fig. 76.

The hunter on the right is bearded and carries a long bow in his left hand. On his head he wears a fillet. In time and style this bronze goes with two others fashioned in the same technique, one in Oxford (*JHS* 30 [1910], pp. 226–29, pl. 12,1) and one in Copenhagen (*JHS* 30 [1910], p. 227). All three depict a hunter carrying his quarry: a wild goat with its legs tied together. Of these three, the plaque in the Louvre is the most complete and preserves, on the narrow plinth, the three holes by which the relief was fastened to a wooden box, or the like.

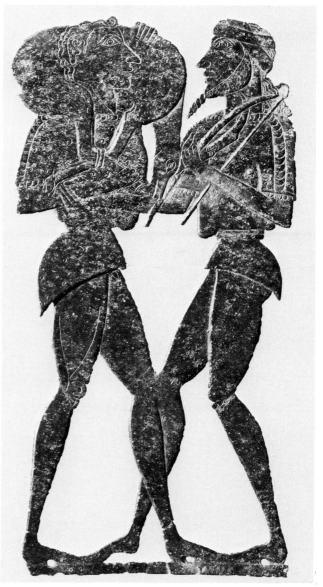

88

89 Bronze helmet with winged youths
Inscribed "Neopolis"
Said to be from Afrati on Crete
Cretan, late 7th century B.C.
Height, 21 cm. (8¼ in.)
The Metropolitan Museum of Art L. 1979.49.2
(Lent by Mr. and Mrs. Norbert Schimmel)

Bibliography: H. Hoffmann and A. E. Raubitschek, *Early Cretan Armorers* (1972), pp. 2–4, 29, 31, 34 ff., 43 ff., pls. 1–5, 7; G. Neumann, *Zeitschrift für vergleichende Sprachforschung* 88 (1974), pp. 38–39; *Ancient Art, the Norbert Schimmel Collection*² (1975), no. 15.

Two winged youths holding intertwined snakes are shown on each side of this helmet, which was made in two halves and riveted together along an overlapping seam. The two scenes worked in repoussé and incision are close replicas of one another. The most obvious difference between the two halves is that, on the right side of the helmet, in the triangle formed by the snakes, the artist has added a small incised drawing of two panthers, their heads conjoined. The frontlet, which was worked separately and riveted, is decorated with repoussé rosettes at each end; other repoussé rosettes (now lost) once decorated the rounded tips of each cheekguard.

89

90 Bronze helmet with two horses
 Inscribed "Synetios, son of Euklotas,
 [took this]"
Said to be from Afrati on Crete
Cretan, late 7th century B.C.
Height, 24.5 cm. (9⅝ in.)
The Metropolitan Museum of Art L. 1979.49.3
(Lent by Mr. and Mrs. Norbert Schimmel)

Bibliography: H. Hoffmann and A. E. Raubitschek, *Early Cretan Armorers* (1972), pp. 4, 15, 30 f., 38, pls. 8–10; G. Neumann, *Zeitschrift für vergleichende Sprachforschung* 88 (1974), pp. 35–36; *Ancient Art, the Norbert Schimmel Collection*² (1975), no. 14.

The helmet is of the same shape and technique as **89**. The repoussé decoration shows two horses facing each other, one on either side of the helmet. On each cheekpiece a small ferocious lion is incised, facing the horse. The frontlet is missing, as are the rosettes at the rounded tips of the cheekpieces.

90

91

91 **Bronze mitra with two facing horse protomai**
 Inscribed "Synetios, son of Euklotas [took]
 this"
 Said to be from Afrati on Crete
 Cretan, late 7th century B.C.
 Height, 15.4 cm. (5⅛ in.); width, 24.2 cm.
 (9½ in.)
The Metropolitan Museum of Art L.1979.49.4
 (Lent by Mr. and Mrs. Norbert Schimmel)

Bibliography: H. Hoffmann and A. E. Raubitschek,
Early Cretan Armorers (1972), pp. 10, 15 f., 30, 38,
43, 45, pls. 31, 33, 42,2; G. Neumann, *Zeitschrift für
vergleichende Sprachforschung* 88 (1974), pp. 35–36;
Ancient Art, the Norbert Schimmel Collection[2] (1975),
no. 16.

 Three bronze rings along the upper edge enabled
the mitra to be attached to a belt and thus to protect
the lower belly. No bronze belts have been found with
the Afrati armor in the Schimmel Collection, and it
is hence assumed that the belts were made of leather
and have perished. The inscription, as well as the
motif of horses, link this mitra with the helmet (90),
and it is reasonable to assume that they were part of
the same set of armor.

92 **Bronze mitra with two facing protomai of**
 winged horses
 Inscribed "Aisonidas, son of Chloridios,
 took this"
 Said to be from Afrati on Crete
 Cretan, late 7th century B.C.
 Height, 15.4 cm. (5⅛ in.); width, as
 preserved, 24.2 cm. (9½ in.)
The Metropolitan Museum of Art L.1979.49.5
 (Lent by Mr. and Mrs. Norbert Schimmel)

Bibliography: H. Hoffmann and A. E. Raubitschek,
Early Cretan Armorers (1972), pp. 11, 15 f., 32, 38,
43, pl. 34; G. Neumann, *Zeitschrift für vergleichende
Sprachforschung* 88 (1974), pp. 34–35; *Ancient Art,
the Norbert Schimmel Collection*[2] (1975), no. 17.

 This mitra gives the inscription, which is metri-
cal, in full: "this," which always refers to the indi-
vidual object (helmet, cuirass, or mitra), and "took,"
which should mean "captured." The name of the
enemy from whom the armor was taken is never
mentioned, nor do we have the name of the god or
goddess to whom the booty was dedicated.

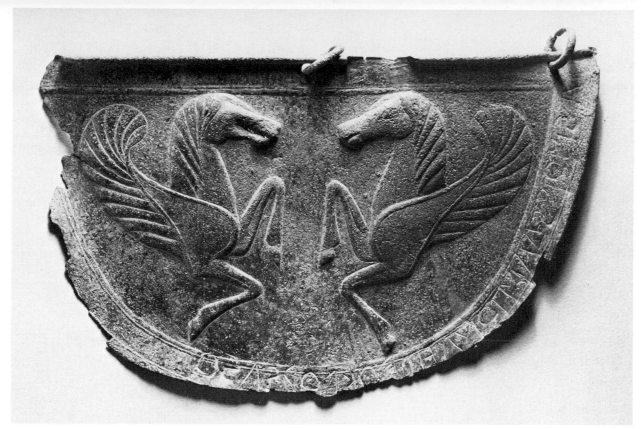

92

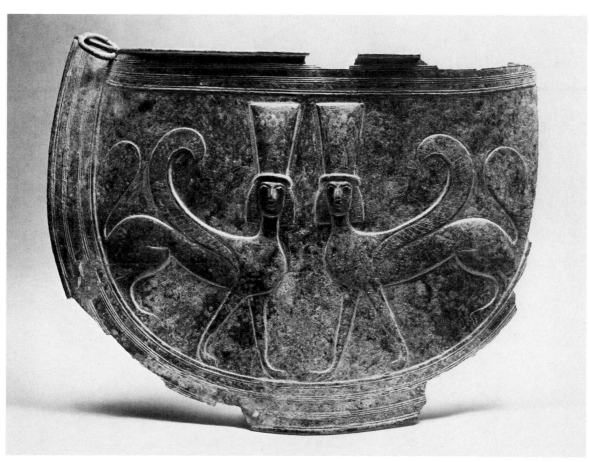

93

93 Bronze mitra with two heraldic sphinxes
Said to be from Afrati on Crete
Cretan, late 7th century B.C.
Height, 17.4 cm. (6⅞ in.); width, as restored,
24.5 cm. (9⅝ in.)
The Metropolitan Museum of Art L.1979.49.6
(Lent by Mr. and Mrs. Norbert Schimmel)

Bibliography: H. Hoffmann and A. E. Raubitschek,
Early Cretan Armorers (1972), pp. 11, 20, 30, 38, 43
ff., pls. 32, 42,1; *Ancient Art, the Norbert Schimmel Collection*[2] (1975), no. 18.

The two sphinxes wear their hair in the short, Daedalic fashion (cf. also the Praisos terracotta, **83**), and, on top of it, an extraordinarily tall polos; in addition, each sphinx has a neckband with a crescent-shaped amulet.

94 (front)

94 Bronze cuirass, front (thorax) and back
Said to be from Afrati on Crete
Cretan, late 7th century B.C.
Height, as preserved: thorax, 39 cm. (15⅜ in.);
back, 39.5 cm. (15⁹/₁₆ in.)
The Metropolitan Museum of Art L.1979.49.7
(Lent by Mr. and Mrs. Norbert Schimmel)

Bibliography: H. Hoffmann and A. E. Raubitschek,

Early Cretan Armorers (1972), p. 9, pls. 28–29.

The two halves of the cuirass were hinged together. The anatomy of the body covered by the armor is shown in relief in schematic form: in front, the pectoral and abdominal arches; in back, the shoulder blades and spine. This bronze bears no inscription.

94 (back)

RHODIAN

Nos. 95–126 Rhodian

The Orientalizing period on Rhodes continues well into the sixth century B.C., and her importance as an artistic center is attested by the exportation of Rhodian pottery to the West, especially to Sicily and Etruria. At the same time, Rhodes imported vases from Attica, Corinth, and Laconia, and traded with Egypt.

Settled by Greeks of Dorian stock, Rhodes succeeded, to a remarkable degree, in assimilating the Ionian style of the neighboring cities on the mainland of Anatolia.

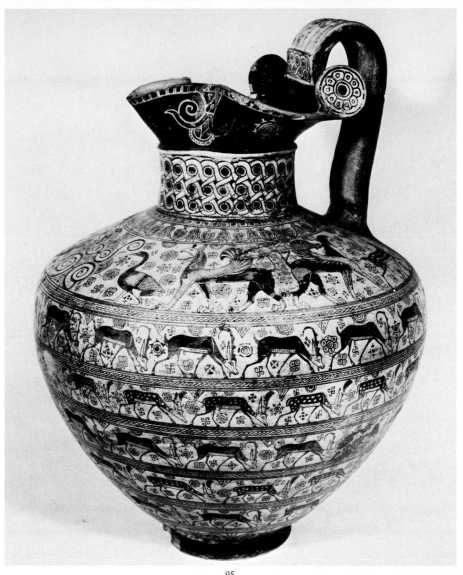

95

95 Terracotta oinochoe (wine jug)

The shoulder scene consists of floral ornament flanked by two birds and two griffins; around the handle are two sphinxes and two fallow deer, with a jackal leaping from a branch, and swallows. On the body, in five registers, are alternating files of wild goats and fallow deer.

Provenance unknown. (Bought in Rome by the painter E. Lévy, 1855)

Rhodian Orientalizing, about 650–640 B.C.

Height, 39.5 cm. (15 9/16 in.); diameter, 30 cm. (11 13/16 in.)

Musée du Louvre CA 350 (E 658; purchase, 1891)

Bibliography: E. Pottier, *Vases antiques du Louvre 2* (1901), p. 9, pl. 52; *idem*, CVA Louvre 1 (1922), II Dc, pls. 6–7; W. Schiering, *Werkstätten orientalisierender Keramik auf Rhodos* (1957), pp. 50, 61, 62, 68, 91, 97, 137, note 697; H. Walter, *Samos 5* (1968), p. 73, pls. 116–117; *Paris Cat.* (1979), p. 144, fig. 78.

Wild goats predominate in Orientalizing East Greek vases, and have given the name to the principal style, the "Wild Goat Style." The painting, as here, is often on a cream-colored slip which increases the contrast. Human figures are rare, and the accent is on decoration. Though there is much repetition, the artists are not slavish: such unexpected details as the jackal ready to pounce on the deer, or a head turned around in the friezes of grazing animals enliven a design that otherwise would be purely formalistic.

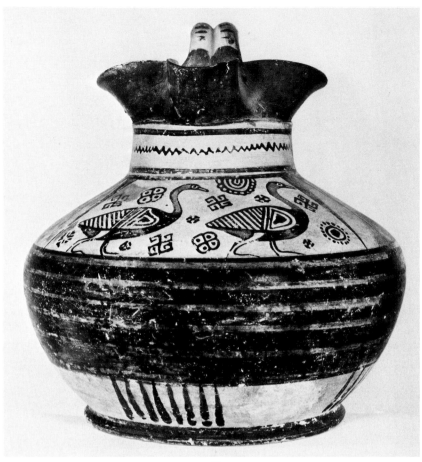

96

96 Terracotta oinochoe (wine jug) with geese
Found in the necropolis at Kameiros on Rhodes, 1864
Rhodian Orientalizing, about 625 B.C.
Height, 22 cm. (8 11/16 in.); diameter, 19.5 cm. (7 11/16 in.)
Musée du Louvre, inv. N III 2358 (A 322)

Bibliography: E. Pottier, *Catalogue des vases antiques de terrecuite* 1 (1896), p. 164, A 322; J. A. J. Morin [-Jean], *Le Dessin des animaux en Grèce d'après les vases peints* (1911), p. 44, fig. 36; K. F. Kinch, *Vroulia* (1914), p. 213, fig. 100, p. 258; E. Pottier, *CVA Louvre* 1 (1923), II Dc, pl. 4,4; C. Kardara, *Rhodiake Angeiographia* (1963), p. 111, no. 5; *Paris Cat.* (1979), p. 145, fig. 80.

This vase belongs to a small class of squat oinochoai that have only one animal frieze on the shoulder. The two stately geese march toward the right; their necks are red.

97 Terracotta oinochoe (wine jug) with a goose between two fallow deer
Said to be from Klazomenai in Anatolia
Rhodian, second quarter of the 6th century B.C.
Height, 35.6 cm. (14 in.)
The Metropolitan Museum of Art 19.192.13
(Rogers Fund, 1919)

Bibliography: W. Froehner, *Cat. des objets d'art antique, Galerie Georges Petit, Vente 25–27 juin 1919* (Collection Prof. S. Pozzi, Paris), p. 32, no. 440,1, pl. 12; A. Rumpf, *JdI* 48 (1933), p. 72, note 42; G. M. A. Richter, *Handbook of the Greek Collection* (1953), p. 42, note 92, pl. 29f; C. Kardara, *Rhodiake Angeiographia* (1963), p. 101, no. 15, pl. 6 b.

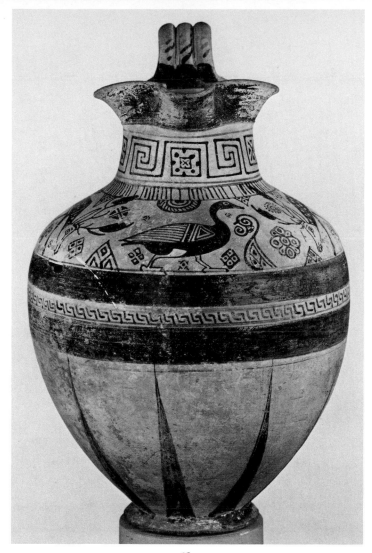

97

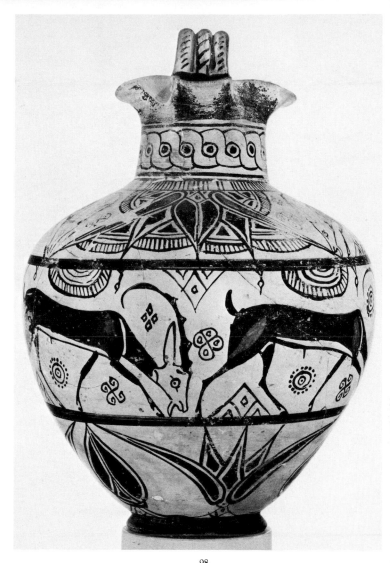

98

In shape and style this oinochoe is particularly close to one in Munich (E. Walter-Karydi, *CVA* Munich 6 [1968], pl. 275) and one in Berlin (inv. 2935: Kardara, *op. cit.*, pl. 5a; H. Schaal, *Griechische Vasen* [1930], pl. 4,7). On the Munich jug, the goose between the two wild goats has the same marking on its wing as the one in New York, and on the jug in Berlin the fallow deer to the left of the central griffin is drawn in exactly the same way as its counterpart in New York.

98 Terracotta oinochoe (wine jug) with wild goats

Provenance unknown
Rhodian, first quarter of the 6th century B.C.
Height, 35.9 cm. (14⅛ in.)
The Metropolitan Museum of Art 19.192.12
(Rogers Fund, 1919)

Bibliography: W. Froehner, *Cat. des objets d'art antique, Galerie Georges Petit, Vente 25–27 juin 1919* (Collection Prof. S. Pozzi, Paris), p. 32, no. 440,2, plate 12; G. M. A. Richter, *Handbook of the Greek Collection* (1953), p. 42, note 92, pl. 29e; C. Kardara, *Rhodiake Angeiographia* (1963), p. 106, no. 2, pl. 62; O. W. Muscarella, *MMA Journal 5* (1972), p. 46, fig. 19; E. Walter-Karydi, *Samos 6,1* (1973), p. 55, fig. 119, p. 132, no. 521.

The cable pattern on the neck, the large flower on the shoulder, and the flowers and buds above the foot connect this oinochoe to one in Berlin (inv. 2937: Walter-Karydi, *op. cit.*, pl. 63, no. 523).

As this oinochoe was sold at the Pozzi sale together with **96**, it might share the latter's provenance.

99

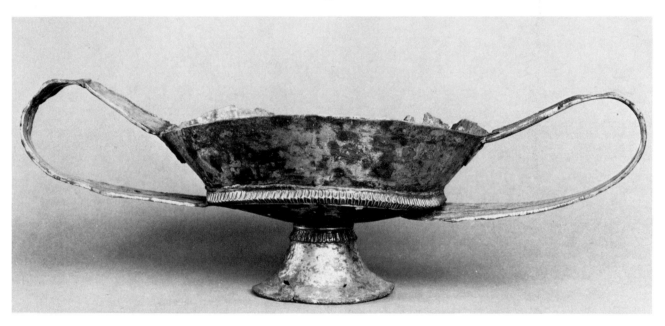

99 Gold and silver kantharos

The bowl and foot were raised separately, with the handles riveted on.

Found at Kameiros on Rhodes
Rhodian Orientalizing, second half of the 7th century B.C., or later
Diameter of bowl, 14.5 cm. (5 ¹¹/₁₆ in.); diameter of foot, 6 cm. (2⅜ in.); the present height, 8.7 cm. (3⁷/₁₆ in.), and width, 28 cm. (11 in.) are meaningless, as the handles have been depressed and stretched out
Musée du Louvre, inv. S 1211 (Suppl. Bj 2165)

Bibliography: A. Salzmann, *Nécropole de Camiros* (1866–75), pl. 1; S. Gsell, *Fouilles de la Nécropole de Vulci* (1891), p. 488, no. 2; P. Jacobsthal, *JdI* 44 (1929), p. 214; P. Mingazzini, *Vasi della Collezione Castellani* (1930), p. 23; D. Strong, *Greek and Roman Gold and Silver Plate* (1966), p. 58, pl. 8B, C; *Paris Cat.* (1979), p. 147, fig. 83.

The silver kantharos is enriched by a gold medallion decorated with a rosette that covers the center of the bowl, and by plaques with geometric designs that are applied to the lower parts of the strap handles above the rim.

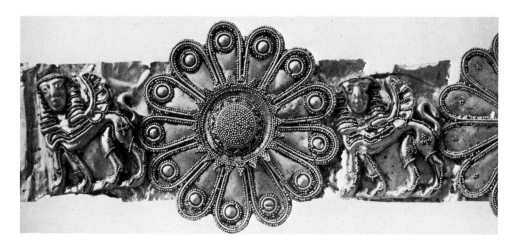

100 (detail)

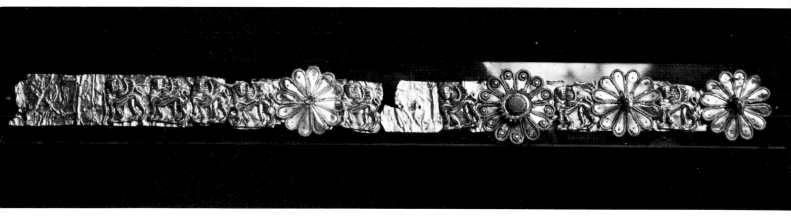

100

100 Gold diadem
Found on Kos
Rhodian, about 630–620 B.C.
Length, as preserved, 24 cm. (9⁷/₁₆ in.)
Athens, Benaki Museum, inv. 6242

Bibliography: *BCH* 71–72 (1947–48), pp. 426–27, fig. 3; R. A. Higgins, *Greek and Roman Jewellery* (1961), p. 105; M. Andronicos, *The Greek Museums* (1975), p. 375, fig. 5a; R. Laffineur, *L'Orfèvrerie rhodienne orientalisante* (1978), p. 222, no. 159, pl. 19; *Paris Cat.* (1979), pp. 147–48, fig. 84.

Sphinxes alternate with rosettes of two types: those with twelve petals have, in the center, a goat's head with long horns. This type of diadem originated in Assyria and spread through Syria to Cyprus and the Greek part of the Mediterranean.

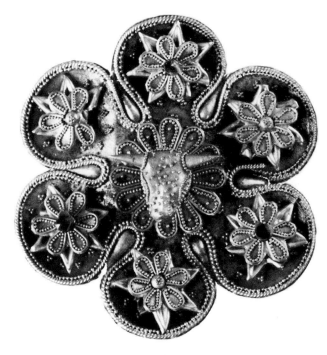

101

101 (detail)

101–104 Four gold rosettes

Found at Limni (or Trypiti) on Melos,
before 1862
Rhodian, about 630–620 B.C.
Diameter, each, 4.6 cm. (1 13/16 in.)
Athens, National Museum, inv. 1180, 1179, 1178,
1181

Bibliography: P. Lemerle, *BCH* 63 (1939), pp. 285–86, pl. 48; O. Walter, *AA* (1940), cols. 124–125, figs. 2–4; J. Konstantinou, *Illustrated London News* (27 April 1940), pp. 568–69; F. Matz, *Geschichte der griechischen Kunst* 1 (1950), pl. 274; C. Picard, *RA* 17 (1961), pp. 92–93; L. Byvanck Quarles van Ufford, *BABesch* 39 (1964), p. 71, fig. 12; R. Laffineur, *L'Orfèvrerie rhodienne orientalisante* (1978), pp. 91–92, 214–15, nos. 117–119, 121, pl. 15,4,2,1,3,6; *Paris Cat.* (1979), pp. 148–49, figs. 85–88.

The four rosettes were found together, with a fifth (not exhibited), on the island of Melos. All come from the same workshop, as does a sixth, now in Munich (Laffineur, *op. cit.*, p. 220, no. 152, pl. 18,1). Each rosette consists of six petals, the contours of which are decorated with a fine border of granulation; each petal, in turn, has a star in its center under another smaller rosette. The center of each large rosette is decorated with a head: either a bull (**101**), a lion (**102**), or a griffin (**104**); the central rosette of **103**, once below the lions' head, is now missing. The added decoration of **104** was further enriched in that three of the petals have bees that alternate with griffin heads on the other three petals. The rosette from the same find, not lent (Laffineur, *op. cit.*, pl. 15,5), is the most elaborate: in the center there is a bird, and on the petals bees alternate with griffin heads.

The purpose of such richly decorated rosettes is still debated. They can hardly have been attached to a gold diadem, as has often been asserted. Rather, as is now held, they were probably sewn to cloth or leather.

The bees on **104** are related to jewelry from Ephesus (D. G. Hogarth, *Ephesus* [1908], pl. 3, no. 5, pl. 4, no. 32), while the griffins can be compared with a gold protome from Ziwiye (A. Godard, *Le trésor de Ziwiyè* [1950], fig. 30) whose connection with Rhodian Orientalizing art has been explained by P. Amandry (*Anatolica* 2 [1968], p. 93).

It may be of some interest to note that the Melian rosettes were bought in 1862 by the Greek government and stored in the safes of the Treasury where they remained, totally forgotten, until 1939.

see colorplate page 34

154

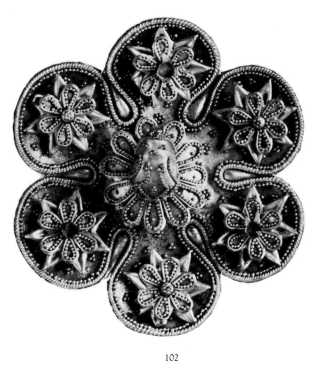

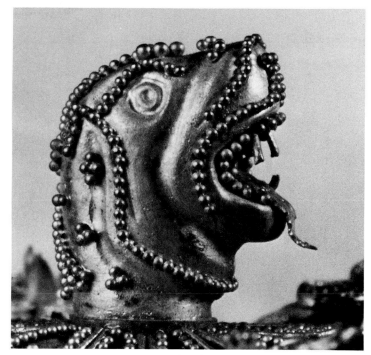

102

102 (detail)

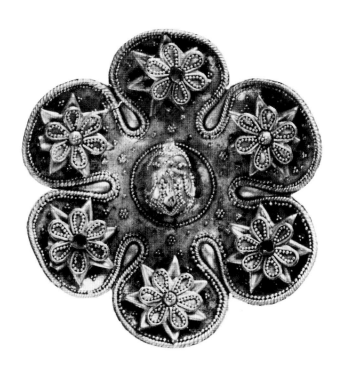

103

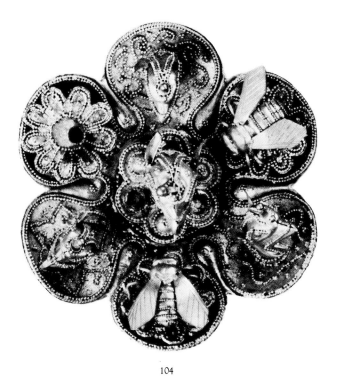

104

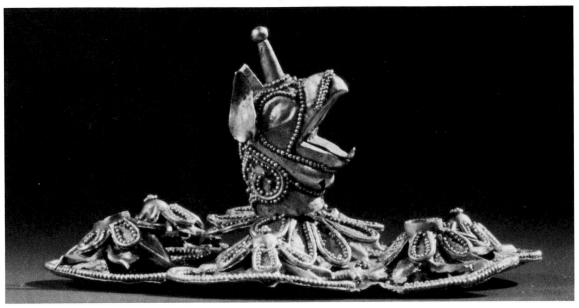

105

105 Gold rosette with the head of a griffin

Said to be from Rhodes
Rhodian, about 630–620 B.C.
Height, 2.2 cm. (⅞ in.); diameter, 4.1 cm.
(1⅝ in.)
The Metropolitan Museum of Art 12.229.24
(Rogers Fund, 1912)

Bibliography: G. M. A. Richter, BMMA 8 (1913), p. 179; C. Alexander, *The Art of the Goldsmith in Classical Times as illustrated in the Museum Collection* (1928), p. 45, no. 99; G. M. A. Richter, *Handbook of the Greek Collection* (1953), p. 156, note 1, pl. 128d; G. Becatti, *Oreficerie antiche* (1955), no. 200; P. Jacobsthal, *Greek Pins* (1956), pp. 36, 42; R. A. Higgins, *Greek and Roman Jewellery* (1961), p. 106; A. Oliver, Jr., BMMA 24 (1965–66), pp. 270–71, fig. 4; BMMA 29 (1970–71), p. 320; R. Laffineur, *L'Orfèvrerie rhodienne orientalisante* (1978), p. 220, no. 153.

This rosette is very much like the set from Melos (for the griffin, cf. **104**), save that it is slightly smaller.

106 Electrum pendant

Found in the necropolis at Kameiros on Rhodes
Rhodian, about 630–620 B.C.
Height, 8.5 cm. (3⅜ in.); width, 3 cm.
(1³/₁₆ in.)

Musée du Louvre, inv. S 1209 (Suppl. Bj 2169)

Bibliography: A. Salzmann, RA n.s. 8 (1863), pp. 1–6, pl. 10 left; E. Fontenay, *Les Bijoux anciens et modernes* (1897), p. 95; F. Poulsen, *Der Orient und die frühgriechische Kunst* (1912), fig. 160; S. Zervos, *Rhodes* (1920), p. 361, fig. 687; G. Becatti, *Oreficerie antiche* (1955), p. 48; E. Coche de La Ferté, *Les Bijoux antiques* (1956), pl. 13,2–3; R. A. Higgins, *Greek and Roman Jewellery* (1961), p. 113; P. Amandry, *Collection Hélène Stathatos 3* (1963), p. 190, fig. 94; R. Laffineur, *L'Orfèvrerie rhodienne orientalisante* (1978), pp. 127–37, 230, no. 199, pl. 23,3; *Paris Cat.* (1979), pp. 149–50, fig. 89.

This richly decorated pendant belongs to a small class of highly complex ornaments, the function of which has never been satisfactorily explained. Salzmann (*op. cit.*) thought of them as fastened to a garment. Fontenay (*op. cit.*), struck by an alleged similarity to the diadems of "Priam's treasure"—which was found by H. Schliemann—called them temple pendants, to be worn on either side of the forehead, covering the temples, and he was followed in this by Coche de La Ferté (*op. cit.*), although Fontenay's original comparison was neither apt nor convincing. The pendants might have served as the endpieces of pectorals (Higgins, *op. cit.*), pendants of earrings (Becatti, *op. cit.*), or pendants of necklaces

(Laffineur, *op. cit.*, p. 136).

The sculptural decoration is composed of a lion, a bird, and two griffin heads on the plaque, and two janiform human heads in the middle of the hanging chains. The filigree and granulation connect the pendant with the technique of the rosettes from Melos and Rhodes (101–105).

see colorplate page 35

107 Electrum pendant

Found in the necropolis at Kameiros on Rhodes
Rhodian, about 630–620 B.C.
Height, 8.9 cm. (3½ in.); width, 4 cm. (1⁹⁄₁₆ in.)
Musée du Louvre, inv. S 1208 (Suppl. Bj 2169)

Bibliography: A. Salzmann, *RA* n.s. 8 (1863), pp. 1–6, pl. 10 right; E. Fontenay, *Les Bijoux anciens et modernes* (1897), p. 96; F. Poulsen, *Der Orient und die frühgriechische Kunst* (1912), p. 145, fig. 168; S. Zervos, *Rhodes* (1920), p. 361, fig. 687; G. Becatti, *Oreficerie antiche* (1955), p. 48; E. Coche de La Ferté, *Les Bijoux antiques* (1956), pl. 13,1; R. A. Higgins, *Greek and Roman Jewellery* (1961), p. 113; P. Demargne, *The Birth of Greek Art* (1964), fig. 493; P. Amandry, *Anatolica* 2 (1968), pl. 7, fig. 7; R. Laffineur, *L'Orfèvrerie rhodienne orientalisante* (1978), pp. 127–37, 230, no. 198, pl. 23,1–2; *Paris Cat.* (1979), p. 150, fig. 90.

The decoration of this pendant differs from the previous one (106) in both its organization and its details. The plaque proper is T-shaped and is surmounted by a large rosette which hides the attachment of a loop on the back. The crossbar of the T has two frontal heads in panels, side-by-side; between it and the vertical oblong below is a panther's head. The oblong shows a frontal figure of a nude woman, her arms and hands at her sides. The pendant chains are attached to the bottom corners of the crossbar by staples. Suspended from the chains are flowers (above) and pomegranates (below).

The frontal nudity of the female figure, again coupled with a panther's head, recurs on a Rhodian pendant in the British Museum (Laffineur, *op. cit.*, pl. 9,7), but there the hands cup the breasts, as on the hybrid bee-woman in Heidelberg (*ibid.*, pl. 22,4).

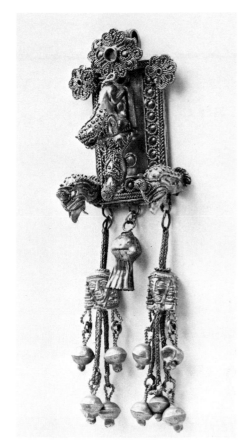

106

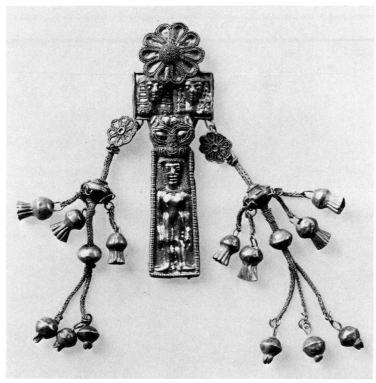

107

108

108 Pair of gold earrings

Found in the necropolis at Kameiros on Rhodes
Rhodian, about 640–630 B.C.
Height, 6 cm. (2⅜ in.); width, 3 cm. (1³/₁₆ in.)
Musée du Louvre, inv. S 1207 (Suppl. Bj 2169)

Bibliography: A. Salzmann, *Nécropole de Camiros*
(1866–75), pl. 1; E. Fontenay, *Les Bijoux anciens et
modernes* (1897), p. 97; S. Zervos, *Rhodes* (1920), p.
17, fig. 4, p. 361, fig. 687 VI, VIII; R. Laffineur,
L'Orfèvrerie rhodienne orientalisante (1978), pp.
139–50, 234, no. 214, pl. 24,6; *Paris Cat.* (1979),
pp. 150–51, fig. 91.

One of the Louvre earrings has a small wire ring
on top of the loop that went through the pierced
earlobe, which explains how these heavy earrings
were worn. The pair is relatively simple in construc-
tion and decoration, with only a rosette disk on top
and two disks with small pyramids of four pellets each
at the lower extremities. In more elaborate earrings of
this class the lower disks are surmounted by griffin
heads, as on other Rhodian gold and electrum jewelry
of this period (cf. Laffineur, *op. cit.*, pls. 23,4,6,
25,3–4,5).

109–113 Eleven electrum plaques

Found in the necropolis at Kameiros on Rhodes
Rhodian, about 640–630 B.C.
Height (with pendants), 109A–C, 110A
–D, each, 6 cm. (2⅜ in.); 111, 4.6 cm.
(1¹³/₁₆ in.); 112, 3.5 cm. (1⅜ in.); 113A
–B, each, 5.4 cm. (2⅛ in.)
Musée du Louvre, inv. S 1210 (Suppl. Bj 2169:
109A–C, 110A–D); S 1211 (Suppl. Bj 2169:
111); S 1222 (Suppl. Bj 2169: 112); S 1218
(Suppl. Bj 2169: 113A–B)

Bibliography: A. Salzmann, *Nécropole de Camiros*
(1866–75), pl. 1; E. Fontenay, *Les Bijoux anciens et
modernes* (1897), p. 144; S. Zervos, *Rhodes* (1920), p.
361, fig. 687 V, XVI, XIX, XX; E. Coche de La Ferté,
Les Bijoux antiques (1955), pp. 55–56, pl. 12,2–5
[112, 109A, 113, 110D]; R. A. Higgins, *Greek and
Roman Jewellery* (1961), pp. 111–13; R. Laffineur,
L'Orfèvrerie rhodienne orientalisante (1978), pp.
33–42, 66–68, 210–11, nos. 98–102 [110, 109,
113, 111, 112]; *Paris Cat.* (1979), pp. 151–53, figs.
92–96.

Among these plaques, two pictorial types can be
distinguished: the winged Artemis with lions or birds
("the Mistress of the Beasts"), and a centaur with a
fawn. Eight of the plaques (109A–C, 110A–
D, 113B) have, preserved, tubes on the top edge
through which a thread could be passed in order to
suspend them, and these may have been worn, strung
together, as pectorals. The other plaques have holes
in the corners indicating that they were fastened to
clothing. The plaques destined for pectorals usually
have pomegranate pendants suspended from the
lower border. In the plaques of the Mistress of the
Beasts (110A–D, 112, 113A–B) the lions are
sometimes held upside down by their tails (110A–
D), or are shown standing upright with the front paws
reaching up to the waist of the goddess (113A–B).
The birds of prey (112) are held by the neck, as are
the fawns carried by the centaurs (109A–C, 111).
There is much variation in the borders; those of the
winged Artemis holding the lions by the tail are more
elaborate. The technique of these reliefs is repoussé.
A bronze relief found at Lindos on Rhodes may well
have served as a positive core over which the elec-
trum, or gold sheets, could have been beaten (Hig-
gins, *op. cit.*, p. 112, note 3).

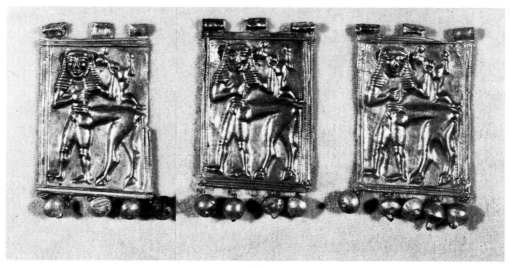

109

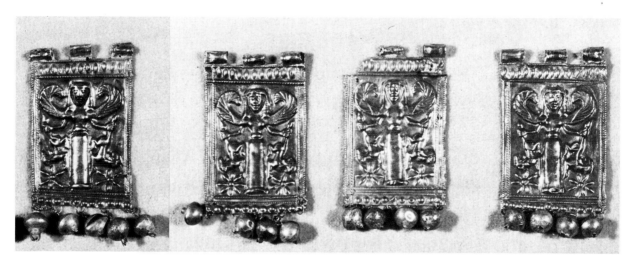

110

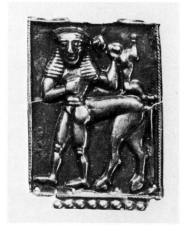

111

112

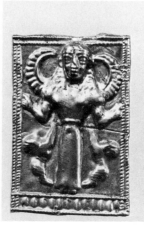

113

159

114 Terracotta aryballos in the shape of a horse's head

Provenance unknown
Rhodian, early 6th century B.C.
Height, 7.6 cm. (3 in.)
The Metropolitan Museum of Art 62.11.12
(Helen H. Mertens Gift, 1962)

Bibliography: A. Oliver, Jr., *AK* 7 (1964), pp. 63–66, pl. 17,1,3,5; J. Ducat, *Les Vases plastiques rhodiens* (1966), pp. 109–12, D 5, pl. 15,4.

More than half of the known aryballoi in the shape of horses' heads have been assigned to Rhodes, and several others are recognized as East Greek. They have been found in both the East and the West, as well as in South Russia. Aryballoi in the shape of helmeted heads appear at about the same time. Once the two types have been found together in a tomb at Vetulonia (*Notizie degli Scavi* [1894], pp. 344 ff.). A Corinthian aryballos in the shape of a seated sphinx, from the same tomb, compares with Corinthian painted pyxides that have female protomai and that date from before 575 B.C. By analogy, these plastic vases are of about the same date.

115 Terracotta aryballos in the shape of the upper body of a warrior

Provenance unknown
Rhodian, early 6th century B.C.
Height, 12.5 cm. (4 15/16 in.)
The Metropolitan Museum of Art 56.11.7
(Rogers Fund, 1956)

Bibliography: J. Ducat, *REA* 59 (1957), p. 238, no. 86; *idem, Les Vases plastiques rhodiens* (1966), pp. 37, 47–48, pl. 7,1–3; K. H. Edrich, *Der jonische Helm* (1969), p. 16, no. K 67.

Of all the Rhodian sculptured vases, the small aryballoi in the shape of helmeted heads are the most common, followed in popularity by those in the shape of a bust—usually of a woman or girl, but sometimes of a youth or man. The rare if not unique vase in New York cleverly combines the two principal Rhodian types. The artist has left the determination of the sex

115

114

rather vague, perhaps deliberately: face and hair are feminine, as are the summary indications of breasts (most of the vases in the shape of feminine busts are flat-chested), but the mustache, perhaps added inadvertently by the painter, makes the figure that of a man.

116 Terracotta aryballos in the shape of a female bust
Provenance unknown
Rhodian, about 560 B.C.
Height, 8.1 cm. (3³/₁₆ in.)
The Metropolitan Museum of Art 39.11.7
(Fletcher Fund, 1939; Ex coll. W. R. Hearst)

Bibliography: *Cat. Vente Hôtel Drouot 19–21 mai 1910*, pl. 23, no. 215; *Cat. Sotheby 11–12 July 1939*, no. 191; G. M. A. Richter, *BMMA* 34 (1939), pp. 286–88, fig. 1; *eadem, AJA* 44 (1940), pp. 181–83, figs. 4–5; *eadem, Archaic Greek Art* (1949), pp. 49, 137, fig. 49; *eadem, Handbook of the Greek Collection* (1953), p. 43, note 107, pl. 30f.; J. Ducat, *Les Vases plastiques rhodiens* (1966), p. 39, C 3, no. 4.

Ducat (*op. cit.*, pp. 31 ff.) has divided these busts into several convenient groups; this bust belongs to his "short" series, so-called since it is not a true bust

117

but stops shortly below the clavicle and shoulders, which gives the figure an appearance of an unintentional décolleté. The face is the same as on the other busts: the same full hair, large eyes, heavy eyebrows, and winning smile.

117 Terracotta aryballos in the shape of a bull's head
Perhaps from Etruria
Rhodian, about 580–560 B.C.
Height, 10.2 cm. (4 in.)
Musée du Louvre, inv. CA 3285
(Gift of F. Villard, 1948)

Bibliography: F. Villard, *Bulletin des Musées de France* (1949), p. 7, fig. 1; J. Ducat, *Les Vases plastiques rhodiens* (1966), p. 103, pl. 14,4; *Paris Cat.* (1979), p. 155, fig. 100.

In contrast to other aryballoi in the shape of a bull's head (cf. Ducat, *op. cit.*, pl. 14), this one does not sit on its neck but has to be suspended. Ducat allots the eight known bull's heads to six different types. The wrinkles above the eyes of the one in the Louvre are particularly forceful.

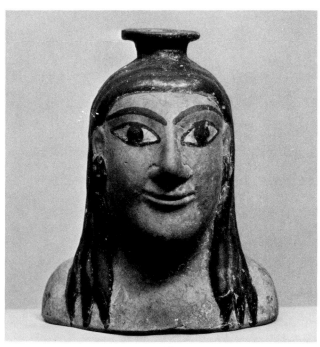

116

**118 Terracotta alabastron (perfume vase)
 in the shape of a standing woman**
Perhaps found on Crete
Rhodian or Samian, 540–530 B.C.
Height, 18.7 cm. (7⅜ in.)
The Metropolitan Museum of Art 26.31.453
 (Bequest of Richard B. Seager, 1926)

Bibliography: G. M. A. Richter, *Handbook of the
Greek Collection* (1953), p. 69, note 27, pl. 51b;
J. Ducat, *Les Vases plastiques rhodiens* (1966), p. 62,
no. 3, pp. 71, 85–86.

The woman is shown wearing the Samian dress,
her hand clutching the garment below and between
her breasts. There are only three parallels known, all
conveniently illustrated, side-by-side, by E. Buschor
(*Altsamische Standbilder* 2 [1934], figs. 121–123).
One of them comes from Locri, one from Rhodes, and
the third was found on Samos. The New York vase
was bequeathed by Seager, and may well have been
found and acquired on Crete.

**119 Terracotta alabastron (perfume vase)
 in the shape of a standing woman**
Found in Thebes
Rhodian, about 560–550 B.C.
Height, 26 cm. (10¼ in.)
Athens, National Museum, inv. 5669

Bibliography: F. Winter, *Die Typen der figürlichen
Terrakotten* 3, 1 (1903), pl. 41,1g; J. Ducat, *Les Vases
plastiques rhodiens* (1966), p. 64, no. 29; G. M. A.
Richter, *Korai* (1968), p. 88, no. 146, figs. 462–465;
Paris Cat. (1979), p. 156, fig. 101.

The woman holds a dove in her left hand and
pulls the chiton with her right. Many examples of this
type exist (Ducat, *op. cit.*, gives thirty-eight); they
have also been found on Samos, Rhodes, Aegina,
Thera, and Delos, and in Perachora, Naucratis,
Locri, Cumae, and Sicily. The same molds were used
for vases and for statuettes. The type has been called
"Samian" because of the facial features, but
their drapery is mostly of the fashion called
"Rhodian."

see colorplate page 36

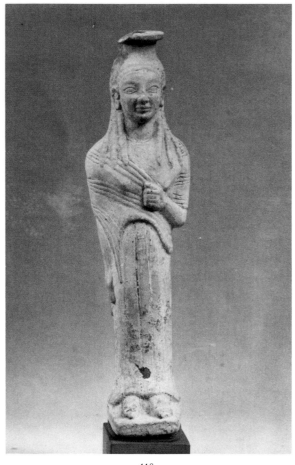

118

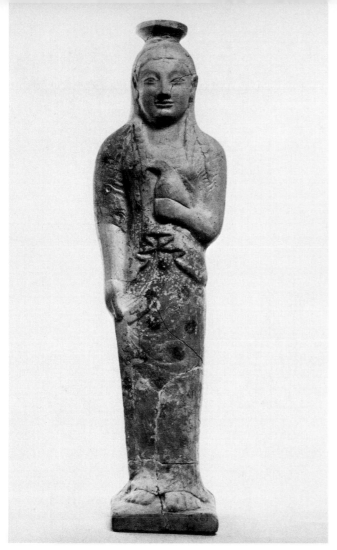

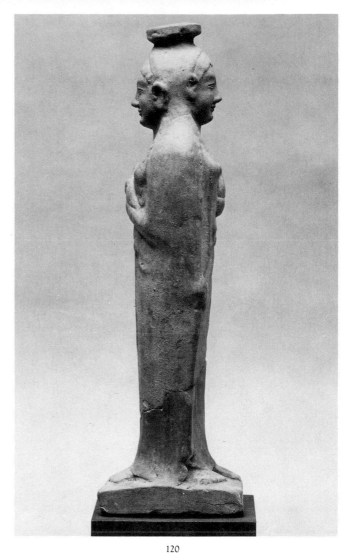

119

120

120 Terracotta alabastron (perfume vase) in the shape of a janiform woman holding a dove
Said to be from western Sicily
Rhodian, about 540 B.C.
Height, with plinth, 27 cm. (10⅝ in.)
The Metropolitan Museum of Art 30.11.6
(Fletcher Fund, 1930)

Bibliography: C. Albizzati, *Antike Plastik. Walther Amelung zum 60. Geburtstag* (1928), pp. 1–4, figs. 1–5; C. Alexander, *BMMA* 25 (1930), pp. 242–44, figs. 1–4; J. D. Beazley (and B. Ashmole) *Greek Sculpture and Painting* (1932), p. 18, fig. 31; E. Buschor, *Altsamische Standbilder* 2 (1934), p. 35, no. 132; C. Alexander, *BMMA* 30 (1935), pp. 178–79; C. W. Lunsingh Scheurleer, *Grieksche Ceramiek* (1936), p. 176; G. Libertini, *Eph. Arch.* (1937), pp. 719–20; G. M. A. Richter, *Archaic Greek Art* (1949), p. 186, figs. 382–383; *eadem, Handbook of the Greek Collection* (1953), p. 69, notes 26, 27, pl. 51c; J. Ducat, *Les Vases plastiques rhodiens* (1966), p. 64, no. 37.

Statuettes, or vases in the shape of statuettes, were mold made, and sometimes, as here, janiform, with two different fronts joined together. The type enjoyed considerable popularity throughout the Greek world and was exported widely. Though probably made in Rhodes, in the eastern part of the Mediterranean, this alabastron was almost certainly found in western Sicily. The drapery is more advanced than that of the alabastron from Thebes (**119**), now in Athens.

**121 Bronze statuette of a kneeling Gorgon
(support of a tripod)**
 Found in the sea off Rhodes, 1883
 About 550 B.C.
 Height, 55 cm. (21⅝ in.)
Musée du Louvre, inv. MNC 482 (Br. 2570;
 purchase, 1883)

Bibliography: A. Furtwängler, in Roscher, *Ausführliches Lexikon der griechischen und römischen Mythologie* 1 (1884–90), col. 1710; S. Reinach, *Répertoire de la statuaire grecque et romaine* 2 (1897), p. 682, fig. 1; A. De Ridder, BCH 22 (1898), p. 453; *idem, Les Bronzes antiques du Louvre* 2 (1915), pp. 98–99, pl. 92; *Paris Cat.* (1979), pp. 156–57, fig. 102.

The Gorgon, shown without wings and snakes and wearing a long belted dress, kneels below a lion's foot that must have been the foot of a tripod. A bronze volute krater in Belgrade (inv. Br. 174/I: N.

Vulić, AA [1930], cols. 287–298; L. Popović, *Katalog Trebeništa* [1956], p. 50, pl. 23a–c; *idem, Antička bronze u Jugoslaviji* [1969], p. 71, no. 33, pl. 21), from Trebenishte, has a tripod support that combines kneeling Gorgons with lions' feet in a similiar manner, save that here the Gorgons kneel on the lions' feet. The large scale of the Louvre support favors the suggestion that this Gorgon is the foot of a tripod that supported a bowl, rather than a volute krater as on the Belgrade tripod.

122 Terracotta neck-amphora
 On obverse and reverse, each,
 is a hare-headed man.
 Found at Kameiros on Rhodes
 Rhodian (Fikellura), about 550–540 B.C.
 Height, 43 cm. (16 15/16 in.); diameter,
 32 cm. (12⅝ in.)
Musée du Louvre, inv. S 445 (A 330)

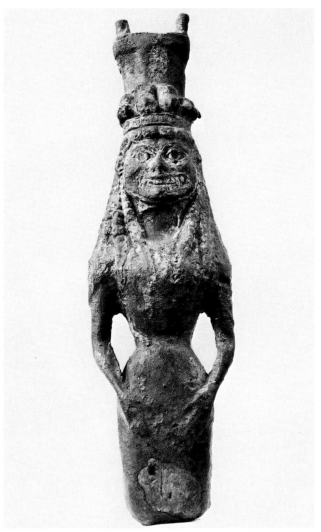

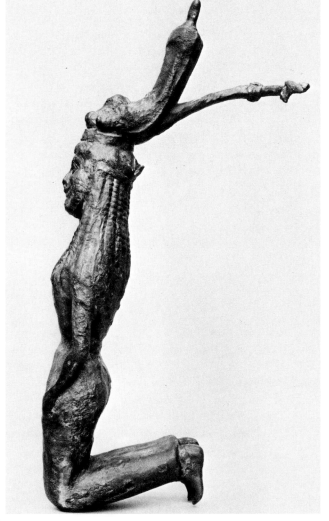

Bibliography: A. Salzmann, *Nécropole de Camiros* (1866–75), pl. 38; A. de Longpérier, *Musée Napoléon III* (1868–74), pl. 9,1; E. Pottier, *Vases antiques du Louvre* 1 (1897), p. 14, no. A 330; idem, *CVA Louvre* 1 (1922), II Dc, pl. 2,11; R. M. Cook, *BSA* 34 (1933–34), p. 20, L (Running Man Group), no. 3; E. Walter-Karydi, *Samos* 6, 1 (1973), pp. 54, 107, note 165, p. 133, no. 549, pl. 72; *Paris Cat.* (1979), pp. 156–57, fig. 103.

The curious figure of a hare-headed man, running to right, is repeated on the other side of the vase. E. Buschor ("Satyrtänze und frühes Drama" [*Sitzungsberichte der bayerischen Akademie der Wissenschaften*, Munich, 1943], p. 63) has thought of these creatures as men wearing a disguise, but F. Brommer (*Vasenlisten*[3] [1973], p. 430) has justly compared the representation with the companions of Odysseus transformed by Circe: the hare-headed runners are certainly not too far removed in spirit from the victims on the two Attic cups in Boston (*CVA Boston* 2 [1978], pls. 87–88), and a Rhodian vase-painter might well have been inspired by Attic imports.

123 Terracotta neck-amphora

Found on Cyprus
Rhodian (Fikellura), about 530 B.C.
Height, 29.7 cm. (11 11/16 in.)
The Metropolitan Museum of Art 23.160.35
(Rogers Fund, 1923; Ex coll. L. P. di Cesnola)

Bibliography: J. Doell, *Die Sammlung Cesnola* (1873), pl. 17,1, no. 3611; L. P. di Cesnola, *Cyprus* (1877), p. 410, fig. 30; idem and L. Stern, *Cypern* (1879), pl. 91,3; G. M. A. Richter, *BMMA* 19 (1924), p. 97; P. Jacobsthal, *Ornamente griechischer Vasen* (1927), pl. 20a,c; R. M. Cook, *BSA* 34 (1933–34), pp. 26–27, figs. 3–4; P. C. Sestieri, *Archeologia Classica* 2 (1950), p. 4; G. M. A. Richter, *Handbook of the Greek Collection* (1953), p. 42, note 94, pl. 29g.

The decoration of this vase is purely ornamental. It is arranged in highly disciplined bands, of which the most prominent, on the body of the vase, has palmettes springing from large volutes. The neck has a triple cable pattern; in the frieze on the shoulder the buds are shown hanging, as befits their location on the vase.

122

123

124

125

124 Terracotta neck-amphora
Found on Aegina
Rhodian (Fikellura), about 540 B.C.
Height, 28 cm. (11 in.)
Athens, National Museum, inv. 10816

Bibliography: J. Boehlau, *Aus jonischen und italischen Nekropolen* (1898), p. 58, no. 35; E. Pfuhl, *Malerei und Zeichnung der Griechen* (1923), p. 157, pl. 28, fig. 129; R. M. Cook, *BSA* 34 (1933–34), p. 48, Y 3 (a) no. 13, pl. 15b; *Paris Cat.* (1979), p. 158, fig. 104.

This is one of the most pleasing Fikellura vases: not only is it exceptionally well preserved, but the purely ornamental decoration is well designed and harmonious. The patterns on neck and shoulder are not identical on both sides. The crescents above the rays in the lower part of the body of the vase occur as early as about 580 B.C. in Cook's Lion Group (*op. cit.*, p. 5, B I, 1, pl. 1f) and are a very common motif, while the dividing band above them—short strokes that spring from the line above and the one below—is very rare in Fikellura vases.

125 Terracotta neck-amphora with four hounds coursing
Said to be from Düver in Anatolia
Rhodian (Fikellura), about 540 B.C.
Height, 25.05 cm. (9 ⅞ in.)
The Metropolitan Museum of Art 65.73.2 (Gift of Mr. and Mrs. J. J. Klejman, 1965)

Bibliography: previously unpublished.

The shape is very close to **124**, which R. M. Cook (*BSA* 34 [1933–34], p. 48) has classed under amphoriskoi, shape (a). Stylistically, the hounds recall the decoration on the olpe in Corinth (Cook, *op. cit.*, pl. 4a–b, Lion Group BI; E. Walter-Karydi, *Samos* 6,1 [1973], pl. 88, no. 642).

126 Terracotta oinochoe (wine jug)
Provenance unknown
Rhodian (Fikellura), about 540 B.C.
Height, 15.3 cm. (6 in.); diameter, 11.14 cm. (4 ⅝ in.)
The Metropolitan Museum of Art 1974.11.2
(Richard A. Van Avery Gift Fund, 1974)

126

127

Bibliography: *The Metropolitan Museum of Art: Notable Acquisitions 1965–1975* (1975), p. 130.

The pattern work connects this jug with R. M. Cook's class BII (*BSA* 34 [1933–34], pp. 6–8), which he has dated (*op. cit.*) "perhaps about 550–540." The shape is rare in Fikellura, and there is no exact parallel. The Attic counterparts of oinochoai with a round mouth (as opposed to a trefoil mouth) begin with the Burgon Group (J. D. Beazley, *ABV* [1956], p. 90, no. 4); the high handle first occurs on an oinochoe in New York (06.1021.64: Beazley, *op. cit.*, p. 442, no. 3), but there is no discernible influence of the Attic shape on the Rhodian one.

127 Terracotta chalice

The figure decoration, a lion, is limited to the obverse.
Found in the necropolis at Kameiros on Rhodes
Chiot, about 580–570 B.C.
Height, 14 cm. (5½ in.); diameter, 14.4 cm. (5 11/16 in.)
Musée du Louvre, inv. S 682 (A 330 [1])

Bibliography: A. Salzmann, *Nécropole de Camiros* (1866–75), pl. 38; A. de Longpérier, *Musée Napoléon III* (1868–74), pl. 52; E. Pottier, *Vases antiques du Louvre* 1 (1897), p. 14; S. Zervos, *Rhodes* (1920), p. 62, fig. 117; E. Pfuhl, *Malerei und Zeichnung der Griechen* (1923), p. 145, pl. 27, fig. 120; R. M. Cook, *Greek Painted Pottery*[2] (1972), pp. 126–28, fig. 20; E. Walter-Karydi, *Samos* 6,1 (1973), pp. 67, 139, no. 756, pl. 94; *Paris Cat.* (1979), p. 124, fig. 66.

Chiot vases are easily recognizable by their white slip, which is whiter than elsewhere in the East, and by certain shapes, of which the chalice is the most characteristic. In the sixth century, having abandoned the Wild Goat tradition, Chiot potters and painters briefly explored the black-figure technique, but their greatest achievement is a style that continued the fashion of showing details in reserved lines — the so-called Chalice Style. What is particularly pleasing is the absence of filling ornaments, which gives these chalices an elegance seldom encountered on Greek vases of this period.

167

SAMOS

Nos. 128–154 Samos

One of the most productive of all the Greek islands, Samos occupies an important position near the Anatolian mainland and its large Ionian cities. A sanctuary of Hera, famous since the tenth century, was enlarged repeatedly: the temple of Hera erected by Rhoikos and Theodoros, already of extraordinary proportions, was rebuilt under Polykrates (533– 522 B.C.) on an even larger scale. Samos has yielded many bronzes (some of which were dedicated in Olympia) and is justly renowned, as well, for its marble sculptures. Side-by-side with many local products, the excavations on Samos have also yielded imports from as far away as Egypt, Assyria, and Phrygia.

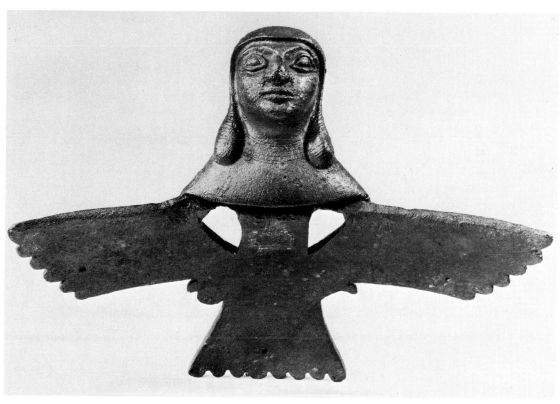

128

128 Bronze attachment of a bowl
 Found on the north slope of the stadium in
 Olympia
 Oriental, last quarter of the 8th century B.C.
 Height of bust, 9 cm. (3 9/16 in.); width,
 25.5 cm. (10 1/16 in.)
Olympia, Museum, inv. B 4260

Bibliography: H.-V. Herrmann, *Olympische For-schungen* 6 (1966), no. A 6, p. 31, pl. 12; *Paris Cat.* (1979), p. 165, fig. 105.

The attachment, which is solid cast, consists of flat spread wings and an avian tail with engraved feathers that hugged the bowl to which it was riveted. This part is surmounted by a fully sculpted human protome that faced inward. Two rudimentary arms emerge on the back and are spread out over the wings. Though commonly called "sirens," the Oriental ancestry of these figures and the absence of avian feet make the term inappropriate. A ring on the back served for a swinging handle (not preserved). A loop over each wrist suggests that the wings are worn, rather than organically connected with the body. The features of the face relate this attachment and the following three to an Eastern workshop, located either in Urartu or North Syria.

171

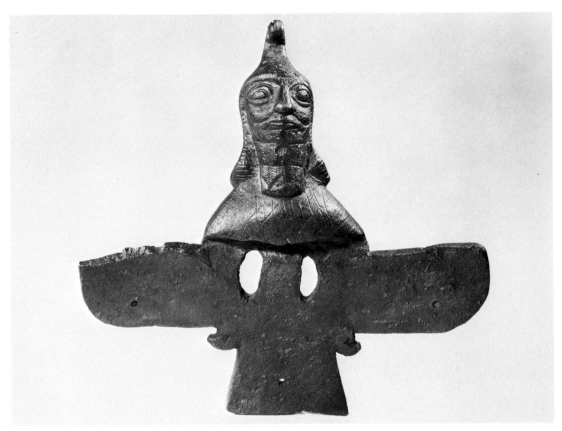

129

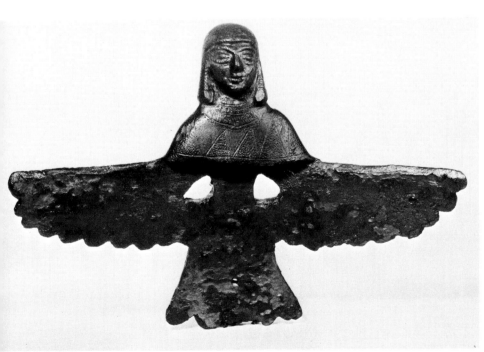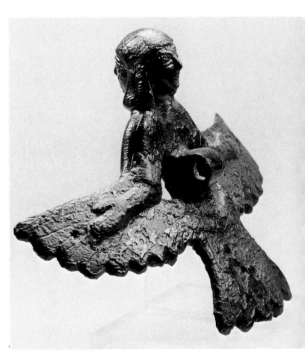

130

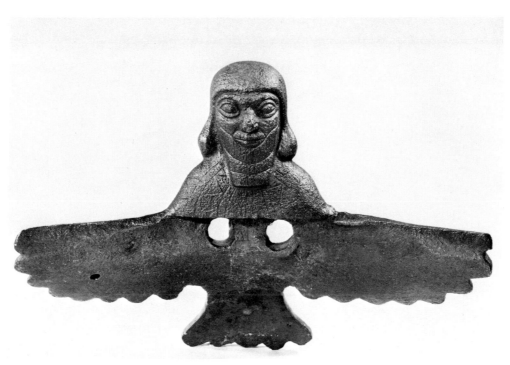

131

129 Bronze attachment of a bowl
Found on the north slope of the stadium in
Olympia
Oriental, last quarter of the 8th century B.C.
Height of bust, 11.5 cm. (4½ in.); width,
21.5 cm. (8½ in.)
Olympia, Museum, inv. B 4312

Bibliography: H.-V. Herrmann, *Olympische For-schungen* 6 (1966), no. A 5, p. 31, pl. 11; *Paris Cat.* (1979), p. 165, fig. 106.

The head of this attachment is bearded and wears a helmet of a type known in the Near East. The bust is now somewhat taller and the shoulders are more pronounced. The arms, spread out as on **128**, are more articulated.

130 Bronze attachment of a bowl
Found south of the stadium in Olympia
Oriental, last quarter of the 8th century B.C.
Height of bust, 7.8 cm. (3¹/₁₆ in.); width, 22.9
cm. (9 in.)
Olympia, Museum, inv. B 1735

Bibliography: H.-V. Herrmann, *Olympische For-schungen* 6 (1966), no. A 2, p. 30, pl. 8; *Paris Cat.* (1979), p. 166, fig. 107.

This attachment has a janiform head. Since the hands are schematized and rather flat, it is not clear whether their backs or palms were intended to be shown.

131 Bronze attachment of a bowl
Found separately, in two pieces, on the north
slope of the stadium in Olympia
Oriental, last quarter of the 8th century B.C.
Height of bust, 6.2 cm. (2 ⁷/₁₆ in.); width,
19.5 cm. (7 ¹¹/₁₆ in.)
Olympia, Museum, inv. B 4313, B 4681

Bibliography: H.-V. Herrmann, *Olympische Forschungen* 6 (1966), no. A 2, p. 31, pl. 8; *Paris Cat.* (1979), p. 166, fig. 108.

The bust is bearded, as is **129**, but does not wear a helmet. Smaller, too, in scale, it appears to lean over into the bowl to which it was riveted.

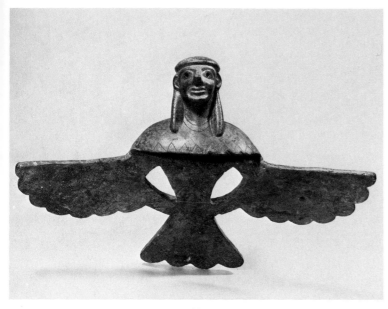

132

132 Bronze attachment of a bowl

Found on the north slope of the stadium in
 Olympia
Greek, first quarter of the 7th century B.C.
Height of bust, 6 cm. (2⅜ in.); width,
 20.3 cm. (8 in.)
Olympia, Museum, inv. B 28

Bibliography: T. J. Dunbabin, *The Greeks and their
Eastern Neighbours* (1957), pp. 42–44, pl. 12,1,3,5;
H.-V. Herrmann, *Olympische Forschungen* 6 (1966),
no. A 22, p. 92, pl. 32; *Paris Cat.* (1979), pp. 166–
67, fig. 109.

At first glance this attachment looks very much
like the previous four, but a view of the back and
profile shows how the Greek artist has subtly im-
proved on his Oriental models. The head sits more
organically on the neck and shoulders, and the nose,
lips, and chin have acquired a prominence lacking in
the others, but comparable to the facial features of
contemporary Greek bronzes and vases. The arms
have gained in volume and the elbows are clearly
indicated by incised lines resembling bracelets. The
ring in back has given way to a solid protrusion, more
ornamental than functional: Greek bowls were set on
tripods and were not carried about like their Eastern
prototypes.

133 Bronze attachment of a bowl

Found in a well at the southwest corner of the
 stadium in Olympia
Greek, first quarter of the 7th century B.C.
Height of bust, 5.9 cm. (2 5/16 in.); width,
 15.3 cm. (6 in.)
Olympia, Museum, inv. B 1690

Bibliography: H.-V. Herrmann, *Olympische For-
schungen* 6 (1966), no. A 20, pp. 91–93, pl. 30; M.
Weber, AM 89 (1974), p. 39, pl. 18,1–2; *Paris Cat.*
(1979), p. 167, fig. 110.

The scale of the human bust is the same as in
132, but the wings are much shorter. Here, the angu-
larity of the construction is extended to the hair and
reinforced by the deliberate divisions of the engraved
patterns on both the hair and the bust. The style is
surely Peloponnesian — either Argive, as Herrmann

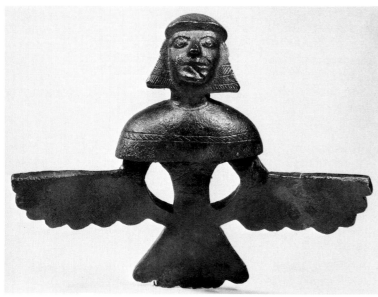

133

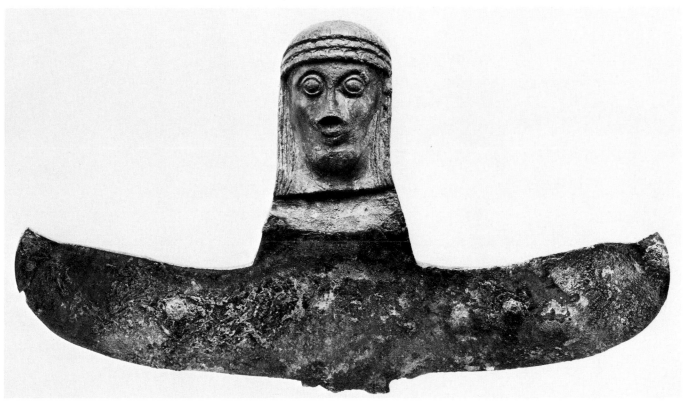

134

proposes, or, more likely, Laconian, Mrs. M. Weber's preference.

The counterpart to this attachment, likewise from Olympia, is in Athens (Herrmann, *op. cit.*, no. A 19, p. 91, pl. 29).

134 Bronze attachment of a bowl
　　Found in the Heraeum on Samos, 1969
　　Samian, about 700 B.C.
　　Height, as preserved, 14.7 cm. (5 13/16 in.);
　　　　width, 25.8 cm. (10 3/16 in.)
Vathy (Samos), Museum, inv. B 1341

Bibliography: H. Walter, *Arch. Deltion* 18 (1963), *Chronika*, p. 294, pl. 342,1; H.-V. Herrmann, *Olympische Forschungen* 6 (1966), pp. 29, 147, 187; U. Jantzen, *AK* 10 (1967), pp. 91–93, pl. 25,1–6; G. Kopcke, *AM* 83 (1968), no. 97, p. 284, pl. 112; *Paris Cat.* (1979), pp. 167–68, fig. 111.

This attachment and its mate, formerly in Berlin (Jantzen, *op. cit.*, pl. 26,1), differ radically from those found at Olympia. There are no loops on the back for the swinging ring-handles by which the bowl was carried, and the human arms spread over the wings are likewise gone. The sculpted parts are much simplified; the feathers of wings and tail (the latter missing on the Samos bronze but known from the one once in Berlin) are lightly incised and do not affect the contours. The modeling is modest and reticent, and the head lacks volume, resembling in this respect Samian terracotta appliqués.

Walter (*op. cit.*) attributed the attachment to Phrygia and Herrmann (*op. cit.*) called it perhaps provincial East Greek. Jantzen (*op. cit.*) was the first to recognize its artistic home and proper date.

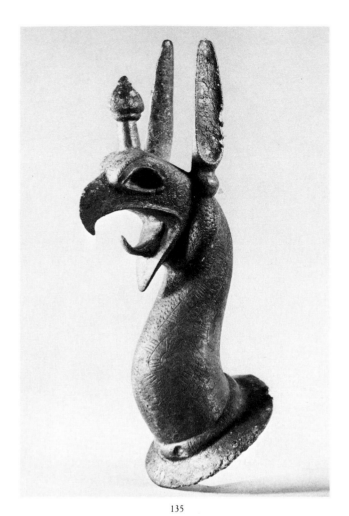

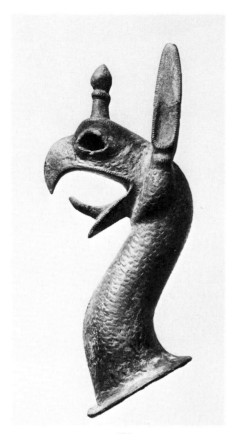

135

136

135–139 Five bronze griffin attachments of bowls
Found in the Heraeum on Samos, 1956–65
Samian, (**135–136**) last quarter of the 7th cen-
tury B.C.; (**137–138**) about 600 B.C.; (**139**)
first half of the 6th century B.C.
Height, **135**, 24.8 cm. (9 ¾ in.); **136**, 13.5 cm.
(5 ⁵/₁₆ in.); **137**, 15.5 cm. (6 ⅛ in.); **138**,
20.1 cm. (7 ¹⁵/₁₆ in.); **139**, 16.5 cm. (6 ½
in.)
Vathy (Samos), Museum, inv. B 1239, 1240, 1156,
1077, 1725

Bibliography: *Paris Cat.* (1979), pp. 168–69, figs.
112–116; two of the griffins have not been published
by the excavators; for B 1239 (**135**) and B 1077 (**138**)
see H. Walter and K. Vierneisel, AM 74 (1959), pp.
30–31, Beilage 68,2, Beilage 70,3; for B 1156 (**137**)

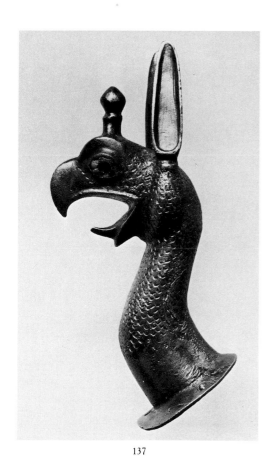

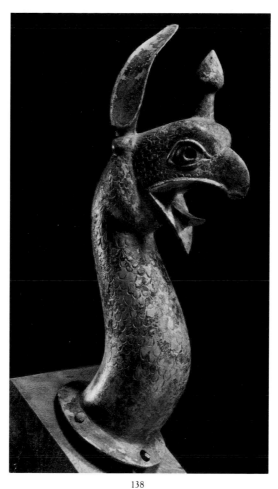

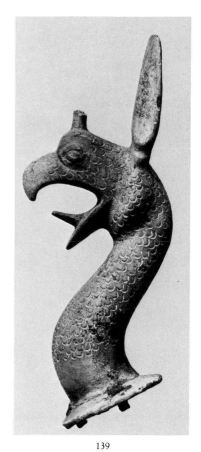

137

138

139

see U. Jantzen, AM 73 (1958), p. 42, no. 132f, Beilage 44,3.

The five griffin protomai once decorated the shoulders of bowls that were set on tripods, popular dedications in archaic Greece and especially in the sanctuary of Hera on Samos. A monograph by Jantzen (*Griechische Greifenkessel* [1955]) deals with this class and establishes chronological groups that, for their convenience, have been retained. Number **135**, with its fillet above the flange, belongs with Jantzen's Group IV; **136**, without the fillet, fits into Group V; **137** and **138** resemble each other in the curvature of the neck, and are of Group VI; the fifth protome, **139**, is later still, and goes well with the griffins of Group VII.

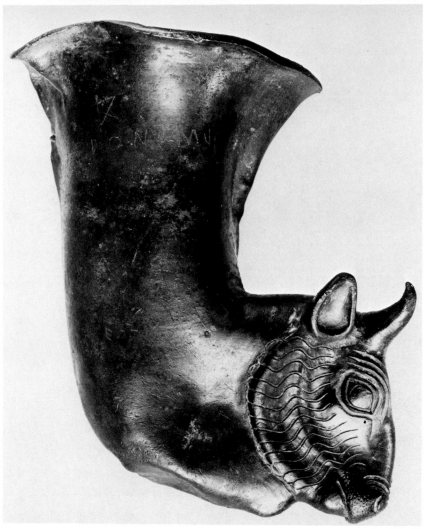

140

140 Bronze rhyton in the shape of a bull's head
Found in the Heraeum on Samos, 1965
Samian, about 600 B.C.
Height, 14.5 cm. (5¾ in.); diameter of cup,
 about 8.5 cm. (3⅜ in.)
Vathy (Samos), Museum, inv. B 1866

Bibliography: E. Homann-Wedeking, *AA* (1966), p.
159, fig. 2; G. Kopcke, *AM* 83 (1968), p. 289, no.
113, p. 314, pl. 121, 1–2; E. Homann-Wedeking,
AA (1969), pp. 553–54, figs. 4, 5; G. Dunst, *AM* 87
(1972), pp. 144–45; *Paris Cat.* (1979), pp. 169–70,
fig. 117.

The earliest inscription on the rhyton identifies
it as a dedication to Hera by Diagores; a second
inscription declares it to be the property of the god-
dess; a third (on the inside of the rim) gives the name
of Charileos, probably a priest, and seems to take with
it the salutation on the outside, "greetings, priest!"
Two letters, A B, below the horns on the bull's
forehead, are probably ancient inventory marks.

Metal rhyta were first developed in the East and
must have reached Greece from Anatolia, but the
angle between the cup proper and the animal head, as
here, is a particularly Greek convention. The model-
ing of the head suggests a date of about 600 B.C.,
which is not contradicted by the date of the inscrip-
tions.

141 Bronze plaque with a winged horse
Found in the Heraeum on Samos, 1936
Phrygian(?), 7th–6th century B.C.(?)
Height, 13.7 cm. (5⅜ in.); width, 14.9 cm.
 (5⅞ in.)
Vathy (Samos), Museum, inv. B 446

Bibliography: E. Buschor, *AA* (1937), cols. 203–210, fig. 5; H. Walter and K. Vierneisel, *AM* 74 (1959), p. 18, Beilage 28, 2; U. Jantzen, *Samos* 8 (1972), pp. 53–54, pl. 49; *Paris Cat.* (1979), p. 170, fig. 118.

This well-preserved bronze plaque and its more corroded mate must have been attached to a piece of wooden furniture or perhaps to a chariot, unless, as on bronze greaves and helmets, the small holes along the edges indicate that there was originally a leather lining. The extreme ornamentalization of the wing and the somewhat exaggerated contours of the horse's head speak for a non-Greek origin and have prompted Jantzen to propose Phrygia.

142 Bronze fountain head
A frog crouching on a lion's head
Found in the Heraeum on Samos
East Greek, last quarter of the 7th century B.C.
Height, 12 cm. (4¾ in.); length, 15 cm.
(5 15/16 in.)
Athens, National Museum, inv. 16512

Bibliography: E. Buschor, *AM* 55 (1930), p. 30, pl. 1; idem, *Altsamische Standbilder* 3 (1935), p. 57, figs. 213, 216, 217; R. Lullies, *Theoria. Festschrift für W.-H. Schuchhardt* (1960), p. 142, note 2; *Paris Cat.* (1979), pp. 170–71, fig. 119.

Frogs love water, and it is therefore not surprising that a Samian artist put one on a fountain head. The discrepancy in scale between the frog and the lion's head is surely deliberate: the frog is a lifesize adjunct, whereas the lion's head is merely the conventional spout, and is quite undisturbed by its intrepid occupant.

143 Fragmentary bronze attachment in the shape
of a winged woman
Found in the Heraeum on Samos, 1938
Samian, early 6th century B.C.
Height, 6.6 cm. (2⅝ in.); width, as preserved,
10 cm. (3 15/16 in.)
Vathy (Samos), Museum, inv. B 491

Bibliography: *Paris Cat.* (1979), p. 171, fig. 120.

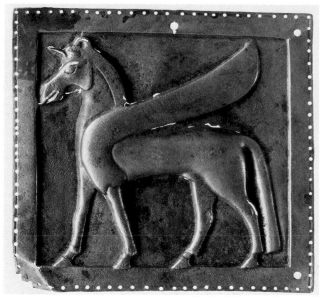

141

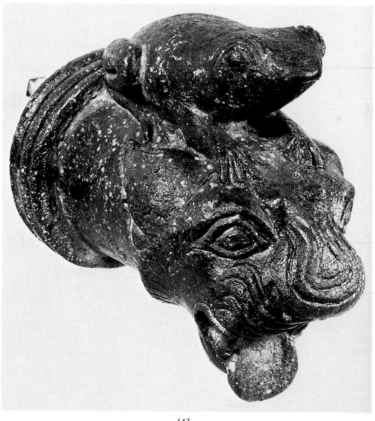

142

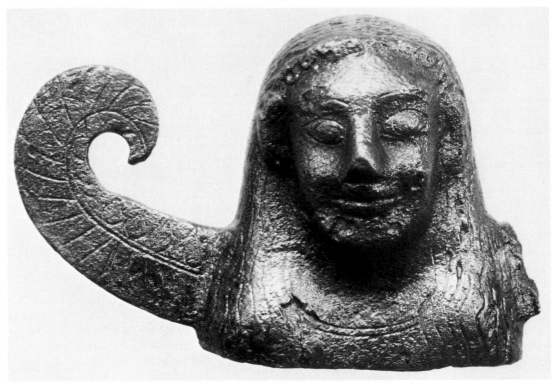

143

This winged figure was probably attached to the rim of a vessel. It has not been published by the excavators, and nothing has become known of the context in which it was found.

144 Bronze statuette of a youth (kouros)
 Found in the Heraeum on Samos
 Samian, early 6th century B.C.
 Height, with plinth, 19 cm. (7½ in.)
Vathy (Samos), Museum, inv. B 1675

Bibliography: E. Buschor, *Altsamische Standbilder* 1 (1934), p. 9, figs. 5, 7, 8; *ibid.* 4 (1960), p. 66, fig. 252; *idem, Frühgriechische Jünglinge* (1950), pp. 74 ff., figs. 84–85; G. M. A. Richter, *Kouroi²* (1960), no. 22, pp. 55–56, figs. 117–119; *Paris Cat.* (1979), pp. 171–72, fig. 121.

Unlike other kouroi, both arms of this bronze from Samos are bent at the elbows, with the hands not fully open but in a carrying position. The forearms are turned toward one another and the upper arms are well separated from the trunk. The contours of the top of the head and the back hair are rather straight. Boots are indicated on both feet by incised lines. Stylistically and chronologically the kouros is very close to another somewhat larger statuette also found on Samos (Buschor, *op. cit.*, 1 [1934], figs. 6, 9, 10; Richter, *op. cit.*, no. 23, p. 56, figs. 120–122).

145 Bronze statuette of a youth (kouros)
 Found in the Heraeum on Samos
 Samian, about 570 B.C.
 Height, as preserved, 19 cm. (7½ in.)
Vathy (Samos), Museum, inv. B 652

Bibliography: E. Buschor, *Altsamische Standbilder* 1 (1934), p. 13, figs. 35, 37, 38; G. M. A. Richter, *Kouroi²* (1960), no. 52, p. 71, figs. 187–189; *Paris Cat.* (1979), p. 172, fig. 122.

Compared with the earlier statuette from Samos (**144**), the advances made by sculptors in a few decades become apparent: the shoulders are more rounded, the waist is narrower, and the hair has lost its flat and angular rigidity.

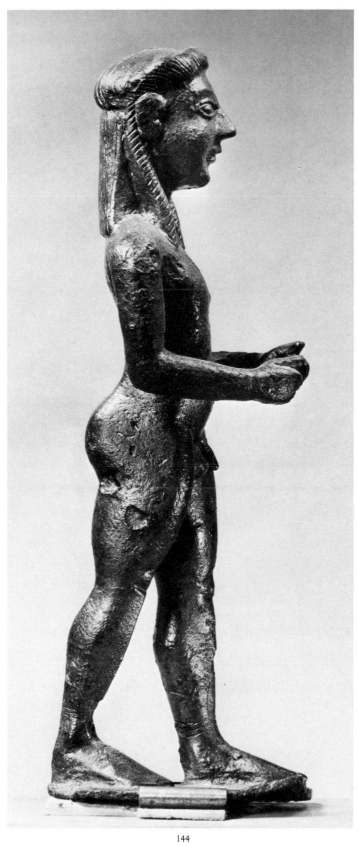

144

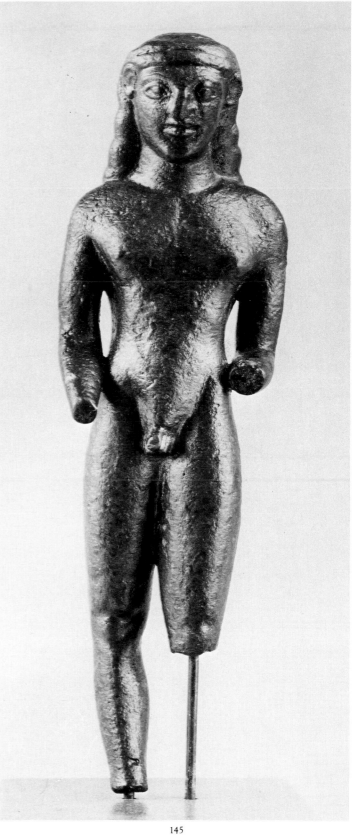

145

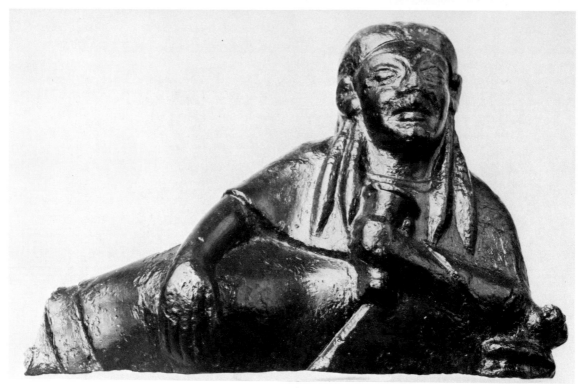

146

146 Bronze statuette of a reclining banqueter

Found in the Heraeum on Samos, 1925
Samian, third quarter of the 6th century B.C.
Height, 9.5 cm. (3¾ in.)
Vathy (Samos), Museum, inv. B 2

Bibliography: E. Buschor, *Gnomon* 2 (1926), pp. 122–23; *idem, Altsamische Standbilder* 3 (1935), p. 50, figs. 181–182, 193; J. Charbonneaux, *Les Bronzes grecs* (1958), p. 84, pl. 14,3; *Paris Cat.* (1979), pp. 172–73, fig. 123.

A youth wearing a himation is shown reclining on his left side, his left elbow supported by a folded pillow. In his left hand he holds a drinking horn; his right is held flat against his knees. The back is summarily treated; the statuette must have been riveted to the upper ring of a tripod rather than to the rim of a bowl (cf. the similar banqueters on the tripod from Trebenishte in Belgrade, *AA* [1933], cols. 467–468, figs. 2–3). The backs of these figures would have been obscured by the bowl placed on the tripod.

147 Bronze statuette of a flute player

Found in the Heraeum on Samos, 1925
Samian, third quarter of the 6th century B.C.
Height, 42 cm. (16½ in.)
Athens, National Museum, inv. 16513

Bibliography: E. Buschor, *Gnomon* 2 (1926), p. 122; E. Langlotz, *Frühgriechische Bildhauerschulen* (1927), p. 118, no. 10, p. 121; E. Buschor, *Altsamische Standbilder* 3 (1935), pp. 43–44, figs. 146–149; G. Lippold, *Die griechische Plastik* (1950), pp. 59–60, pl. 12,3; J. Charbonneaux, *Les Bronzes grecs* (1958), pp. 83–84, pl. 18,1; V. G. Kallipolitis and E. Touloupa, *Bronzes of the National Archaeological Museum of Athens* [n.d.], p. 22, no. 18, pl. 18; *Paris Cat.* (1979), p. 173, fig. 124.

Though the flutes that were worked separately are now missing, the interpretation is secure, thanks to the position of the hands and the indication of the *phorbeia*, the slit leather strap that supported and partly covered the lips, which was fastened across the head and in back under the hair. The musician's head is thrown slightly back. He wears a special, belted tunic with short sleeves. The eyes, now lost, were inlaid.

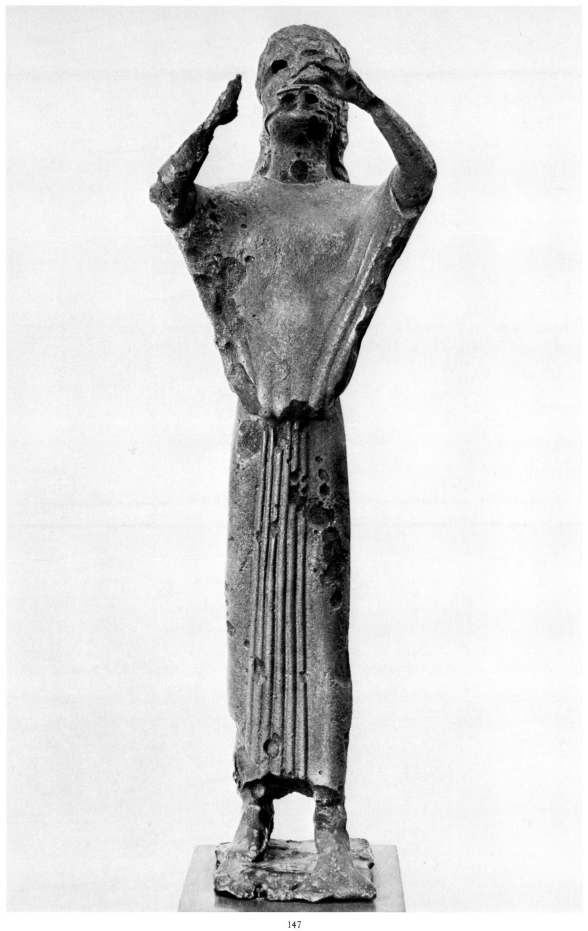

147

149

148 Fragmentary bronze facing with reliefs in panels

Found at Olympia, 1959
East Greek (Samian?), about 570 B.C.
Height, as preserved, 31.3 cm. (12 5/16 in.);
width, 15.3 cm. (6 in.)
Olympia, Museum, inv. M 77

Bibliography: *BCH* 84 (1960), p. 720, pl. 18,2; N. Yalouris, *Arch. Deltion* 17 (1961/62), *Chronika*, p. 107, pl. 114; K. Schefold, *Frühgriechische Sagenbilder* (1964), p. 89, pl. 80; *Paris Cat.* (1979), pp. 173–74, fig. 125.

The bronze strip, like others of this class (cf. F. Willemsen, *7. Olympiabericht* [1961], pp. 181 ff., pls. 79–83; D. von Bothmer, *BMMA* 19 [1960–61], pp. 135–51, figs. 2–6), once decorated the leg of a tripod to which it was riveted. Of the three subjects represented in panels on this fragment, the one on top, only half preserved, has not been identified (a woman appears to the right, behind two male figures

that face each other); the one in the middle shows Orestes slaying his mother Klytaimestra in the presence of Electra, and, at the right, an armed youth runs off, looking back; the lowest panel has two figures wrestling, with a woman looking on. As both wrestlers wear helmets and the one on the right seems to be female, the combat of Achilles and Penthesilea has been suggested, in spite of the absence of shields and a certain resemblance to such scenes as a terracotta relief from Tegea (Schefold, *op. cit.*, pl. 28) that is generally taken to represent Peleus and Thetis.

149 Fragmentary bronze relief with the departure of a warrior

Found at Olympia, 1959
East Greek (Samian?), about 570 B.C.
Height, 21.4 cm. (8 7/16 in.); width, as preserved, 34 cm. (13 3/8 in.)
Olympia, Museum, inv. M 78

Bibliography: *BCH* 84 (1960), p. 720; F. Willemsen, *7. Olympiabericht* (1961), p. 190; N. Yalouris, *Arch.*

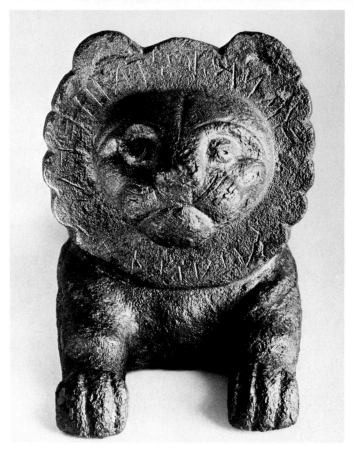

150

Deltion 18 (1961/62), *Chronika*, p. 107, pl. 113; A. Yalouris, *AJA* 75 (1971), pp. 269–75, pl. 64; *Paris Cat.* (1979), pp. 174–75, fig. 126.

A chariot is ready to depart, with the young charioteer already in the box. A hero steps into it with his right leg, looking back at a woman with a small child seated on her left shoulder. To these the hero extends his left hand in a gesture of farewell. If the attitude of the departing warrior toward his family were less friendly, one would at once label the chief figure Amphiaraos, but there is no trace of anger here. Parts of another woman, who lifts the edge of her mantle, appear facing right, on the extreme left of the fragment.

150 Bronze statuette of a recumbent lion
Cut off at the hindquarters.
Found in the Heraeum on Samos, 1925
About 550 B.C.
Height, 10 cm. (3 15/16 in.); length, 16 cm. (6 5/16 in.)

Vathy (Samos), Museum, inv. B.5

Bibliography: E. Buschor, *Gnomon* 2 (1926), p. 122; H. Gabelmann, *Studien zum frühgriechischen Löwenbild* (1965), pp. 69–71, no. 69; G. Dunst, *AM* 87 (1972), pp. 140–41, fig. 6, pl. 56; *Paris Cat.* (1979), p. 175, fig. 127.

The statuette bears a dedicatory inscription "Eumnastos, from Sparta, to Hera" in Laconian characters, and the rather summary treatment of the hindquarters of the lion makes an exact stylistic attribution difficult. If the sculptor was a Samian, the Laconian inscription must have been prepared by someone else — perhaps the dedicator himself.

151 Bronze statuette of a woman
The eyes, now missing, were inlaid.
Found in the Heraeum on Samos, 1963
Samian, about 560–550 B.C.
Height, 27 cm. (10 5/8 in.)
Vathy (Samos), Museum, inv. B 1441

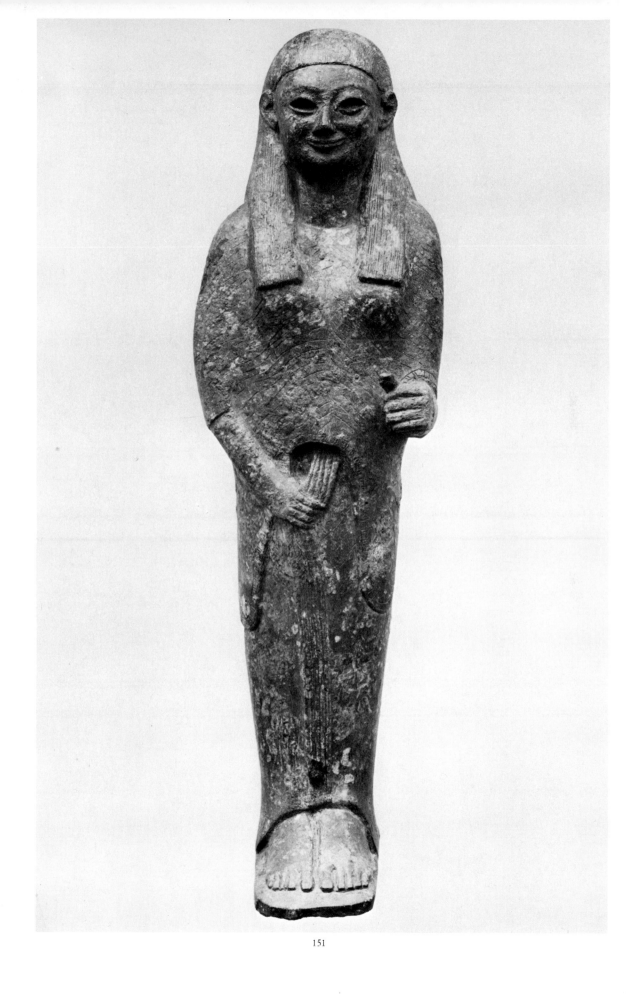

151

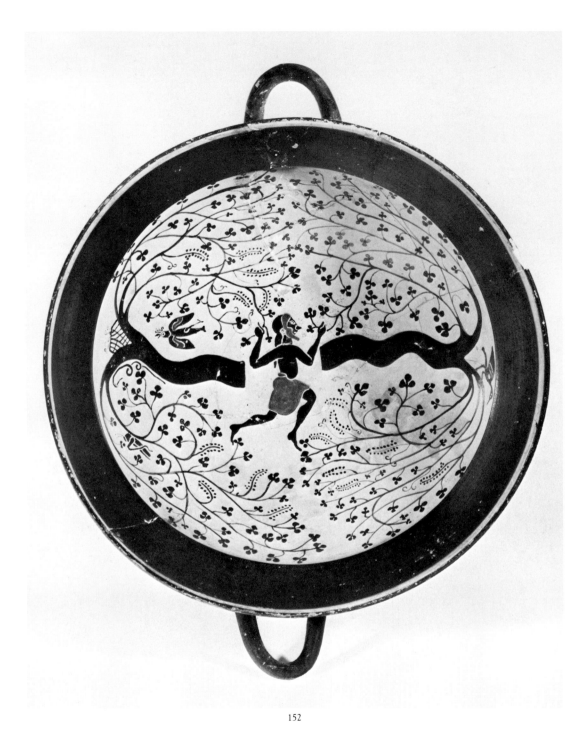

152

Bibliography: E. Homann-Wedeking, AA (1964), cols. 223 – 225, fig. 6; A. Greifenhagen, *Jahrbuch der Berliner Museen* 7 (1965), pl. 145, fig. 25; B. Freyer - Schauenburg, *Samos* 11 (1974), pp. 26, 40, 51; *Paris Cat.* (1979), pp. 175 – 77, fig. 128.

Both in style and pose this bronze statuette invites comparison with the plastic terracotta alabastron in the shape of a woman attributed to Rhodes (see **119**). The function of such statuettes was votive and dedicatory: the votary is represented in an attitude of worship. *see colorplate page 36*

152 Terracotta kylix (wine cup)

The tondo of the interior, which stretches almost all the way to the rim, shows a fowler shaking the branches of two trees, each of which occupies one half of the kylix. The tree on the left has a bird's nest with three fledglings in the crook between two branches, which the mother bird approaches holding an insect in her beak. A grasshopper and a snake appear in the foliage of the same tree, while the opposite tree harbors another bird.

Perhaps found in Etruria
Samian, about 550 B.C.
Height, 15 cm. (5 15/16 in.); diameter, 23.5 cm. (9 1/4 in.); width, 30 cm. (11 13/16 in.)
Musée du Louvre, inv. Cp 263
(F 68; purchase, 1861)

Bibliography: E. Pottier, *Vases antiques du Louvre 2* (1901), p. 97, pl. 68; A. Merlin, *Vases grecs du style géométrique au style à figures noires* (1928), p. 10, pl. 39, 2; J. D. Beazley, *JHS* 52 (1932), p. 169, note 13; E. Pottier, *CVA Louvre 8* (1933), III He, pl. 78, 3, 5, 8; E. Kunze, *AM* 59 (1934), pp. 101–4, Beilage 8, 1–2; R. M. Cook, *BSA* 34 (1936), p. 3, notes 3–5, pl. 11b; C. M. Robertson, *Greek Painting* (1959), pp. 68–72; P. E. Arias, M. Hirmer, B. Shefton, *A History of 1000 Years of Greek Vase Painting* (1961), pl. 51, pp. 295–96; E. Buschor, *Griechische Vasen²* (1969), pp. 96–98, fig. 104; E. Walter-Karydi, *Samos 6, 1* (1973), no. 419, p. 128, pls. 13, 46; E. Simon, *Die griechischen Vasen* (1976), pl. 35, p. 57; *Paris Cat.* (1979), p. 177, fig. 129.

At first classed as "Attic" by Pottier (*op. cit.*) and "Attico-Ionian" by Merlin (*op. cit.*), the kylix was recognized as Ionian by K. Rhomaios (*AM* 31 [1906], pp. 190–91), who was seconded by H. Payne (*BSA* 29 [1927–28], p. 284, note 1). Miss E. R. Price was the first to attribute it to the fabric known as Fikellura (*CVA Oxford* II [1931], pp. 88–89). Shefton (*op. cit.*, p. 296) and J. Boardman (*Greek Art* [1964], p. 98, fig. 84) suggest a Samian workshop, and this has been accepted by Mrs. Walter-Karydi (*loc. cit.*). The interpretation of the subject has recently been revised by Miss Simon (*op. cit.*), who believes that the two "trees" are vines with vine leaves and blossoms and who identifies the man between them as the "Lord of the Trees," hence, a Dionysiac demon or Dionysos himself. The rim of the cup is decorated on the outside with a conventional ivy wreath. As in many East Greek vases, the silhouettes are enlivened with reserved rather than incised lines.

153 Marble statue of a youth (kouros)

The head and lower legs are missing.
Found near Tigani on Samos, 1890
Samian, about 560 B.C.
Height, as preserved, 100 cm. (39 3/8 in.)
Vathy (Samos), Museum, inv. 69

Bibliography: T. Wiegand, *AM* 25 (1900), pp. 149–50, no. 1, pl. 12; E. Buschor, *Altsamische Standbilder I* (1934), pp. 17 ff., figs. 20, 57, 59, 60; G. M. A. Richter, *Kouroi* (1942), p. 143, figs. 201–203; E. Buschor, *Frühgriechische Jünglinge* (1950), pp. 77–78, figs. 86–87; L. H. Jeffery, *The Local Scripts of Archaic Greece* (1961), pp. 329 (no. 5), 341, pl. 63; B. Freyer-Schauenburg, *Samos 11* (1974), no. 35, pp. 69–73, pls. 20–22; J. G. Pedley, *Greek Sculpture of the Archaic Period: the Island Workshops* (1976), no. 33, p. 47, pls. 24b, 25; *Paris Cat.* (1979), pp. 178, 180–81, fig. 131.

This was not a tomb statue, as were other kouroi, but a dedication to Apollo by a certain Leukios, as proved by the inscription which runs in two lines along the left thigh. A sanctuary of Apollo on Samos has not been found, but one was mentioned by Pausanias (II 31, 6). Though, like most kouroi of the sixth century, the pose and attitude are traditional—left leg advanced, both arms close to the sides—there is much difference between individual statues: compare this kouros with the one from Paros (**160**), and the two factors responsible for these differences—period and locality—become apparent.

154

154 Marble statue of a draped youth
Identified by an inscription as Dionysermos, son
of Antenor.
The ankles and feet are missing.
Provenance unknown
Samian (?), about 530–520 B.C.
Height, as preserved, 69 cm. (27 ³/₁₆ in.)
Musée du Louvre, inv. MND 2283 (MA 3600; pur-
chase, 1966)

Bibliography: P. Devambez and L. Robert, *RA*
(1966), pp. 195 ff.; G. Daux, *BCH* 91 (1967), pp.
491–93; E. Langlotz, *Studien zur nordostgriechischen
Kunst* (1975), pp. 133 ff., pls. 31,7,9, 32,1, 34,2;
Paris Cat. (1979), pp. 181–82, fig. 132.

Dionysermos wears a chiton with short sleeves
and a himation which, on its principal vertical fold,
bears the single-line inscription that identifies him.
His features are very full and far from idealized. Less
than half lifesize, this statue is a modest work of an
East Greek sculptor whose interest was less directed
toward anatomy.

ARCHAIC SCULPTURE
OF THE ISLANDS

Nos. 155–171 Archaic Sculpture of the Islands

The transition from limestone to marble at the end of the seventh century marked a new beginning that culminated in the supremacy of Greek sculpture. In this development, which was both rapid and phenomenal, the islands of the Cyclades and their sculptors were in the lead. Naxos and Paros are the earliest centers, to which, in the outer orbit, Samos, Thasos, and Chios must be added. The influence also extended to Attica, and beyond. The chief sculptural types are the kouros and kore — the former, a statue of a nude youth; the latter, a statue of a draped girl. The kouros, more than the kore, placed the emphasis on a progressive understanding of anatomy which, once mastered, liberated sculpture from formal concepts and brought on the full sculptural freedom of the classic period.

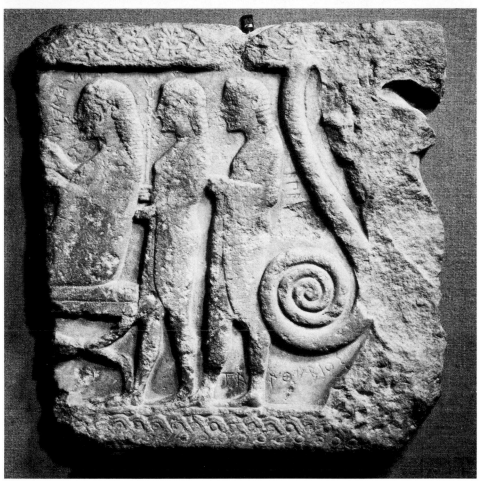

155

155 Fragmentary marble relief with Agamemnon (seated), the herald Talthybios, and Epeios (the names are inscribed)

Said to have been found on Samothrace about 1788 and bought by Count Choiseul-Gouffier on Tenedos

Ionian Island Style, about 560 B.C.

Height, 46 cm. (18 ⅛ in.); length, as preserved, 45 cm. (17 ¾ in.)

Musée du Louvre, inv. Clarac 608 (MA 697; purchase, 1818)

Bibliography: L. J. J. Dubois, *Catalogue d'antiquités . . . formant la collection de feu M. le Cte de Choiseul-Gouffier. . . vente à l'ancien hôtel de Marboeuf. . . le 20 juillet et jours suivants* (Paris, 1818), p. 38, no. 109; J. Millingen, *Ancient Unedited Monuments 2* (1826), pl. 1; O. M. von Stackelberg, *AdI 1* (1829), pp. 220–21, pl. C,2; Mme. Chevallier-Vérel, in *Encyclopédie photographique de l'art 3* (1938), p. 135; K. Lehmann, *Hesperia 12* (1943), pp. 130 ff., pls. 9, 10a; J. Bousquet, *RA 1948, 1* (*Mélanges Picard*), pp. 112 ff.; G. M. A. Richter, *Archaic Greek Art* (1949), p. 96; L. H. Jeffery, *Local Scripts of Archaic Greece* (1961), pp. 299, 307, no. 56, pl. 57; *Paris Cat.* (1979), pp. 189–90, fig. 133.

Agamemnon is seated to the left on a campstool covered with a cushion. His arms are bent at the elbow and his hands are slightly raised. Behind him approach the herald Talthybios, with a caduceus in his right hand, and a second youth whose fragmentary name Epe . . . has been restored to read Epeios (the builder of the Trojan horse). The much-effaced creature to the extreme right is the protome of a griffin, facing right, whose best-preserved feature is the long spiral curl that issues from its head.

The function of the relief (whose thickness has been reduced by sawing off most of the back) remains as enigmatic as its interpretation. The lettering, standard eastern Ionic, is not, however, limited to Samothrace.

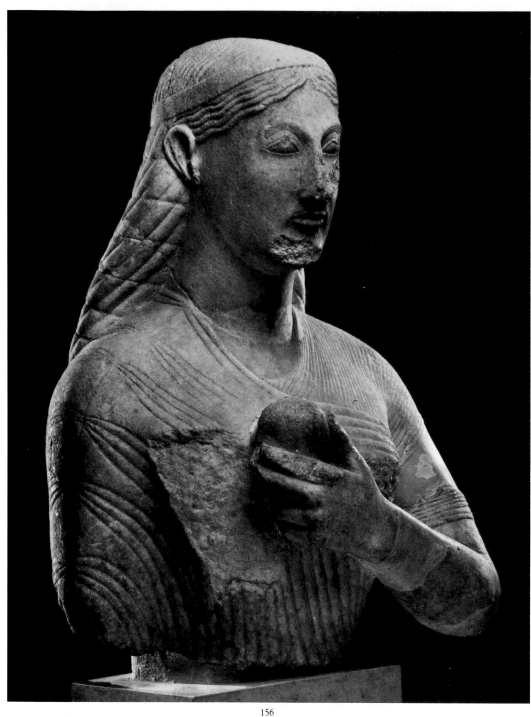

156

156 Upper part of a marble statue of a woman (kore)
Found on the Athenian Acropolis west of the
Erechtheion, February 5–6, 1886
Naxian or Samian, about 560–550 B.C.
Height, as preserved, 53.5 cm. (21 1/16 in.)
Athens, Acropolis Museum, 677

Bibliography: P. Kavvadias, *Eph. Arch.* (1886), p. 82;
H. Lechat, *Au Musée de l'Acropole d'Athènes* (1903),
pp. 393 ff., fig. 44; E. Buschor, *Altsamische Standbilder*
2 (1934), p. 24, figs. 80–83; H. Payne and G.
Mackworth-Young, *Archaic Marble Sculpture from the
Acropolis* (1936), pp. 12–13, pls. 18–19; G. M. A.

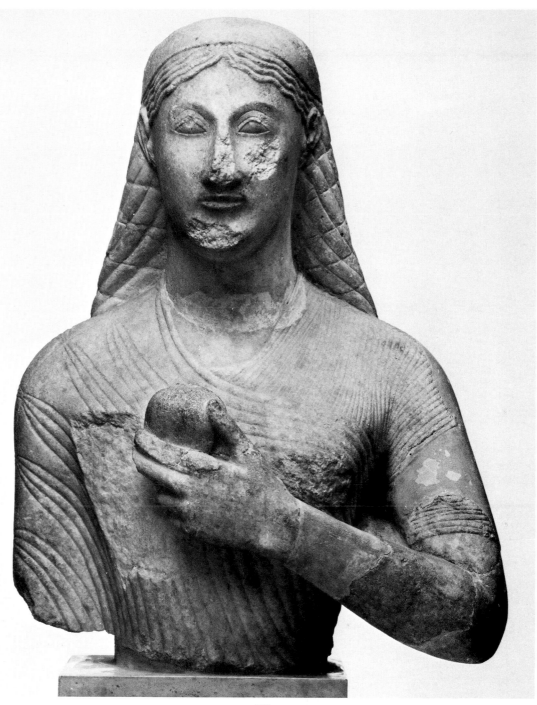

156

Richter, *Korai* (1968), p. 47, no. 59, figs. 198–200; M. Brouskari, *Musée de l'Acropole* (1974), p. 52, fig. 91; J. G. Pedley, *Greek Sculpture of the Archaic Period: the Island Workshops* (1976), pp. 28–29, pl. 5 a–c; *Paris Cat.* (1979), pp. 190–91, fig. 134.

The kore wears a sleeved chiton and an Ionic himation, both buttoned on the shoulder. In her left hand she holds a pomegranate. The ribbon in her hair is knotted in the back. The style of the statue has been compared with Naxos (for the face) and with Samos (for the drapery). *see colorplate page 37*

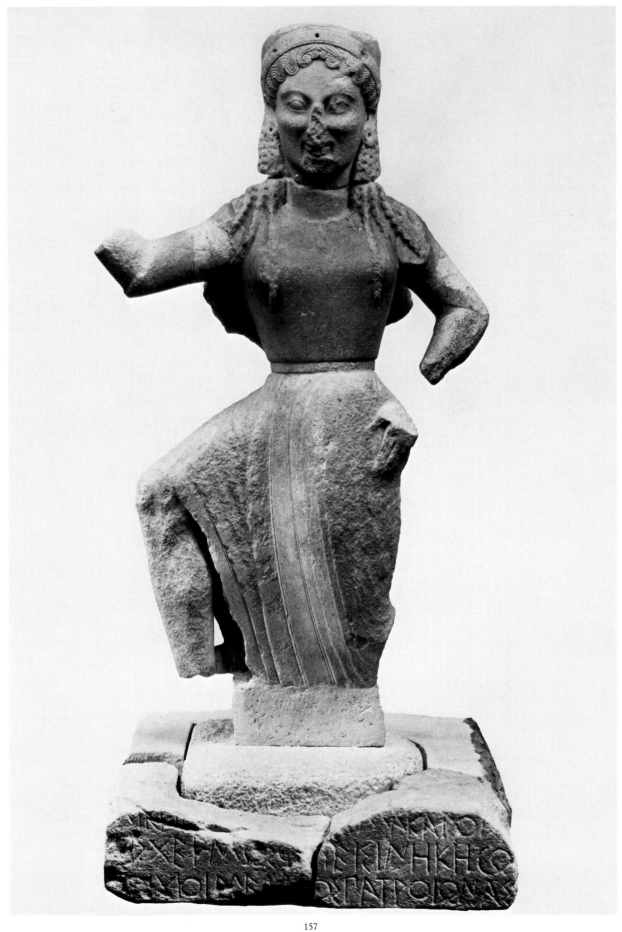

157

157 Marble statue of a running Nike

Most of the wings, right hand, right foot, and left leg below the knee are missing.

Found on Delos, 1877, not far from a base, to which it is now attached, with the signature of Archermos; the arms were found later

Chiot (?), about 550 B.C.

Height (without base), 90 cm. (35 7/16 in.)

Athens, National Museum, inv. 21, 21a

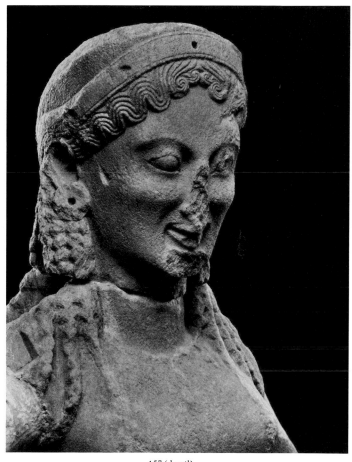

157 (detail)

Bibliography: T. Homolle, *BCH* 3 (1879), pp. 393–99, pls. 6–7; *idem, ibid.* 4 (1881), pp. 272–78; B. Sauer, *AM* 16 (1891), pp. 182–90; F. Studniczka, *JdI* 43 (1928), pp. 213 ff., figs. 61, 63; O. Rubensohn, *MdI* 1 (1948), pp. 21–43; J. Marcadé, *BCH* 74 (1950), p. 182, pl. 31; W. Darsow, *MdI* 3 (1950), pp. 120–21, pls. 3,2, 5,1; L. H. Jeffery, *The Local Scripts of Archaic Greece* (1961), pp. 294–95, 305, no. 30, pl. 56; G. M. A. Richter, *Korai* (1968), pl. XIVa, p. 55; S. Karouzou, *National Archaeological Museum, Collection of Sculpture* (1968), p. 9; C. Isler-Kerényi, *Nike* (1969), *passim*; *Paris Cat.* (1979), pp. 191–93, fig. 135.

A scholiast on Aristophanes' *Birds* (line 574) notes that Archermos of Chios was the first sculptor to show Nike winged, and it must therefore have been tempting to associate this winged figure with the inscribed base that (in three lines) calls this beautiful statue an accomplished work of the clever hands of Archermos, an offering to Apollo by Mikkiades of Chios who lives in the ancestral city of Melas. Pliny, moreover, in his *Natural History* (36.5,11), gives the three names mentioned in the inscription as a dynasty of sculptors: Mikkias son of Melas and father of Archermos. But there are certain difficulties: the inscription is generally dated later than the sculpture, and the lettering is not Chiot. Lastly, it is not even entirely certain that the figure is a Nike. The position of the legs and the direction of the folds seem to indicate that the statue touched the base with both feet and with the drapery between the legs, its chief support—differing in this respect from the later flying figure from the Acropolis (159): for a restored reconstruction see A. Furtwängler, *AZ* 40 (1882), cols. 324–325.

Though the back of the statue is less finished than the front, it preserves the wing of the right foot. Dowel holes in the diadem and earlobes reveal that metal ornaments were once added. The pendants of the necklace, however, are worked in relief.

see colorplate page 38

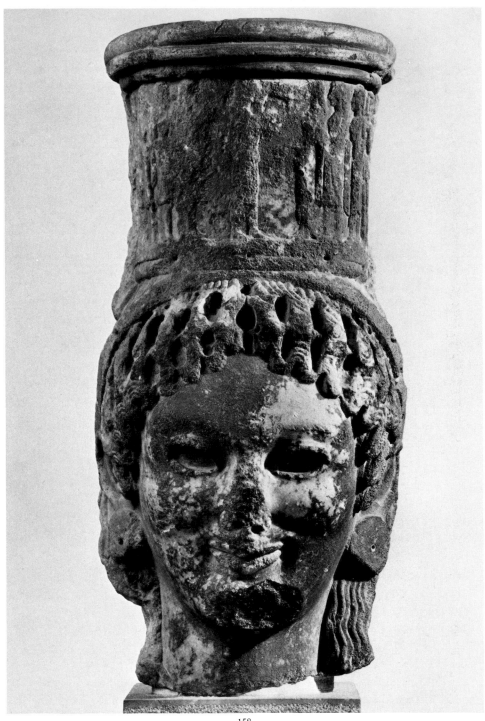

158

158 Marble head of a woman (caryatid)
The eyes were once inlaid.
Found at Delphi, April 13, 1894
Ionian (Chiot?), about 540–530 B.C., or later
Height, as preserved, 66 cm. (26 in.); height
 of head alone, 40 cm. (15¾ in.)
Delphi, Museum, inv. 1203

Bibliography: *Sculptures grecques de Delphes* (1927),
pl. 26; C. Picard and P. de La Coste-Messelière,
Fouilles de Delphes 4,2 (1928), pp. 1–5, figs. 1–4,
suppl. pls. 1–2; P. de La Coste-Messelière, *BCH* 62
(1938), pp. 285–88; W. Darsow, *MdI* 3 (1950), pp.
119–34, pls. 3,2, 4,2; P. de La Coste-Messelière and
J. Marcadé, *BCH* 77 (1953), pp. 354–60; G. M. A.

159

Richter, *Korai* (1968), p. 57, no. 86, figs. 270–274; E. Langlotz, *Studien zur nordostgriechischen Kunst* (1975), pp. 140–43, pls. 15,1–4, 50,4; *Paris Cat.* (1979), pp. 192, 194–95, fig. 136.

Once associated with the Treasury of the Cnidians, the caryatid is now attributed to a North Ionian school. The frieze on the "polos" above the head, unfortunately poorly preserved, shows Apollo playing the lyre, followed by four Nymphs or Muses, and Hermes playing the syrinx, preceded by the three Graces; for the subject, compare the Thasian reliefs (172).

159 Small marble statue of a flying Nike

The head, both forearms, much of the wings, and the lower legs are missing.

Found on the Acropolis in Athens, southwest of the Parthenon, in the 1880s

Ionian (Chiot), late 6th century B.C.

Height, as preserved, 39 cm. (15⅜ in.)

Athens, Acropolis Museum, inv. 691

Bibliography: E. Schmidt, *JdI* 35 (1920), pp. 102–3, 106, figs. 5–6; E. Buschor, *AM* 47 (1922), p. 105; E. Langlotz, *Frühgriechische Bildhauerschulen* (1927), p. 136, pl. 83b; H. Payne and G. Mackworth-Young, *Archaic Marble Sculpture from the Acropolis* (1936), p. 62, pl. 119; E. Langlotz, in H. Schrader, *Die archaischen Marmorbildwerke der Akropolis* (1939), p. 119, no. 69; C. Isler-Kerényi, *Nike* (1969), pp. 91–92, 111; M. Brouskari, *Musée de l'Acropole* (1974), pp. 85–86, fig. 156; *Paris Cat.* (1979), pp. 195–96, fig. 137.

The rapid motion of this Nike in flight is conveyed through the angles of the arms and legs and the windswept hair and drapery. In contrast to the much earlier Nike by Archermos (157), both feet were probably in the air: the statue rested on the lower border of the central vertical folds of the himation. The head was slightly turned.

see colorplate page 39

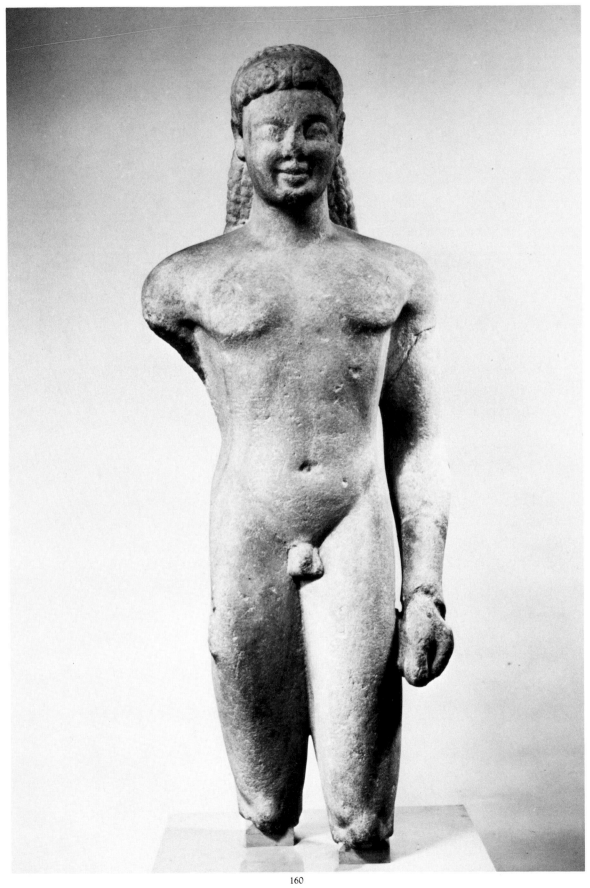

160

160 Marble statue of a youth (kouros)

The right arm and both legs below the knees are missing.

Found northwest of the sanctuary of Asklepios on Paros

Parian, about 540 B.C.

Height, as preserved, 1.03 m. (39 9/16 in.)

Musée du Louvre, inv. MND 888
(MA 3101; purchase, 1910)

Bibliography: O. Rubensohn, AM 27 (1902), pp. 230 ff., pl. 11; Mme. Chevallier-Vérel, in *Encyclopédie photographique de l'art* 3 (1938), pl. 137c; E. Buschor, *Frühgriechische Jünglinge* (1950), pp. 123–26, figs. 142–143; G. M. A. Richter, *Kouroi²* (1960), p. 107, no. 116, figs. 356–358; J. G. Pedley, *Greek Sculpture of the Archaic Period: the Island Workshops* (1976), p. 39, pls. 16–17; C. Rolley, *BCH* 102 (1978), pp. 41–50; *Paris Cat.* (1979), pp. 196–97, fig. 138.

The radiant expression of youth is expressed on this statue through the "archaic smile" and the strong yet soft contours of the body. The Parian school of sculpture was most important, but not many of its works are preserved. The kouros in the Louvre, together with torsos in Copenhagen and in the Museum on Paros, demonstrate the specific contribution of the Parian style — a certain exuberance, not shared by the other archaic schools of Greek sculpture.

161 Marble herm

Found on Siphnos, 1895; brought to Athens, 1935

Siphnian, about 510 B.C.

Height, 66 cm. (26 in.); width, 13 cm. (5¼ in.); depth, 8.8 cm. (3 7/16 in.)

Athens, National Museum, inv. 3728

Bibliography: R. Lullies, *Die Typen der griechischen Herme* (1931), p. 36, note 14, p. 15; J. F. Crome, *AM* 60–61 (1935–36), pp. 300 ff., pls. 101, 103–104; P. Devambez, *RA* (1968), p. 146, note 5; S. Karouzou, *National Archaeological Museum, Collection of Sculpture* (1968), p. 15; *Paris Cat.* (1979), pp. 197–98, fig. 139.

According to a literary tradition, herms were first introduced in Attica in the time of Hipparchos, the son of Peisistratos, who installed such pillars on the roads and crossroads. The rectangular shaft, surmounted by a head of Hermes, later developed into a pillar terminating in a portrait: in that form, herms continued into Roman times and beyond. Two lateral projections, below the shoulders, served for the suspension of wreaths and other offerings. Though often represented on Attic vases, very few marble herms have survived from the archaic period. The sculptured parts of the herm from Siphnos have been compared with certain Attic marbles, and there is a good chance that the herms from Attica served as a model.

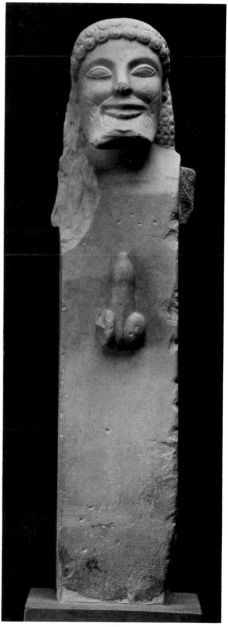

161

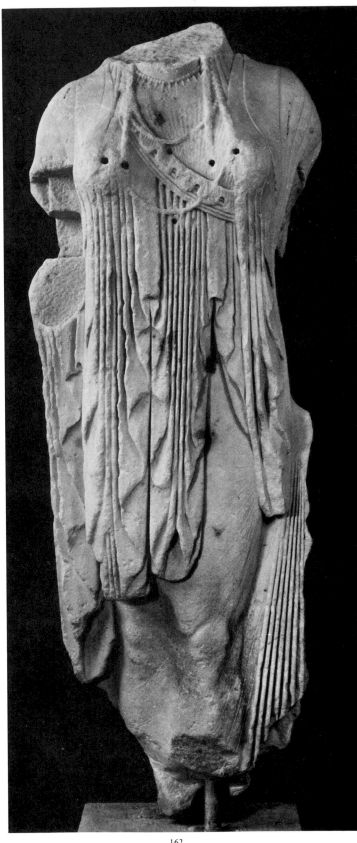

162

162 Marble statue of a woman (kore)
The head, most of the left arm, and the right
arm are missing.
Found in the agora on Delos, July, 1884
Parian (?), about 500 B.C.
Height, as preserved, 1.34 m. (52 ¾ in.)
Athens, National Museum, inv. 22

Bibliography: T. Homolle, *De antiquissimis Dianae
simulacris deliacis* (1885), p. 31; P. Paris, *BCH* 13
(1889), pp. 217–25, pl. 7; E. Langlotz, in H.
Schrader, *Die archaischen Marmorbildwerke der Akropolis* (1939), p. 42; J. Marcadé, *BCH* 74 (1950), pp.
203 ff., and 76 (1952), p. 278; G. M. A. Richter,
Korai (1968), no. 148, pp. 88–89, figs. 472–475; S.
Karouzou, *National Archaeological Museum, Collection
of Sculpture* (1968), pp. 9–10; *Paris Cat.* (1979), pp.
198–200, fig. 140.

The votive statue wears three garments: a chiton, a himation, and an *epiblema* (shawl) draped over
the shoulders, as well as a necklace and two pectorals.
The holes at the extremities of the four tresses that fall
across her breasts indicate that the hair was decorated
with bronze ornaments, as were the pectorals. The
right arm, now missing, was worked in a separate
piece of marble and doweled to the body; it was
probably bent at the elbow. The statue was found
with five others, forming a group: in the center, Zeus
and Hera enthroned, surrounded by Athena, Apollo,
Artemis, and Leto. The shawl, as Marcadé shows,
helps to identify this statue as Leto, who gave birth on
Delos to her twins Apollo and Artemis. Though the
workmanship is Cycladic (perhaps Parian), the
sculptor was clearly familiar with korai dedicated on
the Athenian Acropolis.

Two fragments in the Museum on Delos (A 4076
and A 1724, not exhibited here) complete the right
leg.

see colorplate page 40

163 Marble statue of a woman (kore)
 The head, both arms, and both legs below
 the knees are missing.
 Found on Paros, before 1860
 Parian, late 6th century B.C.
 Height, as preserved, 105.5 cm. (41 ⁹/₁₆ in.)
The Metropolitan Museum of Art 07.306
 (Gift of John Marshall, 1907)

Bibliography: A. Michaelis, *AdI* (1864), p. 267; A. Furtwängler, *AZ* 40 (1882), cols. 326–327, note 7; A. Löwy, *AEM* 11 (1887), pp. 159–60, fig. 13, pl. 6,1; E. Langlotz, *Frühgriechische Bildhauerschulen* (1927), p. 135, pl. 82,a,c; H. Payne and G. Mackworth-Young, *Archaic Marble Sculpture from the Acropolis* (1936), p. 23, note 1, pp. 56, 61; E. Langlotz, in H. Schrader, *Die archaischen Marmorbildwerke der Akropolis* (1939), p. 110; G. Lippold, *Die griechische Plastik* (1950), p. 68; G. M. A. Richter, *Catalogue of Greek Sculptures in the Metropolitan Museum of Art* (1954), no. 5, pp. 4–5, pl. 8; *eadem, Korai* (1968), no. 151, p. 89, figs. 483–486; J. G. Pedley, *Greek Sculpture of the Archaic Period: the Island Workshops* (1976), pp. 43–45, pls. 20–21.

This kore follows the scheme of the korai found on the Acropolis in Athens: she wears a chiton and a himation, and with the left hand (now missing) she pulls the himation tight across her thighs. The right arm was bent at the elbow. Payne compared the Museum's kore with Acropolis 627 and took both to be of Cycladic workmanship. The similarities with the Delian kore (or Leto; see **162**) are less pronounced, though the latter has been attributed to Paros.

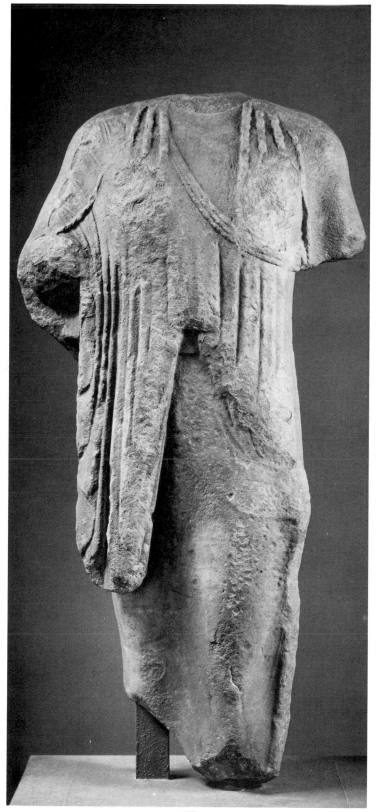

163

164

164 Marble relief of a seated woman
Found on Thasos
Thasian, about 520–510 B.C.
Height, 24 cm. (9 7/16 in.); width, 17.5 cm.
(6 7/8 in.)
Musée du Louvre, inv. MND 475 (MA 3103;
purchase, 1901)

Bibliography: G. Mendel, *BCH* 24 (1900), pp.
554–60, pl. 16; M. Collignon, *Florilegium dédié à M.
le Marquis de Voguë* (1909), pp. 129–36; G. Lippold,
Die griechische Plastik (1950), p. 72, note 5; K.
Schefold, *Meisterwerke griechischer Kunst* (1960), no.
168, pp. 30, 174–75; *Paris Cat.* (1979), pp. 200–
201, fig. 141.

A woman, or goddess (Aphrodite?), is shown
seated on a throne, her feet on a footstool. In her left
hand she holds a dove; in her right, the bud of a flower
(rather than an alabastron). The armrests of the
throne are supported by Ionic columns; the cushion is
relatively short.

The relief is probably votive, rather than
funerary.

165

165 Terracotta revetment (sima)
Galloping centaurs
Found on Thasos, July 31, 1971
Thasian, first half of the 6th century B.C.
Height, 24 cm. (9 7/16 in.); length, as preserved,
 28 cm. (11 in.); depth, 4–5 cm. (1 9/16 –
 1 15/16 in.)
Thasos, Museum, inv. 71/3295 (π 6641)

Bibliography: B. Schiffler, *Die Typologie des Kentauren in der antiken Kunst* (1976), pp. 107–8, 218, no. 373; *Paris Cat.* (1979), pp. 201–2, fig. 142; B. Holtzmann, *BCH* suppl. 5, *Thasiaca* (in press).

On the preserved fragment of the sima two centaurs are fleeing left. The first has uprooted a tree, and his open mouth reveals that he is howling. The subject of the entire revetment is probably the battle of Herakles with the centaurs, which followed his visit to the cave of the centaur Pholos; in honor of Herakles, Pholos had opened a pithos of wine and, attracted by the odor, other centaurs rushed up, armed with trees and stones. Herakles repelled them, first with fire brands and then with arrows. It has been suggested that the building to which the sima belonged was part of the Herakleion.

166

167

168

166–168 Three terracotta antefixes
Bellerophon and the Chimaera
Found in or near the sanctuary of Herakles
on Thasos
Thasian, second half of the 6th century B.C.
Height, **168**, 16.8 cm. (6⅝ in.), **166–167**,
17 cm. (6¹¹/₁₆ in.); width, **166**, 19.4 cm.
(7⅝ in.), **168**, 20.6 cm. (8½ in.), **167**,
as preserved, 13 cm. (5⅛ in.)
Athens, National Museum, inv. 16004 (**166**)
Thasos, Museum, inv. π 284 (**167**); inv. 19444
(**168**)

Bibliography: M. Launey, *Études Thasiennes* 1 (1944),
pp. 39–44, pls. 8,1, 8,3, 9,2; *Paris Cat.* (1979), pp.
202–4, figs. 143–145.

Seven antefixes of Bellerophon have been
found, all pressed from the same mold, differing from
one another only in coloring. We may assume that all
come from the same building—a temple or a banquet
hall. The antefix of Bellerophon on Pegasos, to right,
would alternate with one showing the Chimaera, to
left; the division of a subject on two adjacent an-
tefixes is also known from Lesbos.

169

169 Marble finial of a funerary stele with palmettes and volutes

Found on Paros
Parian, about 480 B.C.
Height, 92 cm. (36¼ in.)
Paros, Museum, inv. 108

Bibliography: E. Buschor, AM 58 (1933), pp. 44–45, Beilage 16,1; C. Karouzos, *To mouseio tēs Thēbas* (1934), p. 61, fig. 46; P. Zapheiropoulou, AAA 6 (1973), p. 355, fig. 6; B. Freyer-Schauenburg, *Samos 11* (1974), pp. 224–25, nos. 153–154, pl. 92; B. Fellmann, in *Wandlungen. Festschrift E. Homann-Wedeking* (1975), pp.112–13, pl. 24a (Amorgos); H. Hiller, *Ionische Grabreliefs* (1975), p. 77, no. 36, p. 89, no. 85 K 3, p. 170, pl. 14,2; *Paris Cat.* (1979), pp. 205–7, fig. 149.

The volutes from which the double palmette springs occur in Attica as early as the last quarter of the sixth century B.C. The second, smaller palmette superposed on the principal one is known from Samian stelai. "Parian" finials have been found in Thebes, and on Naxos, Samos, and Thera. For similar finials of Parian workmanship cf. Buschor, *op. cit.*, Beilagen 15,2–3, 16,2. *see Frontispiece*

170

170 Marble statue of a lion
Found on Kythera
About 520– 500 B.C.
Height, 109 cm. (42 ¹⁵/₁₆ in.); length, 58 cm.
 (22 ¹³/₁₆ in.); width, 33 cm. (13 in.)
Athens, National Museum, inv. 5255

Bibliography: S. Benton, *BSA* 32 (1931– 32), p. 245, pl. 42b; *AA* 1948– 49, cols. 265– 266; C. Blümel, *Antike Kunstwerke* (1953), no. 7, pp. 13– 15, figs. 5– 6; F. Willemsen, *Olympische Forschungen* 4 (1959), pp. 41, 130; J. Dörig, *AM* 76 (1961), p. 68; H. Gabelmann, *Studien zum frühgriechischen Löwenbild* (1965), no. 92, pp. 77– 78, 80, 118, 125; *Paris Cat.* (1979), p. 207, fig. 150.

This seated lion is in the "watchdog position" known from the sphinxes and lions that crown archaic grave stelai, and it may well have come from such a monument. Blümel (*op. cit.*) justly compares the lions in Corfu and Boston (from Perachora).

171 Fragment of a marble relief
Boy with an aryballos and a cock
Found on Kos, 1937, west of the town, in the
 area of the Baths that were excavated later
Late archaic, about 500– 480 B.C.
Height, as preserved, 41.5 cm. (16 ⅜ in.);
 width, as preserved, 27.5 cm. (10 ¹³/₁₆ in.);
 thickness of left edge, 12.5 cm. (4 ¹⁵/₁₆ in.)
Kos, Museum

Bibliography: L. Laurenzi, *Clara Rhodos* 9 (1938), p. 80; L. Morricone, *Bd'A* 44 (1959), pp. 1– 5, fig. 3; E. Berger, *Das Basler Arztrelief* (1970), pp. 120– 21, fig. 140; H. Hiller, *Ionische Grabreliefs* (1975), P 12, p. 52, pl. 8,1; E. Pfuhl and H. Möbius, *Die ostgriechischen Grabreliefs* (1977), no. 26, pp. 17– 18, pl. 7; *Paris Cat.* (1979), p. 213, fig. 151.

It is not clear whether the composition of the relief included another figure, either a seated divinity or, perhaps, a standing, older athlete. The aryballos suspended from the left wrist of the boy speaks for an athletic context; the gamecock held in his right hand may have been a gift. The marble is not of local origin, and there is much in the style that betrays Milesian or Ephesian workmanship or influence.

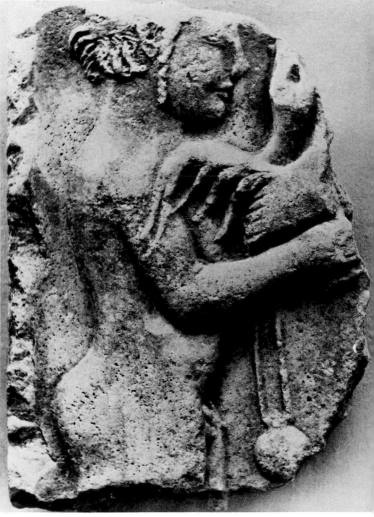

171

CLASSIC SCULPTURE OF THE ISLANDS

Nos. 172–191 Classic Sculpture of the Islands

The art-historical distinction between archaic and classic follows an Athenian historic event, the victory over the Persians (480–479 B.C.). In Athens, the desecration and destruction of the Acropolis was the watershed that prompted the artistic effort culminating in the Periclean building program on the Acropolis. A political parallel was furnished by the rise of Attic hegemony over the islands of the Aegean, through the Delian League. In the fifth century, therefore, regional styles began to lose their local characteristics, and, in any event, the classic style, with its emphasis on naturalism, brought with it an increasing assimilation. Nevertheless, local traditions persist, especially in the shapes of grave reliefs, the finest of which (e.g., 185) antedate the earliest Attic ones of the classic period by several decades.

172 A – C Three marble reliefs
 Apollo, Hermes, Nymphs, and Graces
 Found on Thasos, 1864
 Severe Style, about 470 B.C.
 Height, each, 92 cm. (36 ¼ in.); length, (A),
 209 cm.(82 ⁵/₁₆ in.);(B), 83 cm. (32 ¹¹/₁₆ in.);
 (C), 92 cm. (36 ¼ in.)
Musée du Louvre, inv. Froehner, 9, 10, 11
 (MA 696; Gift of Napoleon III, 1864)

Bibliography: E. Miller, *RA* 8 (1865), pp. 438 ff., pls.
24 – 25; A. Michaelis, *AZ* 25 (1867), cols. 1 – 14, pl.
217; E. Miller, *Le Mont Athos, Vatopédi et l'île de
Thasos* (1888), pp. 94 – 95, 200 – 218; M. Collignon,
BCH 24 (1900), pp. 536 – 38; Mme. Chevallier-
Vérel, in *Encyclopédie photographique de l'art* 3 (1938),
pp. 148 – 49; C. Picard, *Manuel d'archéologie grecque,
la sculpture* 2,1 (1939), pp. 88 – 94; G. Daux, *RA*
29 – 30 (1948), pp. 245 – 48; G. Lippold, *Die
griechische Plastik* (1950), p. 116, note 4, pl. 40,1; G.
Daux,*CRAI* (1954), pp.469 – 80; G. M. A. Richter,
Korai (1968), no. 193, p. 105, fig. 613 [relief C]; H.
Hiller, *Ionische Grabreliefs* (1975), p. 97, note 5, pp.
99 – 101, notes 13 – 15, pp. 103 – 4, 113; *Paris Cat.*
(1979), pp. 213 – 17, figs. 152 A – C.

The three reliefs faced each other in a passage-
way 4.70 meters wide, on walls about four meters
high. On relief (A), from the west wall, Apollo holds
his kithara and is being crowned by a Muse or Nymph,
while to the right of the niche three Nymphs offer
fillets, a dove, and a flower. Dowel holes on top of the
kithara, near the right hand of Apollo, and in and

172 A

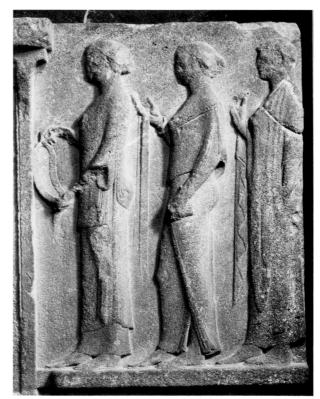

172 A (detail)

near the left hand of his companion show that the top of the kithara, the plectrum, and the wreath were added in another material, as were the diadems of the Nymphs. The two reliefs from the facing, east wall likewise flanked a niche: in the relief on the right (B), Hermes, like Apollo on the facing relief (A), occupies two-thirds of the slab. He advances left, his right hand extended in greeting, his left holding the caduceus. He is followed by a woman (or Nymph?) who fingers a fillet. To the left of the niche, which was larger than that on the opposite west wall, the three Graces are shown holding fillets, fruit, and a flower (relief C). There is much variation in the drapery and coiffure of these Nymphs, or Graces. Numerous small dowel holes with remains of bronze show that the women wore diadems and that Hermes' chlamys was fastened by a brooch. The upper part of his caduceus was worked separately and attached with bronze dowels. An inscription on the lintel of the niche of the Apollo relief gives the dedication to the Nymphs and to Apollo, leader of the Nymphs, and contains instructions for the sacrifice (no sheep and pigs) and cult (no paeans); a second inscription on the plinth of the Hermes relief (B) is a dedication to the Graces with the injunction not to sacrifice goats or pigs. The prominent inscription above the niche on the Apollo relief dates from Roman times, when the relief was reused as a grave monument.

The alphabet of the original inscriptions is Parian. The art of Thasos, a Parian colony, owes much to Paros, and was, at the same time, also influenced by the Aeolian cities of Northwest Anatolia, and, of course, by Athens. The unevenness of the sculptures found on Thasos has prompted some scholars, notably E. Pfuhl (*JdI* 41 [1926], p. 133) and E. Langlotz (*Frühgriechische Bildhauerschulen* [1927], pp. 120, 132, 137, nos. 8, 13, 14, 33, 34, and, again, in H. Schrader, *Die archaischen Marmorbildwerke der Akropolis* [1939], p. 37), to deny Thasos an important artistic school, but Hiller has stressed (*op. cit.*, pp. 98–103) that, at least in the first half of the fifth century, the sculptures from Thasos show enough interconnected stylistic traits to allow us to speak of a Thasian style.

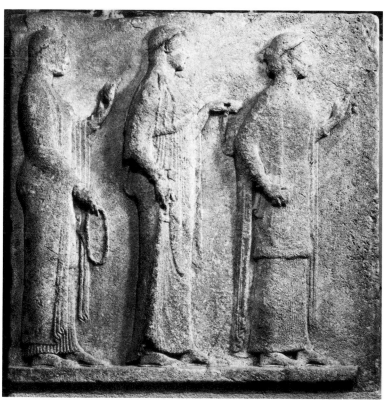

172 C

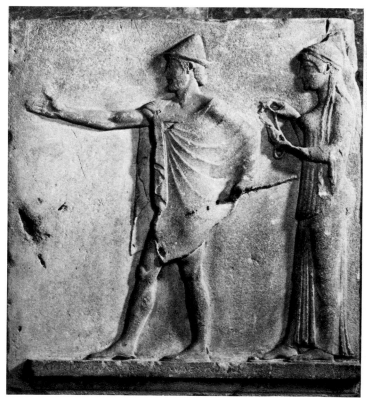

172 B

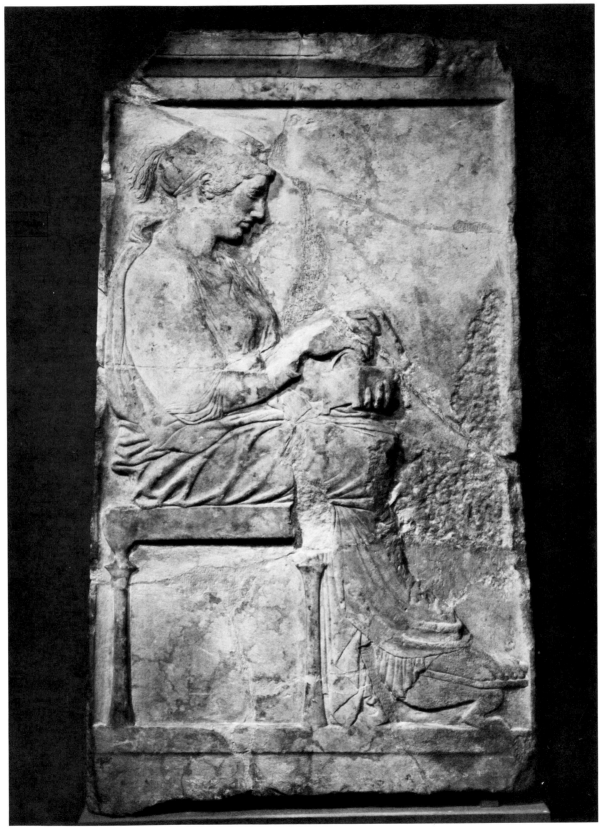

173

173 Marble grave relief of Philis, daughter of Kleomedes
The names are inscribed
Found on Thasos, 1864
Thasian, about 430 B.C.
Height, as preserved, 149 cm. (58 $^{11}/_{16}$ in.);
 width (below), 91 cm. (35 $^{13}/_{16}$ in.)
Musée du Louvre, MA 766 (purchase, 1864)

Bibliography: E. Miller, *RA* 8 (1865), pp. 438 ff., no. 5; A. Prachov, *AdI* 44 (1872), pp. 185–87, pl. L; P. Devambez, *BCH* 55 (1931), pp. 413–22, pl. 21; Mme. Chevallier-Vérel, in *Encyclopédie photographique de l'art* 3 (1938), p. 169; C. Picard, *Manuel d'archéologie grecque, la sculpture* 2, 2 (1939), pp. 847–48, pl. 26; G. Lippold, *Die griechische Plastik* (1950), p. 116, note 7, pl. 41, 4; H. Hiller, *Ionische Grabreliefs* (1975), p. 104, note 37; *Paris Cat.* (1979), pp. 217–18, fig. 153.

The footstool and the casket are shown in a perspective not totally mastered. On the right side of the relief, something has been chiseled away, perhaps the figure of a small child. The date assigned to this relief has fluctuated (cf. Devambez, *op. cit.*, pp. 414 ff.), but it is interesting to note that the comparisons with the Parthenon sculptures that have led to the currently preferred date, about 430 B.C., were already made by Prachov in 1872. Another controversy has centered on the contents of the little casket which, according to Picard, holds the "Book of the Dead" and gold tablets with geographical instructions for the underworld, yet the examples of *Attic* grave reliefs that show seated women with caskets or mirrors, frequently offered by servants, favor a more mundane interpretation of the casket.

174 Fragment of a circular marble relief with the head of a woman or goddess
Found on the slopes of Klema on Melos, 1937 (or 1936?)
About 460 B.C.
Estimated original diameter, 44.8 cm. (17 $^5/_8$ in.); height, as preserved, 32.5 cm. (12 $^{13}/_{16}$ in.); width, as preserved, 33.5 cm. (13 $^3/_{16}$ in.)
Athens, National Museum, inv. 3990

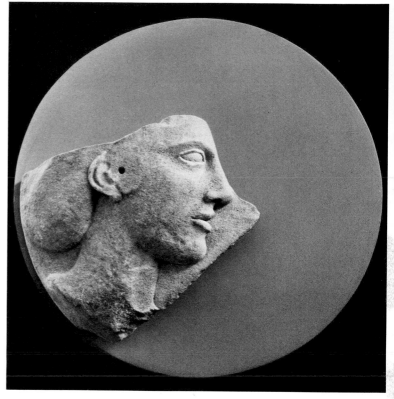

174

Bibliography: C. Karouzos, *AA* (1939), cols. 262–265; *idem*, *JHS* 71 (1951), pp. 96–110, pl. 37; S. Karouzou, *National Archaeological Museum, Collection of Sculpture* (1968), p. 34; *Paris Cat.* (1979), pp. 218–20, fig. 154.

A hole in front of the ear suggests that the hair escaping from the headdress (a sakkos) was worked in another material, perhaps gold. The function of the object is as unclear as its shape is unusual. If the relief had originally been a perfect disk, there would not have been sufficient space to show a second, facing head. C. Karouzos has thought of a flower, perhaps painted on, for the missing part (cf. *op. cit.*, p. 101, fig. 5), but this solution is far from ideal and does not explain why the head is pushed so far to the left.

175

175 **Terracotta relief**
Triton and Theseus
Provenance unknown
Melian, about 470 – 460 B.C.
Height, 12.5 cm. (4 15/16 in.); width, 16.3 cm.
　(6 7/16 in.)
Musée du Louvre, inv. MNC 746 (purchase, 1886)

Bibliography: A. De Ridder, *Mon. Piot* 4 (1897), p.
81; P. Jacobsthal, *Die melischen Reliefs* (1931), no. 3,
p. 17, pl. 3; S. Mollard-Besques, *Cat. 1* (1954), no. C
108, p. 102, pl. 74; *Paris Cat.* (1979), p. 220, fig.
155.

This Melian relief belongs to the earliest group of
the class, and the subject is also known on archaic
vases (J. D. Beazley, *ARV²*, p. 318, no. 1, p. 407, no.
7). On the Onesimos cup in the Louvre (*ARV²*, p.
318, no. 1) Triton is diminutive, but on the Briseis
Painter's cup in New York (*ARV²*, p. 406, no. 7) the
proportions are the same as on the Louvre relief — as is
the tenderness.

The tail of Triton, with its spiked dorsal crest, is
related to the tail of Scylla on other Melian reliefs
(Jacobsthal, *op. cit.*, pls. 34 – 36).

176

176 **Terracotta relief**
Phrixos carried across the sea by the ram
Provenance unknown
Mid-5th century B.C.
Height, 18.1 cm. (7⅛ in.); width, 24.6 cm.
(9 ¹¹/₁₆ in.)
The Metropolitan Museum of Art 12.229.20 (Rogers
Fund, 1912; Ex coll. Comte de Laborde, Paris)

Bibliography: O. Jahn, *AdI* 39 (1867), pp. 90–91,
pl. B; G. M. A. Richter, *BMMA* 8 (1913), pp.
175–77, fig. 4; P. Jacobsthal, *Zeitschrift für bildende
Kunst* 55 (1921), p. 101, fig. 9; *idem, Die melischen
Reliefs* (1931), no. 101, pp. 77–78, 168–88, pl. 58;
G. M. A. Richter, *Handbook of the Greek Collection*
(1953), p. 80, note 15, pl. 62c; K. Schauenburg,
Rheinisches Museum 10 (1958), p. 42, note 4.

An unattributed Attic red-figured cup in Berlin
(A. Greifenhagen, *CVA* Berlin 2–3 [1962], pls. 91,
1–4, 128, 3, 7) is nearly contemporary, and, sig-
nificantly enough, both show the ram swimming
across the Hellespont with Phrixos holding onto his
horns. On the vases, however (to which we must
add a neck-amphora in Naples [J. D. Beazley, *ARV²*,
p. 1161, no. 1] and a pelike in Athens [*ARV²*, p.
1218, no. 1]), Phrixos normally holds onto the ram
with only one hand, whereas on the Melian reliefs
he uses both.

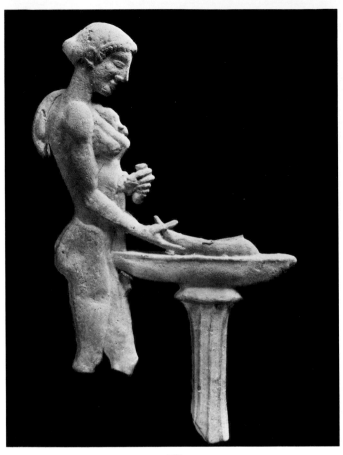

177

177 Terracotta relief
Woman at a laver
Provenance unknown
Melian, about 470 – 450 B.C.
Height, as preserved, 13 cm. (5 1/8 in.)
Musée du Louvre, inv. CA 3003 (Gift of A. de Nanteuil, 1942)

Bibliography: S. Mollard-Besques, *Cat.* 1 (1954), no. C 106, p. 102, pl. 73; *Paris Cat.* (1979), pp. 220 – 21, fig. 156.

Side-by-side with the large number of Melian reliefs that have mythological subjects are some that were inspired by scenes from daily life. Here, the woman has taken off her clothes for a wash. With her left hand she holds the tip of her garment, which is slung over her shoulder, and with her right she dips her shoe in the basin (as on the Attic red-figured column-krater by Myson, J. D. Beazley, *Paralipomena* [1971], p. 349, no. 29 bis). Such naked women have sometimes been called hetaerae (cf. *Münzen und*

Medaillen Auktion 34 [6 Mai 1967], pp. 77 – 78, no. 151), but bathing or washing need not be a prerogative of the profession.

178 Terracotta relief
The tomb of Agamemnon
Said to be from Melos, or the Piraeus
Melian, about 460 – 450 B.C.
Height, 22.8 cm. (9 in.); width, 33.5 cm. (13 3/16 in.)
Musée du Louvre, inv. MNB 906 (purchase, 1876)

Bibliography: A. Conze, *AdI* 33 (1861), pp. 340 – 46, and *Mon. Ined.* 6 – 7 (1861), pl. 57,1; R. Schöne, *Die Reliefs in athenischen Sammlungen* (1872), no. 14; P. Jacobsthal, *Die melischen Reliefs* (1931), no. 1, pp. 11 – 12, 13 – 16, pl. 1; S. Mollard-Besques, *Cat.* 1 (1954), no. C 16, p. 84, pl. 58; R. A. Higgins, *Greek Terracottas* (1967), p. 150; *Paris Cat.* (1979), p. 221, fig. 157.

Electra, accompanied by her nurse, has visited the tomb of her father, Agamemnon. By her side is the bronze oinochoe she has used for her sacrifice. As she sits on the steps of the tomb, deep in mourning, Orestes, his friend Pylades, and an attendant carrying a satchel arrive. Pylades, who, like the servant, wears a pilos, approaches Electra, a herald's staff in his left hand, while Orestes, in the middle, his petasos pushed back onto his nape, awaits the outcome of the encounter. The subject recurs on two other Melian reliefs (Jacobsthal, *op. cit.*, nos. 2 [Syracuse: pl. 2] and 94 [Würzburg: pl. 94]) of which the former is contemporary with the Louvre relief and from the same mold, while the latter is an adaptation from a later period.

The inscriptions on the Louvre relief and much of the added paint are modern.

179 Fragment of a terracotta relief
Aphrodite on a swan
Said to be from Melos
Melian, about 460 – 450 B.C.
Height, as preserved, 8.5 cm. (3 3/8 in.); width, 18.3 cm. (7 3/16 in.)
Musée du Louvre, inv. S 2221

Bibliography: S. Mollard-Besques, *Cat.* 1 (1954), no. C 107, p. 102, pl. 74; *Paris Cat.* (1979), p. 222, fig. 158.

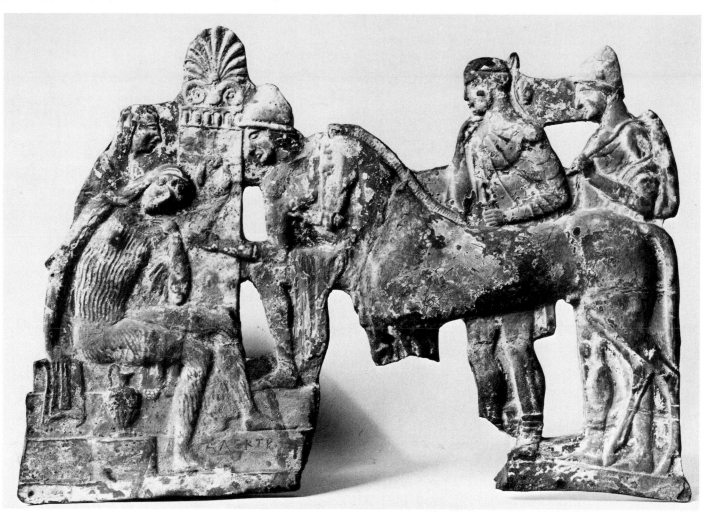

178

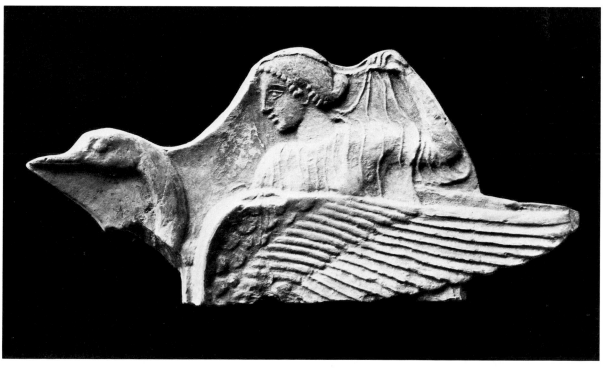

179

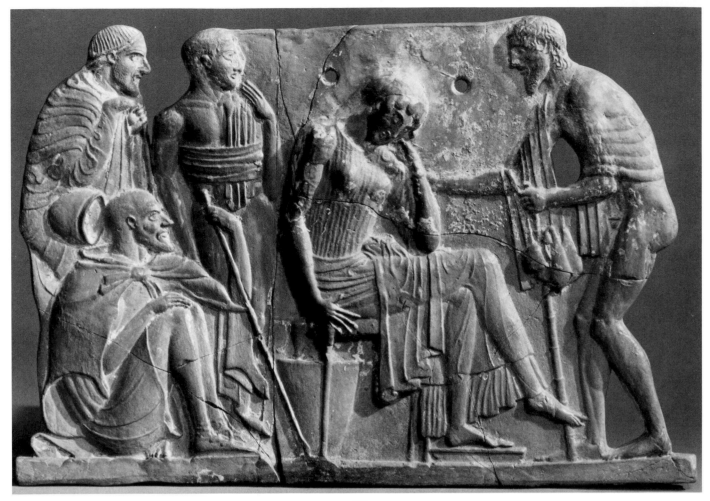

180

This fragment should be compared with a much-damaged relief in Athens (P. Jacobsthal, *Die melischen Reliefs* [1931], no. 49, pl. 24) which is in mirror-reverse. On both, Aphrodite rides sidesaddle, with her knees and feet pointing toward the tail of the swan. The upper part of her body, partly concealed by the wing, is frontal; her head is in profile, facing toward the head of the swan; with her right hand she holds onto the neck of the swan and with her left hand she fingers her himation. The composition, though differing in details, makes one think of the somewhat earlier white-ground cup by the Pistoxenos Painter (J. D. Beazley, *ARV²*, p. 862, no. 22).

180 Terracotta relief
 Odysseus and Penelope in the presence of
 Laertes, Telemachos, and Eumaios
 Provenance unknown

Melian, about 460 B.C.
Height, 18.7 cm. (7⅜ in.); width, 27.8 cm. (10¹⁵/₁₆ in.)
The Metropolitan Museum of Art 30.11.9
(Fletcher Fund, 1930)

Bibliography: F. Müller, *Die antiken Odyssee-Illustrationen in ihrer kunsthistorischen Entwicklung* (1913), p. 83, fig. 7; P. Jacobsthal, *AA* (1914), cols. 107–110, fig. 3; M. Bieber, *Deutsche Literaturzeitung* 39 (1919), pp. 22–24; E. Buschor, in A. Furtwängler and K. Reichhold, *Griechische Vasenmalerei* 3 (1921), p. 127, fig. 60; H. Stuart Jones, *The Sculptures of the Palazzo dei Conservatori* (1926), p. 218, note 1; G. M. A. Richter, *BMMA* 25 (1930), p. 279; P. Jacobsthal, *Die melischen Reliefs* (1931), no. 88, pp. 67–69, 219, pl. 50; D. von Bothmer, *Guide to the Collections, Greek and Roman Art* (1964), p. 21, fig. 27; G.

Neumann, *Gesten und Gebärden in der griechischen Kunst* (1965), p. 204; K. Friis Johansen, *Acta Archaeologica* 38 (1967), p. 185, fig. 9, pp. 193–94; O. Touchefeu-Meynier, *Thèmes Odysséens dans l'art antique* (1968), no. 425, pp. 221, 233, 239, 287; C. M. Robertson, *A History of Greek Art* (1975), pp. 202, 209, pl. 65b.

When the relief was cleaned in 1963, it was revealed that it had been made in two molds, with the seam running vertically between Telemachos and Penelope, thus bearing out Jacobsthal's contention that the left group (which, incidentally, is missing on the replica [Jacobsthal, *op. cit.*, no. 87]) was added by an apprentice, who must also have reworked the right half to accommodate the continuation of the staff of Eumaios.

The New York relief has been known since 1904 and was once in the collection of A. Peytel, who had obtained it from Feuardent. The suspicions of a forgery first voiced by Miss Bieber (*op. cit.*) and H. Stuart Jones (*op. cit.*) were refuted by Buschor (*op. cit.*): cleaning has shown that these suspicions are without foundation, and has also strengthened Jacobsthal's argument (*op. cit.*, p. 68) that this relief is crisper than the replica of the right half.

181 Terracotta relief
Odysseus disguised as a beggar, and Penelope
Said to be from Melos (bought on Melos)
Melian, about 450 B.C.
Height, 18.2 cm. (7 3/16 in.); width, 15.5 cm. (6 1/8 in.)
Musée du Louvre, inv. CA 860 (purchase, 1897)

Bibliography: E. Pottier, *AA* (1899), p. 96; *idem, RA* 34 (1899), p. 14; P. Jacobsthal, *Die melischen Reliefs* (1931), no. 89, pp. 69–70, pl. 51; S. Mollard-Besques, *Cat.* 1 (1954), no. C 105, p. 101, pl. 73; *Paris Cat.* (1979), p. 222, fig. 159.

Though fragmentary (the right arms of Odysseus and Penelope are missing), this is the best of several later versions of the previous type. Here Odysseus wears a pilos. His stance is more helpless than on the earlier example, and he is more emaciated. The treatment of the folds, on the other hand, is stiffer than on the New York-Berlin type; the four legs of the chair are shown in perspective.

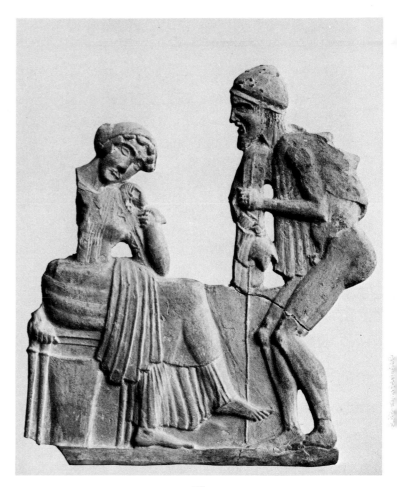

181

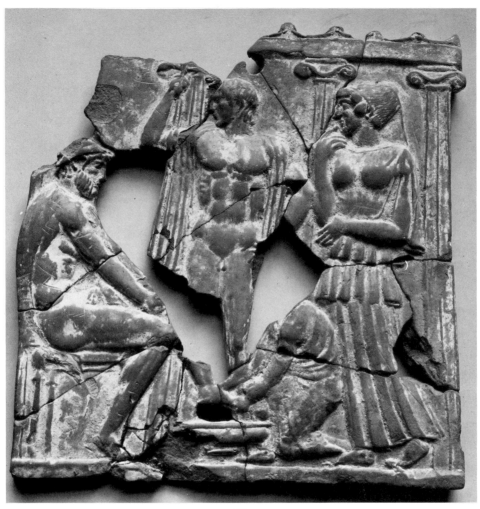

182

182 Terracotta relief
The footwashing of Odysseus
Provenance unknown
Melian, about 450 B.C.
Height, 19.7 cm. (7¾ in.); width, 18.6 cm. (7 5/16 in.)
The Metropolitan Museum of Art 25.78.26 (Fletcher Fund, 1925)

Bibliography: E. Buschor, in A. Furtwängler and K. Reichhold, *Griechische Vasenmalerei* 3 (1921), p. 127, fig. 59; G. M. A. Richter, *BMMA* 21 (1926), pp. 80–82, fig. 1; P. Jacobsthal, *Die melischen Reliefs* (1931), no. 95, p. 71, pl. 54; U. Hausmann, *Griechische Weihreliefs* (1960), p. 53, fig. 27; G.

Neumann, *Gesten und Gebärden in der griechischen Kunst* (1965), p. 112; O. Touchefeu-Meynier, *Thèmes Odysséens dans l'art antique* (1968), no. 430, pp. 221, 235, 239.

A fragmentary replica in Athens (Jacobsthal, *op. cit.*, pl. 55) preserves the left knee of Odysseus, the right thigh of Telemachos, and the head of Eurykleia, and the two reliefs are remarkably similar save that on the Athens relief the right arm of Penelope rested on the shoulder of Telemachos.

As in many other Melian "confrontations," the moment depicted is the one immediately before recognition, and its anticipation accounts for much of the dramatic tension.

183

183 Fragment of a terracotta relief with Orestes

Provenance unknown
Melian, about 440–430 B.C.
Height, as preserved, 16 cm. (6 5/16 in.); width,
 as preserved, 9.6 cm. (3 13/16 in.)
Musée du Louvre, inv. S 1678

Bibliography: E. Pottier, in A. Dumont and J. Chaplain, *Les céramiques de la Grèce propre 2* (1888), pp. 228–29, no. 42; P. Jacobsthal, *Zeitschrift für bildende Kunst 55* (1921), p. 104, fig. 11; *idem, Die melischen Reliefs* (1931), no. 105, pp. 82–85, pl. 62; S. Mollard-Besques, *Cat. 1* (1954), no. C 243, p. 122, pl. 87; *Paris Cat.* (1979), pp. 222–23, fig. 160.

This fragment preserves only part of the right third of a relief that has been interpreted by Jacobsthal (*op. cit.*) as Orestes and Pylades at the tomb of Agamemnon. On the Louvre fragment, Orestes has cut off his forelock and placed it on the steps of the tomb; his petasos rests on his nape and shoulders, as on **178**. The foot and the edge of the drapery to his left must be those of Electra, and the frontal figure in the background, who holds a fillet in her right hand, next to an oinochoe that she has set down, should be a *choephore*. The time is once again the moment *before* the recognition of Orestes and Electra.

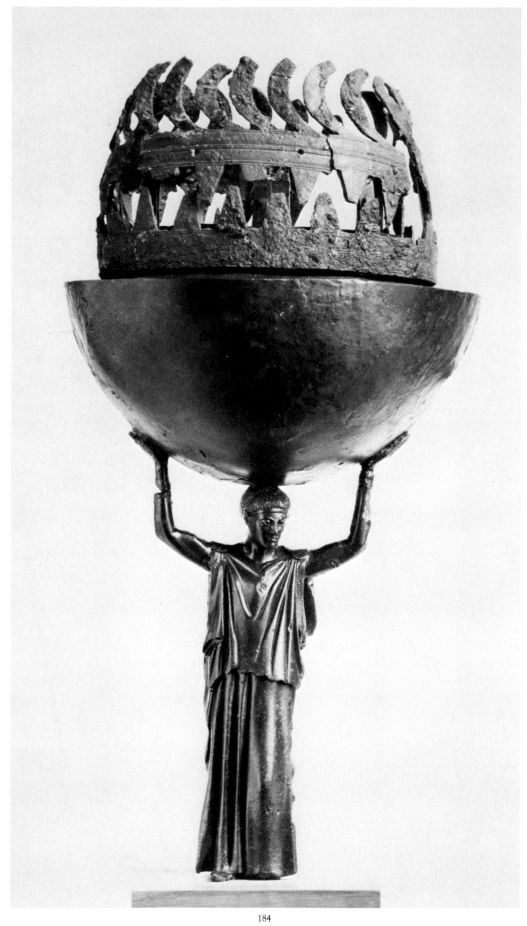

184

184 Bronze incense burner, supported by a statuette of a woman

The statuette is solid cast; the bowl is raised from a disk of sheet bronze; the cover (not exhibited here) is cast. The base is missing.

Found in Delphi, under the Sacred Way, 1939; the cover was found later

Perhaps Parian, mid-5th century B.C.

Height, with cover, 34 cm. (13⅜ in.); height of statuette, 16 cm. (6⁵/₁₆ in.)

Delphi, Museum, inv. 7723

Bibliography: P. Amandry, *BCH* 63 (1939), p. 88, fig. 2; E. Will, *ibid.*, pp. 112–14, no. 62, pl. 41; P. Amandry, ibid. 64–65 (1940–41), p. 272, pl. 20; E. Will, *Mon. Piot* 40 (1944), pp. 53–68, pls. 5–6; C. Rolley, *Fouilles de Delphes* 5 (1969), pp. 155–60, no. 199, pls. 44–47; E. Walter-Karydi, *JdI* 91 (1976), pp. 1–27, figs. 1, 3,1–2, 5,2, 11,1, 12,1; *Paris Cat.* (1979), pp. 223–24, fig. 161.

The scheme of a flat mirror disk supported by the raised arms of a girl or a woman has been known ever since the New Kingdom of Egypt, and similar supporting figures occur on paterae and at least one incense shovel (cf. *Mon. Piot* 61 [1977], pp. 7 ff.). A woman balancing a hemisphere on her hands and head, however, is not known other than in the exceptional bronze from Delphi, which evokes something of the effortless grace of the Olympia metope on which Athena helps Herakles, who has temporarily replaced Atlas. *see Cover*

185 Marble stele of a girl holding two pigeons

Found on Paros, 1775

Parian, about 450–440 B.C.

Height, 80 cm. (31½ in.); width (bottom), 40 cm. (15¾ in.), (top), 36.8 cm. (14½ in.); depth (without plinth), 6 cm. (2⅜ in.), (of plinth), 10 cm. (3¹⁵/₁₆ in.)

The Metropolitan Museum of Art 27.45 (Fletcher Fund, 1927; purchased from the collection of the Earl of Yarborough, Brocklesby Park)

Bibliography: *Museum Worsleyanum* 1 (1794), pl. 35; A. Michaelis, *Ancient Marbles in Great Britain* (1882), pp. 229–30, no. 17; A. Furtwängler, *Collection Sabouroff* 1 (1883–87), p. 7; *Antike Denkmäler* 1 (1887), pl. 54; G. Roesch, *Altertümliche Marmorwerke von Paros* (1914), no. 7, pp. 30, 31, 36, 45, 51–54; E. Langlotz, *Frühgriechische Bildhauerschulen* (1927), p. 173, IV; V. H. Poulsen, *EA* pl. 3007 (1929); G. M. A. Richter, *Sculpture and Sculptors of the Greeks* (1929), pp. 32, 62, 100, figs. 205, 426; eadem² (1930), pp. 41, 80, 132, 145, 204, figs. 205, 426; eadem, *Animals in Greek Sculpture* (1930), pl. 61, fig. 206; H. Diepolder, *Die attischen Grabreliefs* (1931), p. 8, note 7; P. Jacobsthal, *Die melischen Reliefs* (1931), p. 159, note 3, p. 161, fig. 41; E. Pfuhl, *JdI* 50 (1935), pp. 21–22; W. Kraiker, *RM* 51 (1936), pp. 136, 143; V. H. Poulsen, *Acta Archaeologica* 8 (1937), p. 86; S. Benton, *JHS* 57 (1937), p. 42, note 20; G. Becatti, *Critica d'Arte* 14 (1938), pp. 54 ff., fig. 2; E. Buschor, *Grab eines attischen Mädchens* (1939), pp. 16, 18, fig. 11; G. Kleiner, *JdI* suppl. 15 (1942), p. 201; G. Lippold, *Die griechische Plastik* (1950), p. 176, note 2, pl. 64,1; G. M. A. Richter, *Sculpture and Sculptors³* (1950), p. 80, fig. 205, p. 415; eadem, *Catalogue of Greek Sculptures in the Metropolitan Museum of Art* (1954), no. 73, pp. 49–50, pl. 60a; E. Kukahn, *Anthropoide Sarkophage in Beyrouth* (1955), p. 16, fig. 11; T. Dohrn, *Attische Plastik* (1957), pp. 94, 122; W.-H. Schuchhardt, *Gnomon* 30 (1958), p. 491 *s.n.* no. 73; C. Karousos, *AM* 71 (1956 [1959]), pp. 245 ff.; idem, *AM* 76 (1961), pp. 116–17; W. Fuchs, *Die Skulptur der Griechen* (1969), p. 484, fig. 568; F. Eckstein, *Städel Jahrbuch* 2 (1969), p. 17, fig. 10; H. Hiller, *Ionische Grabreliefs* (1975), pp. 88, 131, note 35, p. 136, pl. 31, 2; E. Walter-Karydi, *JdI* 91 (1976), p. 9, note 16; A. Kostoglou-Despoinē, *Problemata tēs Parianēs plastikēs* (1979), pl. 34 a-b.

The proportions of the girl and her plump wrists and hands suggest that she is very young, perhaps not more than eight or nine years old. Two dowel holes on the top edge of the slab indicate that the relief was once surmounted by a palmette finial (perhaps of the type shown in **169**). The style is not without Attic influences, but the treatment of the hair, in particular, coupled with the known provenance, favors an

attribution to a Parian sculptor (*pace* C. Picard, *Manuel* 2[1939], p. 96, note 5). For the most striking parallel, a relief in Salonica, see Kostoglou-Despoinē, *op. cit.*, pls. 30–32.

The date is much debated. Dohrn (*op. cit.*) opted for a date as low as 420 B.C. and was followed in this by Schuchhardt (*op. cit.*), but others, notably C. Karousos (*op. cit.*) and Mrs. Walter-Karydi (*op. cit.*), do not go down much beyond 440 B.C. The date proposed by Jacobsthal (*op. cit.*), the "mid-forties," still seems the most convincing.

186 Fragment of a marble relief
Youth leading a horse
Found on Kythera, 1912

Mid-5th century B.C.
Height, 42 cm. (16 9/16 in.)
Athens, National Museum, inv. 3278

Bibliography: S. Karouzou, *National Archaeological Museum, Collection of Sculpture* (1968), p. 52; W. Fuchs, *Die Skulptur der Griechen* (1969), pp. 514–15, fig. 602; *Paris Cat.* (1979), pp. 225–26, fig. 162.

The horse probably had a bridle added in bronze, and part of the reins must likewise have been of bronze while the end of one, held in the hands of the boy, was sculpted in marble. Fuchs (*op. cit.*) suggested that the relief belonged to a statue base, but it is just as likely that it was an independent votive offering.

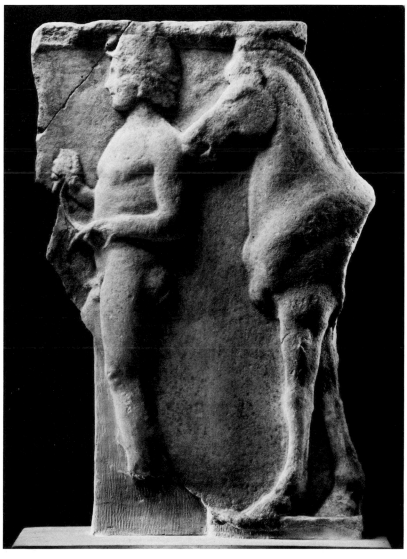

186

187

188

187 Fragment of a marble grave relief of a youth
Found on Amorgos
About 430 B.C.
Height, as preserved, 38 cm. (14 15/16 in.);
 width, as preserved, 45 cm. (17 ¾ in.)
Athens, National Museum, inv. 4470

Bibliography: N. Kotzias, *Polemon* 6 (1956–57), p. 49, fig. 21; C. Karousos, *AM* 76 (1961), pp. 115 ff., Beilage 73, pl. 4; S. Karouzou, *National Archaeological Museum, Collection of Sculpture* (1968), p. 49; *Paris Cat.* (1979), pp. 226–27, fig. 163.

The standing youth looks down at a seated figure, perhaps a woman, of whom nothing but the left hand is preserved. This hand holds an indistinct object, probably a triptych, by the thumb and the tips of the fingers. Though of Island workmanship, the style was influenced by the Parthenon. The original width of the relief must have been considerable.

188 Fragment of a marble grave relief of a nude youth
Found on Kythnos
About 430 B.C.
Height, as preserved, 62 cm. (24 7/16 in.);
 width, as preserved, 37 cm. (14 9/16 in.)
Athens, National Museum, inv. 37

Bibliography: E. Pfuhl, *JdI* 50 (1935), p. 21, fig. 8; K. Schefold, *AK* 1 (1958), p. 70, note 11;

M. Andronikos, *BCH* 86 (1962), p. 266, fig. 5; S. Karouzou, *National Archaeological Museum, Collection of Sculpture* (1968), pp. 48–49; E. Berger, *Das Basler Arztrelief* (1970), p. 123, fig. 143; *Paris Cat.* (1979), p. 227, fig. 164.

The inclination of the figure has reminded Schefold of a relief in Munich (Berger, *op. cit.*, p. 148, fig. 161) on which a boy in a similar pose holds a scroll in his hands in front of a seated man playing the lyre—but there are other possibilities. The youth may well have been the principal figure, especially since his head touches the upper border of the relief; he may be looking at a dog or other pet, or even a small attendant.

189 Marble grave relief of a youth and a man
Found near the Dipylon in Athens, 1910
About 410 B.C.
Height, as preserved, 103 cm. (40 9/16 in.); width, 56 cm. (22 1/16 in.); depth, 22.5 cm. (8 7/8 in.)
Athens, National Museum, inv. 2894

Bibliography: S. Papaspyridi, *Arch. Deltion* 10 (1926), pp. 111–23, figs. 1–2, pl. 3; H. Diepolder, *Die attischen Grabreliefs* (1931), p. 30, fig. 25; H. K. Süsserott, *Griechische Plastik des vierten Jahrhunderts vor Christus* (1938), pp. 105 ff.; K. Friis Johansen, *The Attic Grave-Reliefs* (1951), pp. 29–30, 33, 104, fig. 13; S. Karouzou, *National Archaeological Museum, Collection of Sculpture* (1968), p. 78; *Paris Cat.* (1979), pp. 227–29, fig. 165.

The shape and construction of the stele are non-Attic. Two holes on the top, one of which still preserves the lead of a dowel, indicate that the stele was surmounted by an ornamental finial. The handshake on grave reliefs, formerly taken as a gesture of farewell or greeting on arrival, is now—thanks to Friis Johansen—recognized as the symbol of a union: a mystical union between the dead and the survivors that takes place beyond the boundaries of space and time. Here, the youth on the left, accompanied by a dog, must be the deceased. The bearded man, who carries an aryballos, should be either the father or a pedagogue—an interpretation that is strengthened by a comparison of the expressions on the two faces.

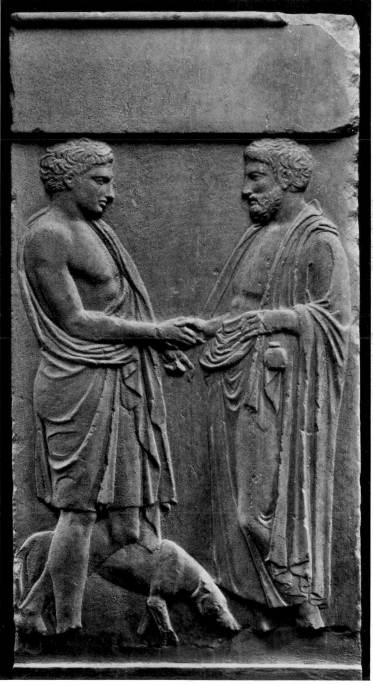

189

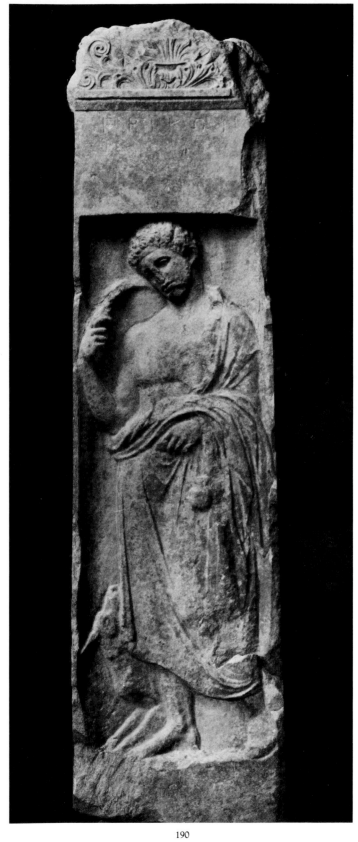

190

190 Marble grave relief of Prikon
His name is inscribed
Found at Karystos on Euboea, 1848
About 370 – 360 B.C.
Height, 161 cm. (63 ⅜ in.); width, 40 cm.
 (15 ¾ in.); depth, 13 cm. (5 ⅛ in.)
Athens, National Museum, inv. 730

Bibliography: G. Pervanoglou, *Die Grabsteine der alten Griechen* (1863), p. 36, no. 6; *Inscriptiones Graecae* XII, 9 (1915), p. 8, no. 37; S. Papaspyridi, *Arch. Deltion* 10 (1926), p. 112; H. Möbius, *Die Ornamente der griechischen Grabstelen klassischer und nachklassischer Zeit* (1929), p. 53, pl. 43b; G. Lippold, *Die griechische Plastik* (1950), p. 206, note 6; *Paris Cat.* (1979), pp. 229 – 30, fig. 166.

The dead youth Prikon is shown standing, facing left, in three-quarter view, his head bent forward and to his right. In his right hand he holds a strigil, and suspended from his left wrist is an aryballos; both are athletic equipment. His dog sits at his feet, looking up at its master.

The shape of the stele, tall and narrow, and even the floral finial hark back to the early Ionian tradition, yet the carving of the youth, the inclination of his head, and especially the three-quarter view reveal the strong Attic influence to which the Island sculptors increasingly succumbed.

191 Marble grave relief of Kalliarista
Funerary inscription in five lines
Found in a classic necropolis southwest of
 the ancient city of Rhodes
About 360 – 350 B.C.
Height, 128 cm. (50 ⅜ in.); width, 86 cm.
 (33 ¹⁵/₁₆ in.); depth, 20 cm. (7 ⅞ in.)
Rhodes, Museum

Bibliography: L. Laurenzi, *Clara Rhodos* 9 (1938), pp. 81 – 84, figs. 49 – 52; S. Charitonides, AM 79 (1964), p. 146; C. W. Clairmont, *Gravestone and Epigram* (1970), pp. 54, 107 – 9, no. 32, pl. 16; C. Karouzos, *Rhodos*² (1973), pl. 16; E. Pfuhl and H. Möbius, *Die ostgriechischen Grabreliefs* 1 (1977), no. 66, p. 29, pl. 17. On the inscription, see J. and L. Robert, REG 59 – 60 (1946 – 47), *Bulletin épigraphique*, p. 338, no. 158; W. Peek, *Griechische Versinschriften* I, *Grabepigramme* (1955), no. 893, p. 246; Clairmont, *op. cit.*; G. Daux, BCH 96 (1972), pp. 541 – 42, no. 32; *Paris Cat.* (1979), pp. 230 – 31, fig. 167.

The classic Attic composition of a maid offering her dead mistress a casket is here totally incorporated into the repertory of a Rhodian(?) artist, but non-Attic elements remain visible in the somewhat clumsy treatment of the hands, the stiffness of the hair, and a certain lack of expression in the faces. Non-Attic, too, is the depth of the relief and the manner in which the heads, though fully three dimensional, are attached to the background.

The metrical epigram is in five lines: two hexameters, two pentameters, and a line [2] that ends like a pentameter but, because of the proper names, does not scan at the beginning. From the epigram we learn that Kalliarista was the daughter of Phileratos and that her husband, Damokles, erected the tomb as a memorial of his love, "because she enjoyed, thanks to her wisdom and virtue, the highest human praise when she died." Clairmont (*op. cit.*) speculates that Kalliarista was the Athenian wife of a wealthy Rhodian who "had lived for some time in Athens and had thus become familiar with the memorials which were fashionable in Attica at the time." He further believes that the sculptor was an Athenian who went to Rhodes to execute the relief there. But neither Kalliarista nor Phileratos are Attic forms, and the execution of the relief is not impeccably Attic.

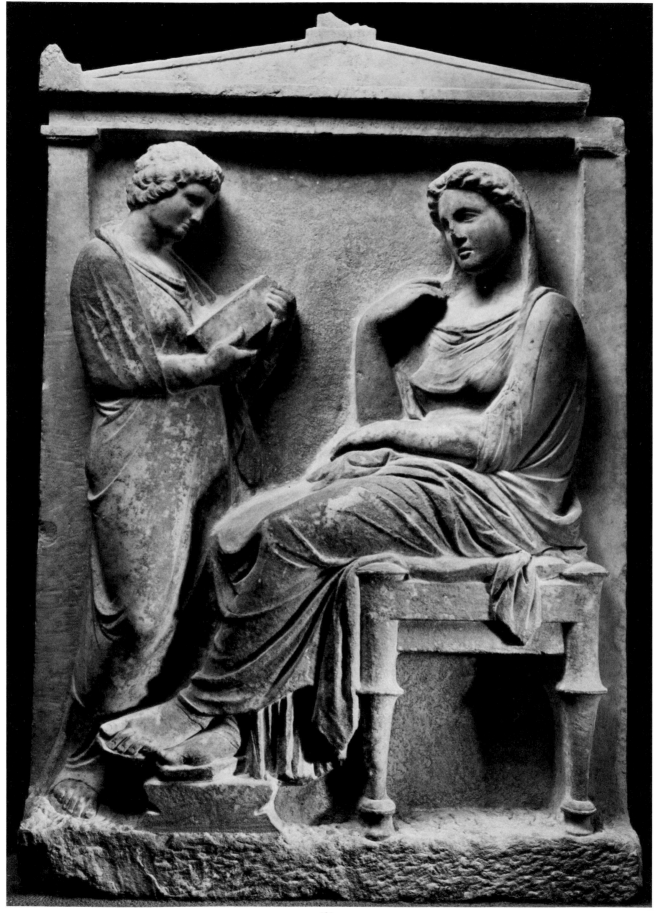

Photograph Credits

In addition to the photographs furnished by the Department of Antiquities of the Greek Ministry of Culture and Science, the Metropolitan Museum gratefully acknowledges the photography by M. Chuzeville of objects in the Louvre and by Otto Nelson of objects in the Schimmel Collection, New York.

Composition by Zimmering and Zinn, Inc., New York. Set in Goudy Old Style.
Printed by Colorcraft Offset, Inc., New York
Bound by Mueller Trade Bindery Corp., Middletown, Connecticut,
 and Publishers Book Bindery, Inc., Long Island City, New York